THE COMPLETE ENCYCLOPEDIA OF
PHOTOGRAPHY

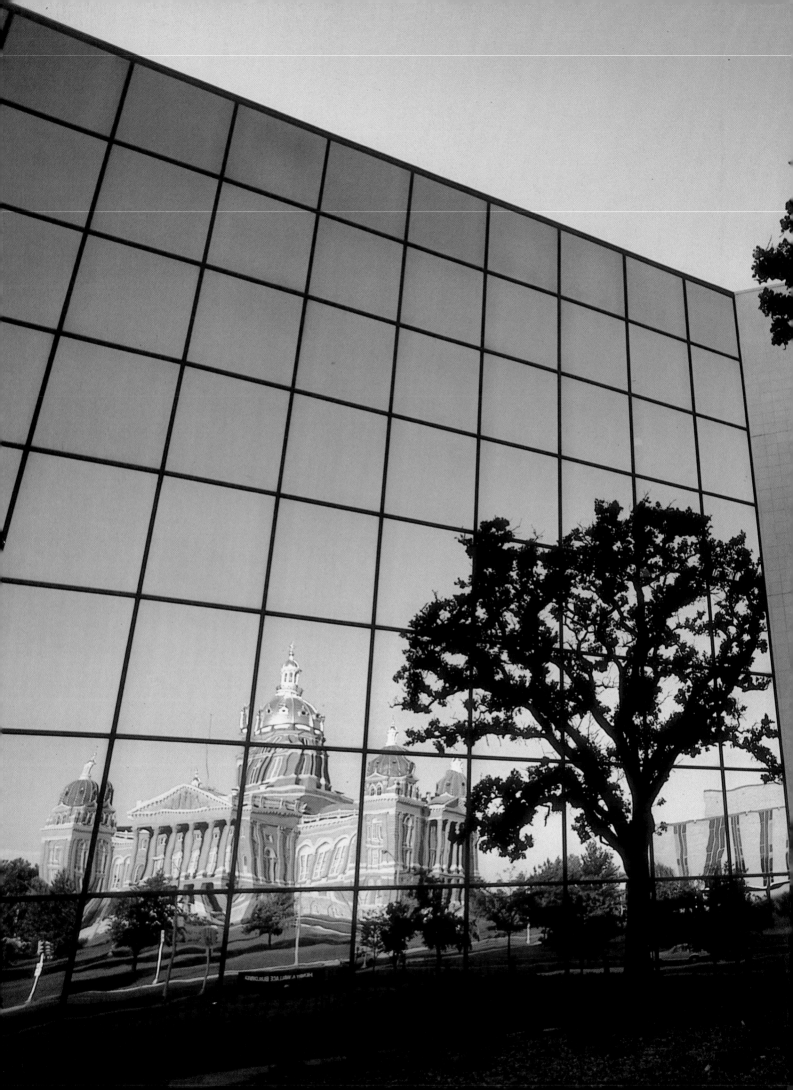

THE COMPLETE ENCYCLOPEDIA OF
PHOTOGRAPHY

MARK EDWARDS
GENERAL EDITOR: JONATHAN HILTON

PRION

Published in the United Kingdom by
Multimedia Books Limited,
32-34 Gordon House Road, London NW5 1LP

Exclusive distribution in the USA by
Smithmark Publishers Inc.
16 East 32nd Street, New York, NY 10016

Editors: Richard Rosenfeld and Anne Cope
Assistant Editor: Diana Vowles
Production: Hugh Allan
Jacket Design: Patricia Houden
Design: Michael Hodson Designs
Picture Research: Helena Beaufoy, Veneta Bullen,
 Jackum Brown and Charlotte Deane

ISBN 1 85375 003 4

Typeset by Letterspace Ltd
Printed in Hong Kong by Imago

10 9 8 7 6 5 4 3 2 1

CONTENTS

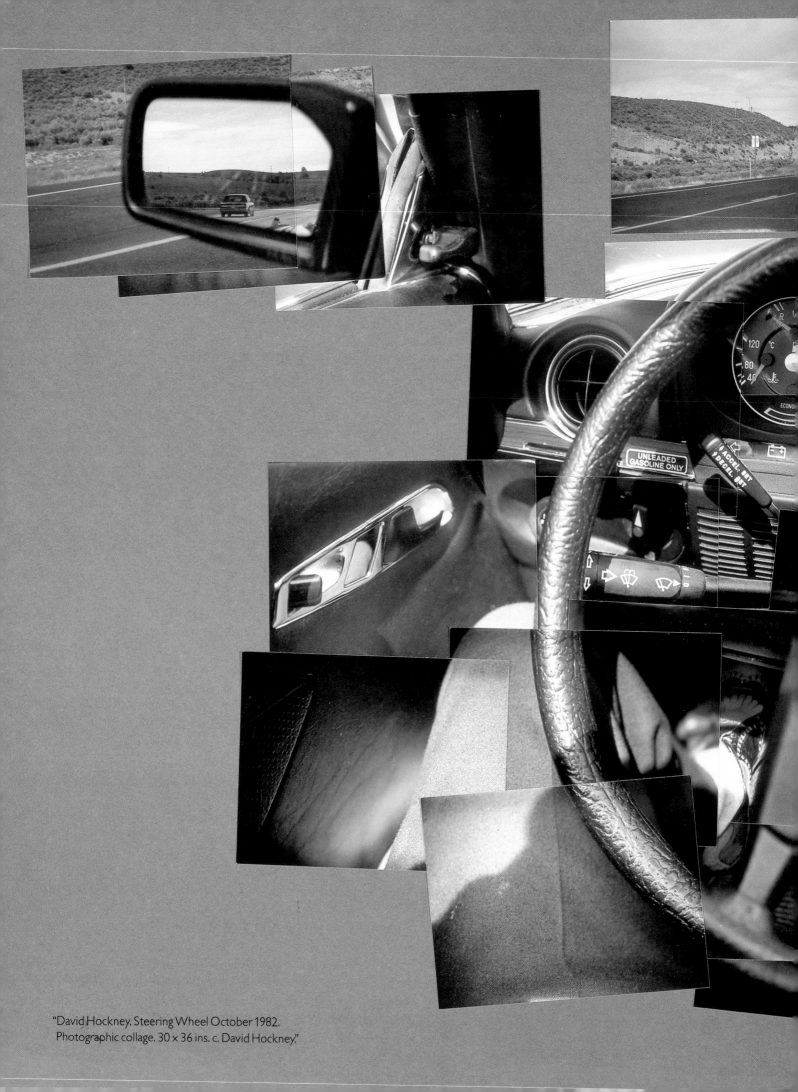

"David Hockney. Steering Wheel October 1982.
Photographic collage. 30 × 36 ins. c. David Hockney."

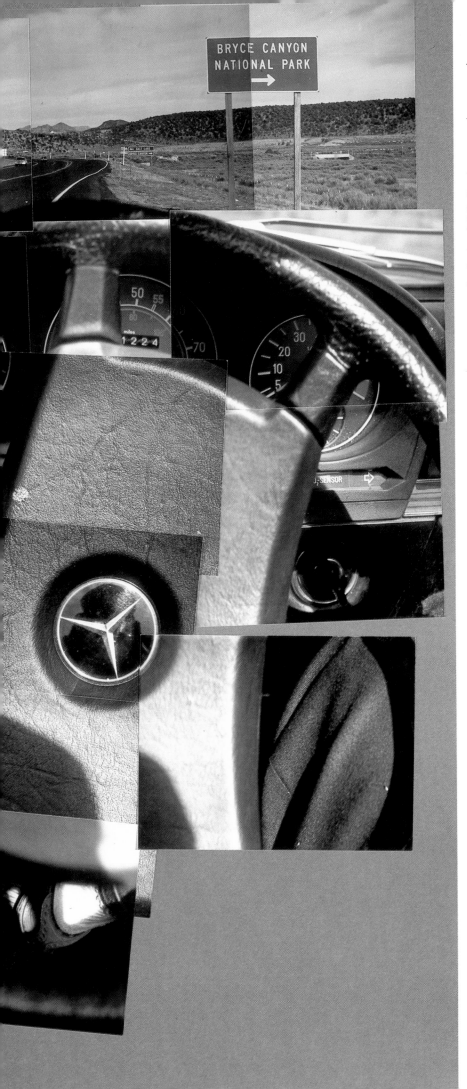

INTRODUCTION

Since the birth of photography in the nineteenth century, the development of equipment and technique has proceeded with bewildering rapidity. Today, the beginner who wishes to wade into these complex waters can easily be deterred by the choice of equipment, all too often described in impenetrable jargon.

The aim of this book is both to lead the beginner into this new world, while also updating the more experienced hand with details of new cameras, lenses and film. Although there is necessarily much technical information, it has been presented in a way that it is accessible to the novice. The book describes the full process of photography from the moment you pick up your first camera to mastery of advanced darkroom techniques. It cannot promise to turn you into the top-flight professional photographer; what it can do is help you achieve your maximum potential, whether you simply want to take good family snapshots, or earn your living by photography.

The first chapter begins with the basics; you must first decide what sort of pictures you will most want to take. The capabilities of the different varieties of camera are carefully explained, the film sizes they use, their advantages and limitations. And, in making your selection of camera type, you will also want to know what accessories will be available – lenses, motor drives and flash units.

The next thing to know about is the wide variety of films available. This section unravels the mysteries of the different sorts of film, their structure and the conditions they are most suitable for.

Having chosen your materials, you will now want to find out how to use them. Depth of field, often a stumbling block for beginners, and how it is affected by different lenses is clearly explained. You will also discover how to control image movement and exposure. Next, you must consider the light, for it is when the light strikes your film that the magic of photography begins.

The principal source is the sun – but dull and misty days can produce stunning pictures. Perhaps you want to photograph indoors, using only window light – or perhaps you want to be familiar with the whole battery of studio lights. And a good knowledge of flash, of course, is invaluable. Chapter 4 helps you to understand how to use your light source to its best advantage.

Chapter 5 moves to the darkroom, where you will reap the harvest of your work with the camera. There is advice on how to convert a room into a permanent or temporary darkroom. Step-by-step diagrams show you how to process the film, and the chemicals and equipment needed for different varieties of film are described. You must then decide what sort of paper best suits your subject, and how you are going to print your negative. Color and black and white prints and transparencies all require different handling in the darkroom.

'Selecting a Theme' suggests directions you may wish your photography to take and tells you how to handle every situation from holiday snaps to high-speed action.

Finally, there is a selection of important photographs offering a personal view as to what makes them great. For, through all your study of the technical skills, it is that still, perfect, final image you are striving for.

CHOOSING THE RIGHT EQUIPMENT

All photographers, amateur or professional, are concerned with pictures. To take consistently good photographs you need a keen sense of observation, a thorough understanding of technique and, of course, the right equipment to do the job.

But choosing the right equipment can be difficult. A brief visit to any large photographic store will reveal a seemingly bewildering variety of camera types, model numbers, lenses and accessories. In common with other areas of interest, such as hi-fi or computers, there is little point paying for facilities you are unlikely to use. Why, for example, buy a camera capable of accepting different lenses if you intend only to use the standard lens supplied? Is it necessary to have a camera designed to make thousands of exposures every year if you take photographs only on vacation? Professional cameras are expensive because they are made strong enough to withstand rough use, day after day. They will be specially designed to operate in extremes of climate, and unless you intend to work under these types of conditions, you will be better off buying a less-expensive model and using the money saved to buy extra film or some other accessory. Choosing the right equipment is basically a question of assessing your own needs.

This first section is intended to provide a brief introduction to the whole field of camera formats, lenses and accessories, such as light meters, flash units and tripods. Whether you are a first-time buyer or an experienced amateur, or a professional looking to update and improve your existing equipment, the following pages will provide valuable information on what is currently available. The jargon that has grown up within the subject of photography is the first barrier that needs to be dismantled. Wherever practicable, all unfamiliar terms and expressions are explained in the text, and unless a particular camera or system is available only from one manufacturer, features are discussed without reference to brand names.

The machinery of photography is constantly changing. Photographic equipment is improving and becoming simpler to use all the time. But don't lose sight of the fact that the camera is simply a tool; it is the vision of the photographer that differentiates the snap from a memorable image.

The basic camera

All cameras have certain features in common. Stripped of all its refinements, a camera is basically a light-tight box with a viewfinder (or sighting device), which allows you to aim the camera at the chosen subject, and a lens at the front, which bends incoming light reflected from the subject to a point of focus. It is at this point, known as the focal plane, that the light-sensitive film is positioned.

The aperture

To help control the brightness of the incoming light, a diaphragm is built into the lens. This can be adjusted to provide a range of different-size apertures, or holes, through which the light passes. On some camera lenses the aperture control is a ring marked in a series of numbers, known as f numbers – the smaller the number the larger the aperture. As an example, f 1.8 indicates a larger aperture setting than f 16. Every adjustment of the aperture either doubles (f 5.6 to f 4) or halves (f 4 to f 5.6) the amount of light that can pass through the lens.

On simple cameras, the aperture control ring is replaced by a ring or slide control marked in a series of symbols denoting a limited range of different weather conditions – usually from 'sunny' to 'cloudy'.

The shutter

The other feature common to all cameras that helps to control the amount of light that reaches the film is the shutter. The position and design of the shutter varies depending on the type of camera. Its functions, however, remain the same – to prevent light reaching the film until the exposure is made (by pressing the shutter release button) and to control the length of time light is allowed to pass through the aperture to the film.

Most fixed-lens cameras have a bladed shutter situated in the lens itself. At the moment of exposure the blades open to the pre-selected aperture and then close again to exclude all light. With single lens reflex cameras (see pp. 16-19), a lens shutter would have to be built into each additional lens used. This would add unnecessary manufacturing costs, and so a focal plane shutter is used instead. As its name implies, this type of shutter –

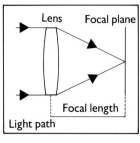

The lens
The function of the camera lens is to collect light travelling out from the subject and to bend it so that it comes into focus at the focal plane.

Principal parts
*Stripped of all its refinements, the principal parts of all camera types can be seen **below**, set out in their correct relative positions.*

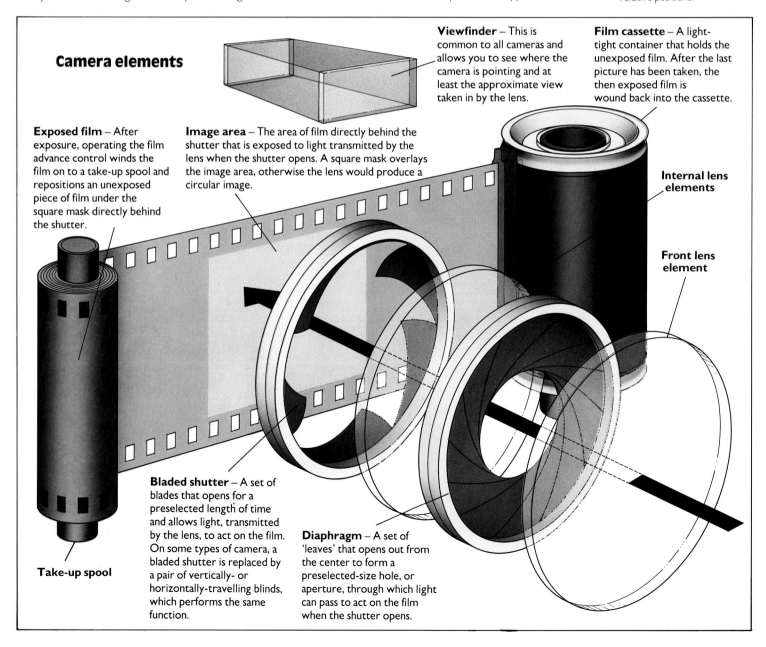

Camera elements

Viewfinder – This is common to all cameras and allows you to see where the camera is pointing and at least the approximate view taken in by the lens.

Film cassette – A light-tight container that holds the unexposed film. After the last picture has been taken, the then exposed film is wound back into the cassette.

Exposed film – After exposure, operating the film advance control winds the film on to a take-up spool and repositions an unexposed piece of film under the square mask directly behind the shutter.

Image area – The area of film directly behind the shutter that is exposed to light transmitted by the lens when the shutter opens. A square mask overlays the image area, otherwise the lens would produce a circular image.

Internal lens elements

Front lens element

Take-up spool

Bladed shutter – A set of blades that opens for a preselected length of time and allows light, transmitted by the lens, to act on the film. On some types of camera, a bladed shutter is replaced by a pair of vertically- or horizontally-travelling blinds, which performs the same function.

Diaphragm – A set of 'leaves' that opens out from the center to form a preselected-size hole, or aperture, through which light can pass to act on the film when the shutter opens.

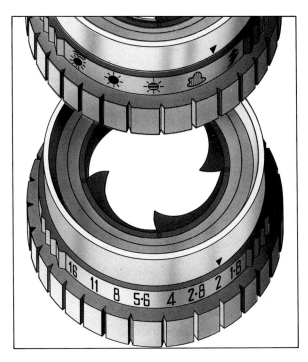

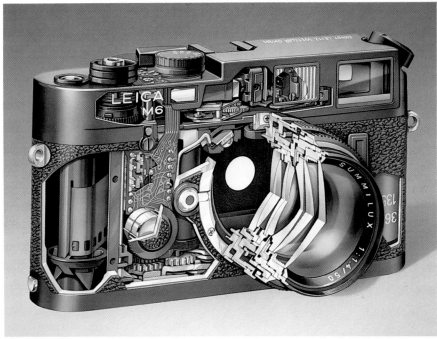

Aperture control
The aperture ring on the lens **above** *is calibrated either in f stops or weather symbols.*

Camera cutaway
In contrast to the basic camera **opposite,** *you can see a cutaway of a modern rangefinder* **above right**.

Pinhole image
A box with a pinhole and a piece of film taped inside was used to take the picture **below**.

consisting of a set of horizontally- or vertically-travelling cloth or metal blinds – is positioned just in front of the focal plane inside the camera body. At the point of exposure the blinds open to allow light travelling through the lens to reach the film, and then close again.

The length of time the shutter remains open is determined by the shutter speed control ring. On a fixed-lens camera a ring is usually provided on the lens, while on a single lens reflex (SLR) camera, the shutter speed control is usually found on the top surface of the camera body, near the shutter release button.

With both types of camera, the control is marked in a series of fractions of a second – typically from one full second to 1/1000 sec. More sophisticated cameras will have a range between four full seconds or more right down to 1/2000 sec or less. Simple cameras may not

have any adjustment control – one fixed shutter speed having been determined by the manufacturer. On such a camera this will usually be about 1/125 sec.

As with the aperture, the shutter control is designed so that each adjustment either doubles or halves the previous time set. As an example, selecting 125 (1/125 sec) will hold the shutter open for twice as long as 250 (1/250 sec).

The viewfinder

This feature allows you to see the amount of the scene in front of the camera that will be included on the film. As with the features already mentioned, viewfinders break down into two types. On a fixed-lens camera, a viewfinder window on the front of the camera allows you to see directly the scene through an eyepiece on the back surface. This type of direct-vision viewfinder is adequate in most situations, but because the scene you see in the window is not exactly that taken in by the lens, any subject closer than about 3 ft (1 m) will be slightly offset on the resulting photograph.

A more accurate viewfinding system, found on all SLRs, allows you to see exactly the view taken in by the lens. This is achieved by including an angled mirror inside the camera body behind the lens. Light entering the lens strikes the mirror and is deflected onto the reflective surfaces of a five-sided prism, known as a pentaprism, housed in the top of the body. The light then emerges through the eyepiece. Most cameras capable of taking a variety of lenses require this system, so that the scene through the viewfinder always corresponds to the view taken in by the lens.

Direct-vision, interchangeable-lens cameras show the field of view of each lens by means of bright frame-lines which overlay the image in the viewfinder. Changing to a lens with a narrower field of view automatically brings a smaller frame into the camera eyepiece. Although not now being produced in any great numbers, this system is found on the extremely popular Leica cameras (made by the LEItz CAmera company).

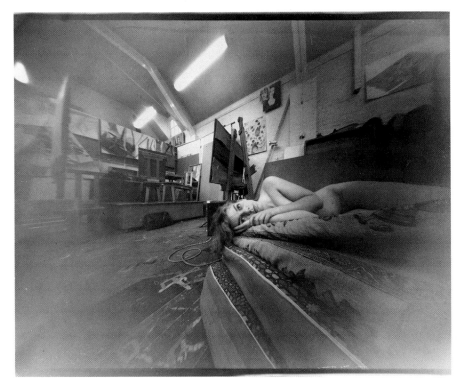

35mm compact cameras

This category of camera satisfies the need for small, unobtrusive devices that can be taken anywhere and which, generally, require the minimum of adjustment. They are the modern descendants of the original box camera, which carried the advertising slogan from the manufacturer, Eastman Kodak: "You press the button, we do the rest."

But far from being simple, compact cameras are sophisticated marvels of the micro-electronic age, capable of producing good quality pictures. Nowadays they offer many automated features, where the camera itself is capable of controlling exposure, focusing and flash. The more expensive models allow you to control or override these features, but at the expense of having more to think about then just 'point and shoot'.

Non-autofocus compacts

Many of the models in this range have a fixed-focus lens, which is set to take reasonably sharp pictures in good light from about 4 ft (1.3 m) to infinity. With most lenses, for all practical purposes, infinity is anything beyond about 30 ft (9 m). On other models, focusing is achieved by guesswork using a focusing guide, either marked with distances or symbols, such as a mountain for infinity or a head and shoulders for a portrait shot. Bear in mind, however, that with a direct-vision compact the scene you see in the eyepiece at the back of the camera will not change to indicate any adjustment made to the focus control. The exception to this rule is what is known as a coupled rangefinder camera (see box), which neatly overcomes this problem.

Pioneering days

George Eastman was without doubt the most influential single figure responsible for popularizing photography. The launch in 1888 of his now famous brand name – Kodak – must rate as one of the most successful advertising coups of all time. The name, in fact, does not have any meaning at all – Eastman simply wanted a name that could be easily pronounced anywhere in the world. And for most of this century 'Kodak' has been synonymous with photography. The box camera illustrated in this advertisement, although mass-produced, was capable of taking reasonable quality photographs.

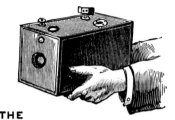

The Camera that takes the World !

THE
KODAK

No previous knowledge of Photography necessary.

"YOU PRESS THE BUTTON, WE DO THE REST,"

(Unless you prefer to do the rest yourself)

AND THE PICTURE IS FINISHED.

Price from £1 6s.

EASTMAN PHOTOGRAPHIC MATERIALS CO. LD., 115-117 OXFORD-ST., LONDON, W.

SEND FOR PRETTY, ILLUSTRATED CATALOGUE, POST FREE.

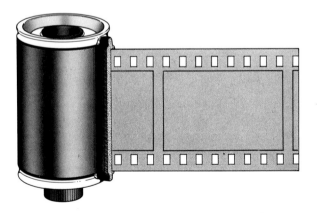

35 mm cassette

The 35 mm cassette illustrated here is shown actual size, with image size indicated.

Non-autofocus camera

The Kodak 635 has a fixed-focus lens which will produce sharp pictures of anything from 4 ft (1.3 m) to infinity. It is a simple camera with just one fixed shutter speed and only two apertures, one for daylight and one for flash.

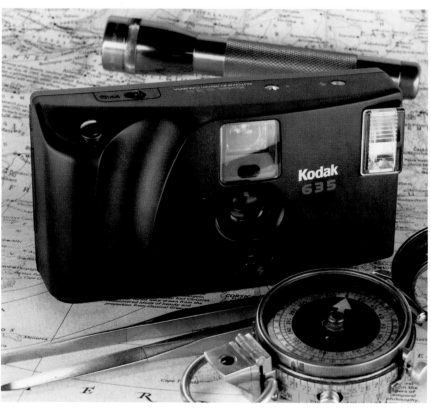

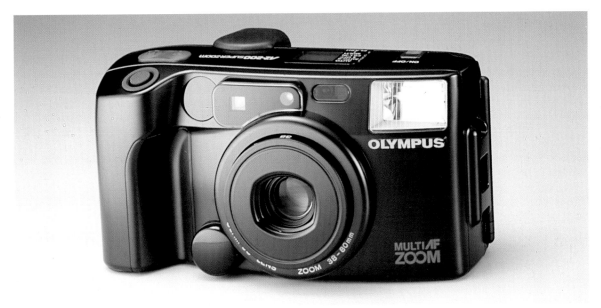

Zoom autofocus compact
Like several of the Olympus cameras, the AZ-200 Super Zoom, **left**, has an impressive built-in flash system with a special mode for reducing the 'red-eye' effect in portraits.

Active autofocus system
The Olympus AF-10 Super, uses an infrared beam to focus the lens on one of five pre-set distances. Depth of field ensures that anything between these distances is still rendered sharp.

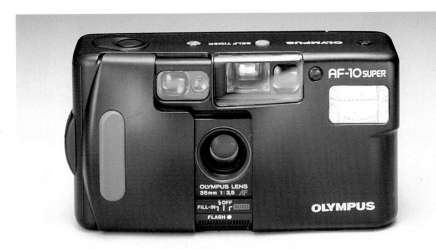

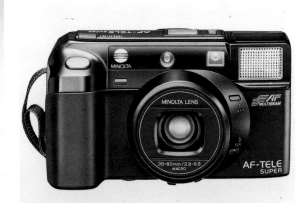

Twin-lens autofocus camera
An interesting feature of the Minolta AF Tele-Super, **above** is 'multibeam' focusing which can detect an off-center subject. This, coupled with 25 focusing steps, makes it very accurate.

Zoom autofocus compact
Top of the compact range are cameras like the Olympus AZ-330 Super Zoom, **left**, which are called 'bridge' cameras since they bridge the gap that used to exist between 35 mm compact and SLR cameras. Only the direct-vision viewfinder and lack of interchangeable lenses make the difference between this and the fully automated SLRs.

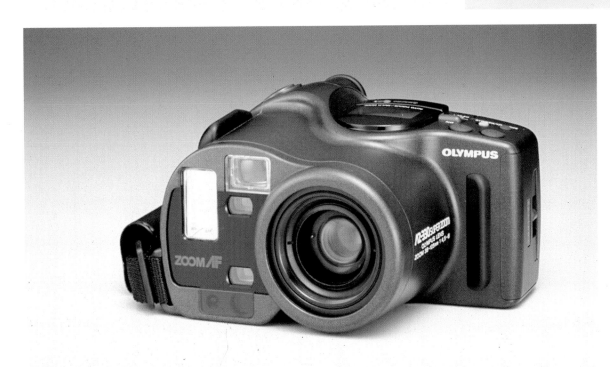

Autofocus compacts

An autofocus camera decides electronically the distance between you and your subject, and then sets the lens to this distance using an internal motor. There are two ways, one 'passive' and one 'active', in which a camera can decide on the correct distance. A passive system is like an electronic version of a coupled rangefinder, while an active system sends out a beam of infrared light or ultrasound which bounces back off the subject. Since the passive systems use ambient light, they can be confused by low-light or night-time conditions. Active systems work well under these conditions, but if you want to photograph an object in a shop window, they will focus on the glass, not on the object behind it.

Many autofocus cameras restrict the number of positions to which the focus can be set, relying on depth of field (see p. 54) to cover up for any inaccuracies caused. Some may have as few as two steps, while the most expensive models are nearly stepless and hence focus with much greater accuracy.

The simpler models assume that the subject is centrally placed in the frame, and this can cause problems if you wish to be more adventurous with picture composition. Some cameras overcome this by using a 'multibeam' system which sends out several infrared beams over an area.

Fixed focal length autofocus compacts

As their name implies, these cameras offer you no choice as to the lens you use. This has the disadvantage that you must move physically closer to or further from your subject in order to frame it carefully in your photograph. Indeed, a common error with this type of camera is to stand too far away, making the subject too small and insignificant on the final print or slide.

But there are advantages to this kind of camera too. Many are very simple to use and small enough to fit into a pocket, making them less obtrusive for candid shots. They are excellent for taking on holiday, and give good quality snaps. It is much better to have a record of where you were and what you were doing than to be always fiddling with the focus.

Most models also have a built-in, self-adjusting flash unit, which greatly extends the conditions under which they can be used. Also common is a motor drive to advance the film after each exposure is made and, after all exposures have been taken, to rewind the film back into the cassette. Another feature that has recently been developed is called 'DX coding' and it enables the camera to automatically set the correct film speed (see pp. 36-37) every time a new film is loaded.

Twin-lens autofocus compacts

These cameras have the same features as the fixed focal length autofocus compacts above, but with one important addition: by simply pressing a button you can change from one focal length to another. You have the option of two lenses, typically a slightly wide-angle lens (e.g. 35 mm) and a mildly telephoto one (e.g. 70 mm) – wide-angle and telephoto lenses are discussed on pp. 23-27. A telephoto lens enables you to fill the frame with your subject even when it is some distance away – ideal if you do not want to be noticed taking the photograph.

Having only the two lenses, these cameras lack the versatility of zoom compacts (see below), but since surveys show that most people use a zoom lens at either its wide or at its telephoto end, they make an attractively priced alternative.

Zoom autofocus compacts

These are the most expensive and versatile of the 35 mm compact cameras. Their zoom lenses allow you to frame the picture exactly without having to move closer to or further from your subject. The more expensive models have very sophisticated exposure and built-in flash systems as well. Some of the Olympus cameras have a unique flash, useful with portraiture, which emits several pulses of light before the main exposure is made. This reduces the effect known as 'red-eye' (see p. 30) by contracting the pupils of the subject's eyes.

But there are disadvantages to zoom autofocus compacts. With the greater amount of electronics on board, they are larger and heavier than their simpler cousins – indeed the word 'compact' is sometimes stretched to its limit. And the price is much higher too, making many of the SLR cameras (see pp. 16-19), which also have autofocus systems and zoom lenses, a viable alternative.

Advantages of direct-vision viewfinders

All 35 mm compacts have direct-vision viewfinders. The direct-vision viewfinder has some advantages over the single lens reflex system (see pp. 10-11). Because the viewfinder is basically a hollow tube with a small lens on either end, there is no need to incorporate the bulky pentaprism found on all SLRs. The viewfinder window also produces a brighter image of the scene than is possible with an SLR, making it easier to use in low-light conditions. The other major advantage of the direct-vision viewfinder is that the camera is quieter in operation.

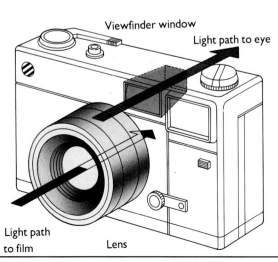

Viewfinder window

Light path to eye

Light path to film

Lens

Light paths

Simplicity of mechanical design, reliability and quietness of operation have all led to the wide-spread popularity of the direct-vision 35 mm compact. Light enters the viewfinder directly to allow the user to frame and compose pictures. The lens, behind which is the film, 'sees' a slightly different view because of the separation of the viewfinder window and lens.

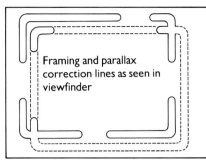

Framing and parallax correction lines as seen in viewfinder

View taken in by viewfinder

View taken in by lens

Parallax error

The separate views taken in by the viewfinder and lens do not usually cause problems, unless the subject is too close to the camera. Cut-off heads is the most common symptom of parallax error in photographs. To help overcome this, manufacturers often include not only framing lines in the viewfinder, but parallax correction lines as well. The recommended closest subject distance varies between makes, but it should be clearly stated in the user's manual.

In an SLR, the angled mirror which directs light up into the pentaprism must swing out of the light path just before exposure and then flop down again afterwards to restore vision at the eyepiece.

Disadvantages of direct-vision viewfinders

Apart from not being able to see the effects of adjusting the focus control, the major disadvantage of direct-vision viewfinders is known as parallax error. This is a problem caused by the viewfinder and lens being in slightly different positions. On inexpensive models, a line at the top of the viewfinder indicates how much you must reposition the camera for close-up work. On Leica rangefinder cameras, the frame line indicating the edge of the picture moves as the lens is focused. It is not practicable to photograph closer than about 3 ft (1 m) using one of these cameras, so if you intend to take a lot of close-ups, for example, you would be better off with the more flexible SLR, which indicates in the viewfinder exactly the scene taken in by the lens.

Coupled rangefinder cameras

Cameras incorporating a coupled rangefinder have two windows on the front, instead of the more usual one. The window to the left is the rangefinder window. Light entering here is reflected by a pivoting mirror that changes position as you adjust the focusing ring. In the viewfinder you will see two images of the subject – one produced by the rangefinder window and one direct through the viewfinder window. Moving the focus ring causes the 'ghost', rangefinder image to move in relation to the 'real' image. When they coincide exactly the subject will be in perfect focus. This is the fastest and easiest manual focusing system there is.

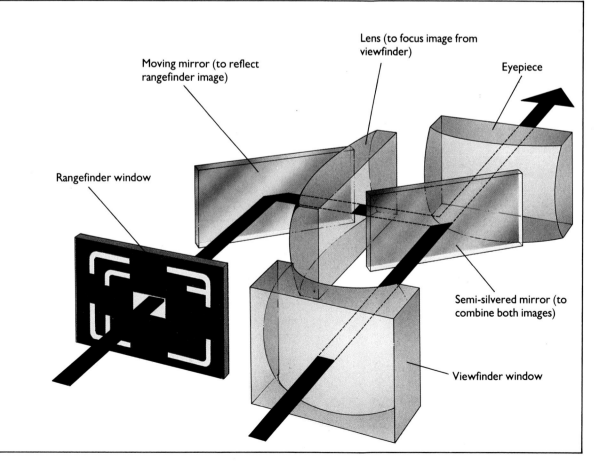

Rangefinder window

Moving mirror (to reflect rangefinder image)

Lens (to focus image from viewfinder)

Eyepiece

Semi-silvered mirror (to combine both images)

Viewfinder window

The single lens reflex (SLR) camera

This is the most sophisticated 35 mm camera system, used by most professional photographers and keen amateurs. Although SLR has become synonymous with the 35 mm film format, a few larger types of SLR camera are made (see pp. 20-1) and there are also a few examples of 110 SLR cameras.

no light reaches the viewfinder. In the majority of picture-taking situations, when shutter speeds faster than about 1/60 sec are being used, this is of little consequence: the image is restored to the viewfinder almost before you realize that it has gone.

When shutter speeds longer than 1/15 sec are used, however, there may be problems when the viewfinder blanks out. At an athletics meeting, for example, a shutter speed as slow as 1/2 sec may be chosen to 'pan' a moving runner. Panning involves moving the camera while the shutter is open in order to keep the subject in the same

Features to note
These two views of a modern SLR camera show the most important camera functions and their typical locations.

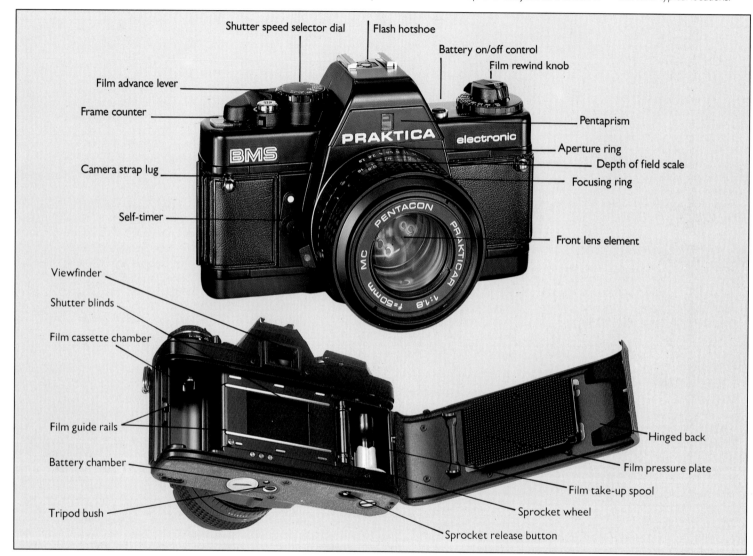

- Shutter speed selector dial
- Flash hotshoe
- Battery on/off control
- Film rewind knob
- Film advance lever
- Frame counter
- Pentaprism
- Aperture ring
- Depth of field scale
- Camera strap lug
- Focusing ring
- Self-timer
- Front lens element
- Viewfinder
- Shutter blinds
- Film cassette chamber
- Film guide rails
- Hinged back
- Battery chamber
- Film pressure plate
- Film take-up spool
- Tripod bush
- Sprocket wheel
- Sprocket release button

PRAKTICA BMS electronic
MC PENTACON PRAKTICAR 1:1.8 f=50mm

The reflex viewfinder

The name of this camera type comes from the fact that there is a single lens, which performs both the viewing and picture-taking functions, and a reflex mirror positioned behind the lens. When the shutter release button is pressed, the mirror, which reflects light transmitted by the lens into the pentaprism and then to the eyepiece, swings up out of the light path and the iris diaphragm closes from fully open to the preset aperture. Next, the shutter opens and closes to expose the film and, finally, the mirror swings back down again and the aperture opens once more.

From this description it can be seen that at the actual time of exposure (when the mirror is in the up position),

Exposure step by step

In normal viewing mode (**1**), light enters the lens with the aperture fully open, strikes the reflex mirror and is reflected up to the pentaprism and viewfinder. When the shutter is pressed, the aperture closes down and the mirror swings up (**2**). The final stage of exposure occurs when the shutter opens to reveal the film (**3**). After exposure, the aperture opens and the mirror flaps down.

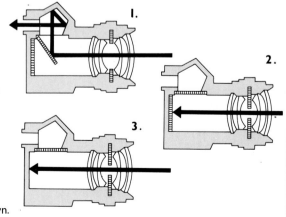

Autofocus SLR

The first single lens reflex to depend on automatic focusing was the Minolta 7000. There are now several Minolta cameras based on this early design, such as the Dynax 8000, right. There is now little doubt the autofocus is becoming as standard on SLRs as automatic exposure.

The Minolta's new range of lenses has no aperture setting dial – this function is carried out electronically. The lenses do have a narrow manual focusing ring that unlocks when the AF system is switched off.

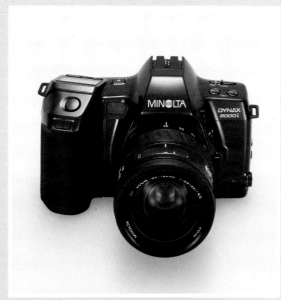

Focus detection is rapid and should normally establish focus quicker than conventional systems. The camera is power-driven only, with the usual single and continuous exposure options, and so there is no film wind-on lever.

position in relation to the film. This technique renders the main subject relatively sharp, but the background blurred, and to achieve a precise effect it is of great advantage to be able to see the subject throughout the entire exposure period.

The advantages of reflex viewing, however, greatly outweigh any potential disadvantages. Because you see the image the film will be exposed to, a wide range of lenses of varying focal lengths and applications can be used. A number of independent manufacturers produce lenses with adaptors to suit most camera bodies in production. Zoom lenses (see pp. 24-27), increasingly popular nowadays, can be used with SLR cameras and since there is no parallax problem extreme close-up photography can easily be carried out with these cameras, as can photography through telescopes or microscopes with the addition of simple adaptors to replace the lens.

Viewfinder brightness

The brightness of the image seen in the reflex viewfinder, unlike that of a direct-vision camera (see pp. 12-15), is directly dependent upon the amount of light transmitted by the lens. Lenses are often described as being 'fast' or 'slow'. A fast lens has a wide maximum aperture, f 1.4 on a 50 mm lens, for example. A slow 50 mm lens could have a maximum aperture of f 2 or f 2.8 and would as a result transmit only about 50 per cent or less of the light of the f 1.4 lens. If you are likely to take a lot of low-light photographs it is important to have the brightest possible viewfinder to focus and compose your shots, and so the extra expense of a fast lens (which can be significant) would be justified.

Built-in light meters

Modern SLR cameras are always equipped with built-in light meters. Depending on the system used, a number of light-sensitive cells are positioned in the camera body where they will be exposed to light transmitted by the lens. Modern systems, once understood, are extremely accurate, and also make allowances for any filters used over the lens.

Built-in light meters differ in the way they measure the light, in the way the information is displayed in the viewfinder and in the degree of automation. Many cameras now offer a choice of several different light-

Panning
One of the drawbacks of SLR viewing can be when panning a moving subject, above.

SLR pentaprism
The lens inverts and laterally reverses the image, right. The mirror re-inverts the image before passing it to the pentaprism.

High contrast
Scenes with bright highlights and deep shadows, far right, can cause metering problems.

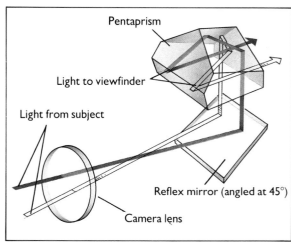

Pentaprism

Light to viewfinder

Light from subject

Reflex mirror (angled at 45°)

Camera lens

measuring systems and can be switched between manual and automatic operation.

Whichever light-measuring system is used, you will value a clear display in the viewfinder, showing the shutter speed and aperture in use, which should be visible in all lighting conditions. Also important is an exposure memory lock. This lets you move in close to your subject to take a light reading, lock the reading into the system and then move back to recompose the picture and shoot.

Light-measuring systems

In a full-frame light-measuring system the meter takes account of the whole subject area seen in the viewfinder. It will produce acceptably exposed pictures in the majority of photographic situations.

A more popular system is the center-weighted light meter. In this, the meter reads the light from the entire focusing screen but weights the reading in favor of the central area. This method produces more correctly exposed pictures compared with the full-frame method, even though it assumes that the central area of the frame contains the most representative tones. Neither system, however, will give accurate readings in very contrasty light, or for backlit subjects (with the sun shining into the camera lens), or for subjects of higher or lower than average brightness. Trying to describe 'average brightness' is almost impossible and is largely a matter of experience and trial and error.

Narrow-angle light metering (sometimes known as selective or partial metering) measures light only from a central area. It enables the experienced photographer to obtain more precise results than is possible with the two systems already described. In contrasty light, the exposure can be biased toward the dark tone detail or highlight detail. In back-lit conditions, an accurate light reading can be taken from the shadowy side of the subject, permitting this to be properly exposed at the expense of the background.

Spot metering measures the light from an extremely small subject area – typically about 1°. A spot meter built into the camera, or used as a separate accessory, cannot be simply pointed in the general direction of the subject, and therefore requires more skill to use properly. They are invaluable, however, when shooting in difficult lighting conditions that would mislead even a narrow-angle light meter. Olympus make a camera that allows the user to make up to eight spot readings from different parts of the same subject, which are then averaged.

Multi-pattern metering is the most complex to manufacture, but the most accurate to use. It calculates the degree of compensation required for subjects by metering from five different parts of the focusing screen. Those readings are compared in a tiny microprocessor which has been programmed with light readings from thousands of situations.

Viewfinder displays

Once the light meter has measured the brightness of the subject, the reading is displayed so that you can set the shutter speed and aperture. On automatic cameras, this is done for you.

On a manual camera (or an automatic set to manual), the exposure reading may be indicated in the viewfinder by a needle. The shutter speed dial or aperture ring is then moved to center the needle in a window, or it may be aligned with a bar, the position of which changes according to the shutter speed in use.

Another less popular way of displaying the exposure recommendation uses two lights, which indicate correct exposure when both are shining. When only one is lit, indicating incorrect exposure, the photographer moves the shutter speed dial or aperture ring until both are lit.

On an automatic camera there are three systems in

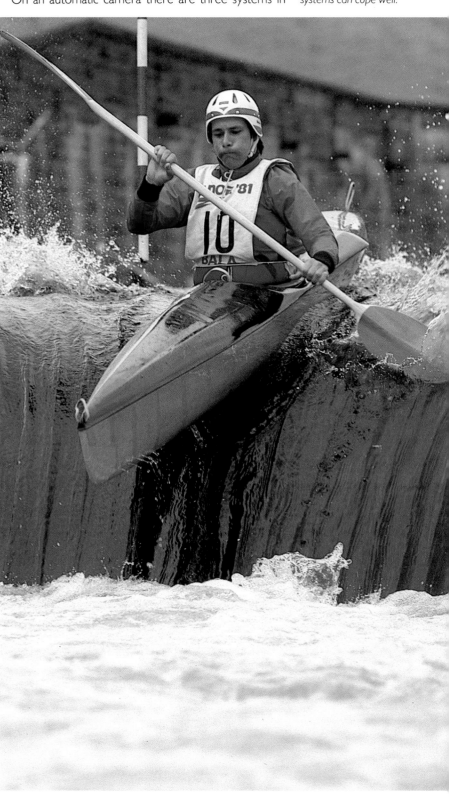

Central subject
With the main point of interest placed centrally in the frame **below**, *all modern metering systems can cope well.*

SLR focusing screens

The surface on which the image is seen in the viewfinder is known as the focusing screen. Many SLRs are fitted with a split-image rangefinder. When the subject is unsharp the center of the rangefinder shows a split image. Sharp focus is indicated when the image is continuous. A different system uses a central circle of microprisms that fracture the image when unfocused and snap into clarity when the subject is correctly focused. Some focusing screens use both these systems combined. Other more specialized screens are also available. If vertical and parallel lines are vital, such as in architectural photography, a screen engraved with a grid of lines can be used. Only the more expensive SLRs allow you to change focusing screens.

1. Horizontal split and microprisms
2. Diagonal split
3. Diagonal split, microprisms and guidelines
4. Architectural screen

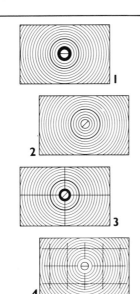

Motor drive sequence
*The sequence of photographs **below** could only have been taken with a motor drive. A sequence such as this says more than a single picture ever could.*

popular use, and some cameras may be used in all three ways. The most commonly used system is known as aperture priority, in which the aperture is set manually and the light meter determines the correct shutter speed. This method would be chosen when 'depth of field' (the zone of acceptably sharp focus associated with any particular aperture setting) is critical.

Shutter priority allows you to set the shutter speed and the aperture is selected by the camera meter for correct exposure. This system is preferable if you need to 'freeze' the motion of a car, for example.

The third system is the most fully automatic and is known as programmed exposure control. In this system, the camera meter chooses both shutter speed and aperture, aiming at an optimum combination depending on the brightness of the scene, film speed (its sensitivity to light) and (sometimes) focal length of the lens in use. Faster shutter speeds, for example, will be required for a telephoto lens in order to minimize camera shake and resulting blur. Obviously with this type of system you must relinquish control to a program statistically calculated to be successful for a wide range of situations, but on certain occasions the chance to concentrate on the picture alone is worth the loss of technical control.

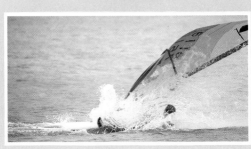

Motor drive and bulk film backs

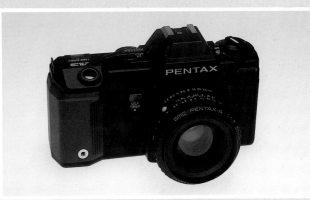

Built-in autowind

Motor drives

Many SLRs can be equipped with a motor drive, which advances the film after each exposure up to six times per second. These are useful for action photography, but they do increase the weight of the camera and the noise level of operation. One advantage of a motor drive not immediately apparent is that you do not have to take the camera away from your eye to operate the film wind-on lever. For the professional photographer, bulk film backs can be used in conjunction with the motor drive. A normal 36-exposure cassette could be run through the camera in just six seconds; a bulk film back, on the other hand, can hold up to 750 exposures.

Larger-format cameras

Most cameras larger than 35 mm use 120 or 220 rollfilm. These two films are identical except for the length of the roll, but camera designs do vary, resulting in up to four different image formats being available from the same basic film format – 6 × 4.5 cm, 6 × 6 cm (also commonly known as 2¼ × 2¼ in), 6 × 7 cm and 6 × 9 cm.

The professional's camera

Rollfilm cameras have changed their status dramatically over the last 25 years. Before the almost universal acceptance of the 35 mm format, rollfilm cameras were the popular size for casual snapshots. Now, however, the format is firmly established as the professional's medium, and is used extensively by commercial, industrial, fashion and landscape photographers.

Because the film (either negative or positive) requires less enlargement than 35 mm to obtain the same-size image, picture quality is noticeably better; more detail can be recorded and the structure of the film is less intrusive. The cameras themselves, though, are larger and more awkward to handle. They are also produced in relatively small numbers, which makes them more expensive than 35 mm cameras.

Rollfilm SLRs

In this category there are basically two designs. The first, made by Pentax, is a scaled-up version of a 35 mm SLR producing a 6 × 7 cm negative or transparency. All the controls are located in approximately the same positions and it has the immediately recognizable pentaprism, which directs light to the viewfinder. Because of its increased size, it is a heavy camera to use, but for many people progressing to this format from 35 mm, the familiar shape makes the transition easier. A range of different lenses is available to cover most situations.

The other, more common, type of rollfilm SLR looks radically different. The pentaprism is replaced by a focusing hood, and the camera is more box-like. The lack of a pentaprism means that the image seen on the focusing screen is reversed left-to-right. All lenses produce this effect and it is only the many reflecting surfaces inside the pentaprism that correct the laterally-reversed image. (An accessory pentaprism is available.) Film loading is also very different. The roll is loaded into a magazine which fits into a separate film back. There are

1
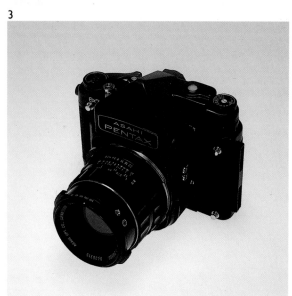

2
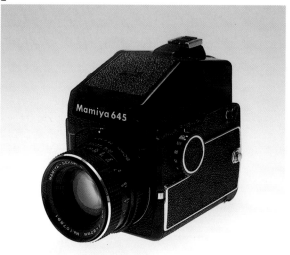

3
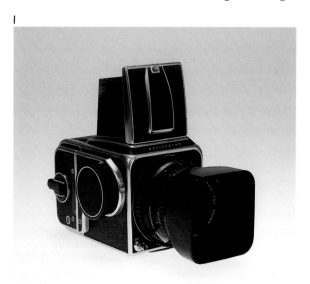

4
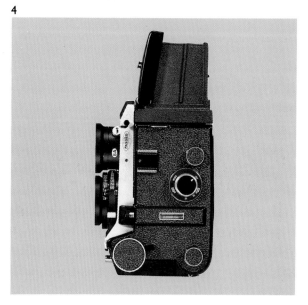

Rollfilm models
The four main types of rollfilm cameras can be seen on the **left***. The instantly recognizable Hasselblad (***1***) is probably the most widely used professional camera in the world, and was even taken to the moon by NASA astronauts. Built along similar lines is the newer Mamiya 645 (***2***), which produces a film image 6 × 4.5 cm. More popular with many professional photographers when on location is the Pentax 6 × 7 cm (***3***), which looks just like a scaled-up 35mm SLR. Rarely seen these days is the rather unwieldy Mamiya C330S twin-lens reflex (***4***).*

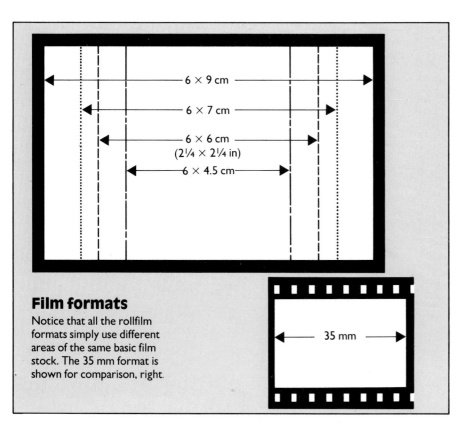

Film formats

Notice that all the rollfilm formats simply use different areas of the same basic film stock. The 35 mm format is shown for comparison, right.

6 × 9 cm
6 × 7 cm
6 × 6 cm
(2¼ × 2¼ in)
6 × 4.5 cm

35 mm

are many thousands of well-cared-for TLRs on the second-hand market.

The TLR gets its name because it has two vertically mounted lenses. Behind the upper lens is the usual reflex mirror, which directs light on to the focusing screen in the top-mounted hood. The lack of pentaprism means that you see a laterally-reversed image. The lower lens is the picture-taking lens, behind which are the shutter and the film. Because viewing and taking lenses are physically separate, all the problems of parallax error (see pp. 12-15) are present. On some models a limited range of additional lenses is available, but both lenses have to be replaced each time, so increasing the expense. The TLR is a basic camera; film magazines, built-in light metering or motor drives are not available.

Sheet film cameras

In addition to the range of rollfilm cameras, there are larger cameras which use single sheets of cut film. Usual sizes of this film are 4 × 5 in (10 × 12 cm) and 8 × 10 in (20 × 25 cm). These cameras are used only when outstanding quality is essential or especially big enlargements are necessary. Their use tends to be very specialized even by professionals. Their most common application is in advertising and architectural work.

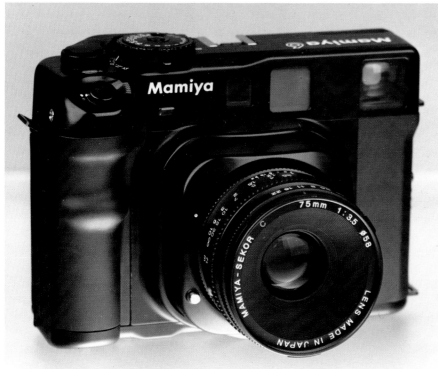

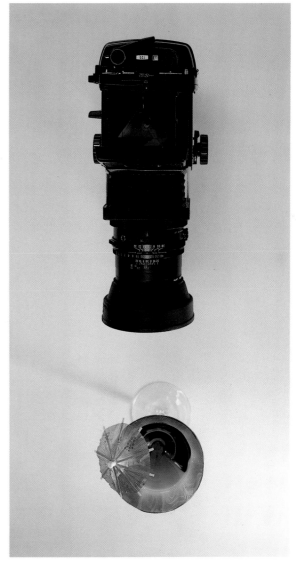

many advantages to this system; at any point, even mid-roll, you can simply remove the back (a dark slide protects the film from stray light) and change from color transparency film, for example, to black and white print film. A complete range of accessories and additional lenses are available.

Rollfilm TLRs

Another type of rollfilm camera is the twin lens reflex. Although not made in any great numbers anymore there

Rangefinder rollfilm
The Mamiya 6, above, is one of the few rollfilm cameras available with a rangefinder focusing system (see pp. 12-15).

Rollfilm viewfinder
The shot right shows the typically reversed image produced by a rollfilm camera.

Instant picture cameras

Instant picture film allows you to see a finished print in a matter of seconds after pressing the shutter release button. With the commonly available amateur models picture quality is not always good, and color rendition can be extremely suspect, but the immediacy of the results makes up for many of the system's shortcomings and accounts for the medium's steady popularity, despite the high cost per print.

Camera and film types

Instant picture cameras are available in either direct-vision or SLR models. The SLR type is mechanically more complex and, therefore, more expensive. The usual number of exposures per film pack is 10, and the price per image is many times that of traditional film. All the chemicals necessary to process the film, however, are present in the film itself, and these are released when the sheet of film is ejected through a set of rollers. The power necessary for this operation is provided by batteries, either bought separately or in some cases provided as an integral part of the film pack. Peel-apart instant picture film is also available, but is not as popular. Usual image sizes are between 3 × 3 in (7.5 × 7.5 cm) and 2 × 3½ in (7 × 9 cm).

Most models provide only a minimum of possible adjustment – usually a lighten-darken control – and are otherwise fully automatic, including autofocus. Flash units

Professional Polaroid
Polaroid instant picture film, **above**, *does produce an image quite unlike that of traditional film. Color saturation is good, as is contrast.*

are now commonly built-in but they can also be bought as a separate accessory.

Professional applications

There are many occasions when a professional photographer cannot afford to wait while traditional film is processed in order to check a lighting set-up, for example, or an arrangement of props for an advertising shot in some exotic location. In such cases, a special instant picture film back can be attached to some 6 × 6 cm rollfilm cameras. Seconds later, the fully processed print is ready, any adjustments can then be made to lighting and so on, another test print made and, only minutes later, a traditional film back clipped into place on the camera.

Some photographers do not bother using traditional film at all, preferring the unique qualities of professional-quality, large-format instant picture film for their final images. To cater for these photographers, a professional rangefinder instant picture camera is made, which can accept a limited range of interchangeable lenses.

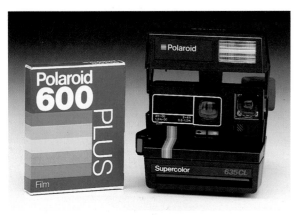

Polaroid 635CL
Simpler and less versatile than the more expensive models, this fixed-focus instant picture camera, **left**, *has automatic exposure and a built-in flash.*

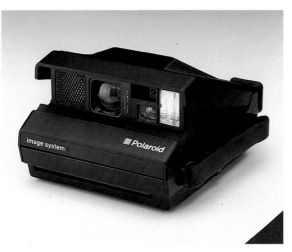

Polaroid Image System
This camera is at the top of the amateur range. It features automatic exposure and autofocus with a sophisticated built-in flash.

Film backs
Of great benefit to professional photographers are instant picture film backs for use with ordinary rollfilm cameras.

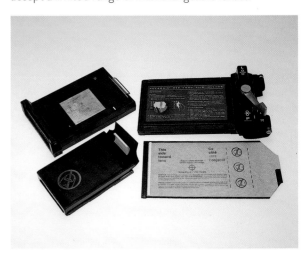

Camera lenses

It is the lens that actually makes the picture. It does this by collecting the light reflected from the subject and then focusing it on the surface of the film. It is, in fact, the most important element in the whole camera system; the camera body is little more than a sophisticated light-tight box with a film advance mechanism.

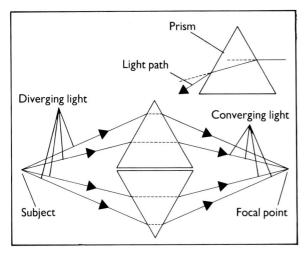

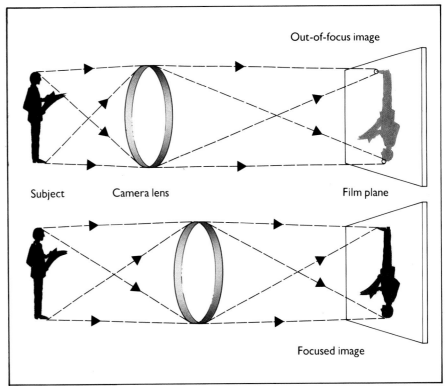

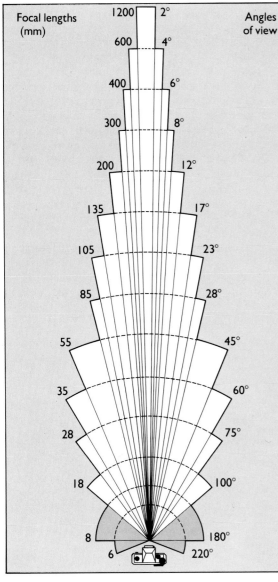

Basic converging lens
*Light passing through a simple prism is refracted. Place two prisms, base to base, and you have a basic converging lens, **above left**.*

Lens focusing
*For an image to be accurately focused, the lens must be at the correct distance from the focal plane (or film plane), as shown in the illustration **above right**.*

Angles of view
*Each focal length lens has a different angle of view, **left**. Telephoto lenses can have a few degrees only, while fisheye lenses can produce circular 220° views.*

Lens cutaway
*As well as refracting light, a simple converging lens will also split light into its component colors, as in a prism. To counter this, elements made out of different types of glass, each with a different refractive index, are used in modern lens construction, **right**, in order to bring all the components of light to a common point of focus.*

Lens principles

Whenever light enters a medium of different density it is slightly deflected, or refracted. A drinking straw in a glass of water, for example, appears to be bent because of the refraction of light as it travels from the water into the much less dense air. Light entering the camera lens can be thought of as travelling in diverging rays. It is the job of the lens to bend the light rays so that they converge in one plane – the camera's focal plane.

But light from subjects at varying distances from the camera must be bent to different degrees in order to bring it into focus. This problem is overcome, on focusable lenses, by moving the lens either farther from or closer to the film. If you have a camera, operate the focus control and you will see that for distant subjects the lens is at a position closest to the film.

From this explanation, it would appear that lenses are relatively simple pieces of glass. But this is far from true. A modern camera lens is composed of many separate elements, each of which has a different refractive index, or ability to bend light. White light is composed of many

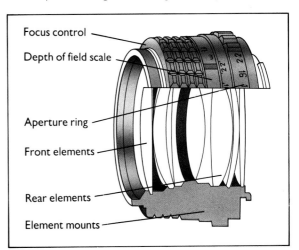

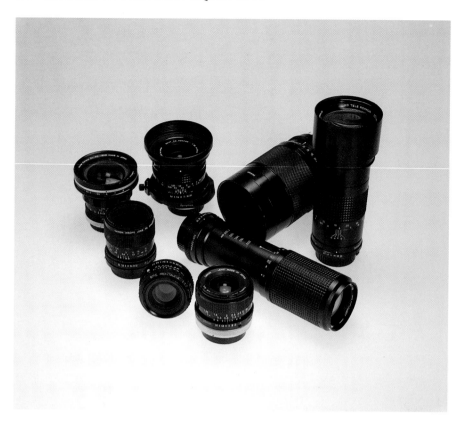

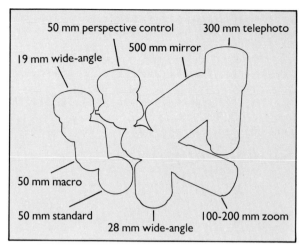

Lens options
Some of the more useful lenses for the 35 mm format can be seen **above**.

Perfect balance
A good example, **right,** *of the use of the wide-angle lens. Each element of the composition draws the viewer's eye deeper into the scene.*

different wavelengths, which all tend to refract to varying degrees. If glass of a single type were used, these wavelengths would separate and appear as individual colors, as happens when light shines through a prism.

Lens sharpness

This term is often used when talking about lenses, and it refers to a lens's ability to resolve fine detail. When a lens is correctly focused, and all the elements within the lens are correctly aligned, the image consists of pin-points of light. In a misaligned or unfocused lens these pin-points

turn into discs of light. Every lens has an aperture, usually somewhere in the middle of the range, which renders the sharpest subject detail. Toward the aperture extremes, a lens's resolving power tends to deteriorate, especially at the edges of the picture area.

Choice of lenses

The choice of lenses is wide, especially for the 35 mm format. If, however, you do not have an SLR or one of the few rangefinder cameras that accepts additional lenses, then the camera and lens represent one fixed unit, and the lens will probably be the standard focal length for that format or a slightly wide-angle lens.

Technically, the focal length of a lens is the distance between the rear element and the focal plane when the lens is set to focus on infinity. All lenses are classified in terms of their focal lengths, which are quoted in millimeters. In practical terms, the focal length of a lens determines the size of the image on the film.

A point to remember is that one of the greatest photographers, Henri Cartier-Bresson, takes nearly all his photographs with a standard lens on a manual

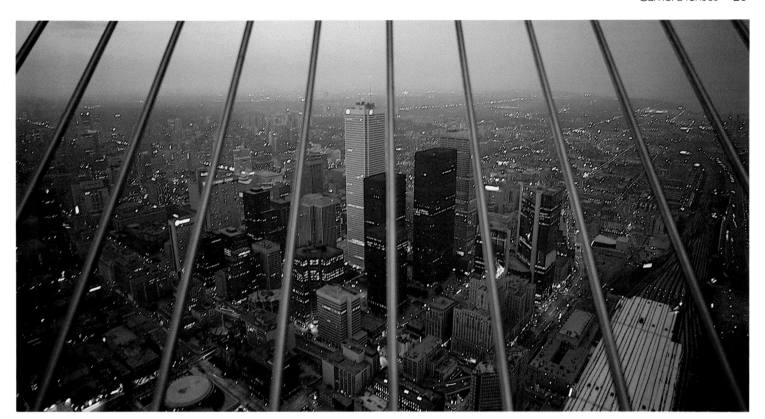

camera. It is important to understand the range of optional lenses available, but to use them only sparingly.

Standard lens

The focal length of a standard lens is approximately equal to the diagonal of the image format for which it is designed – 50 to 55 mm for the 35 mm film format, but about 80 mm for the 6 × 6 cm film format. In the rest of this section on lenses it will be assumed that the 35 mm film format is being referred to.

Pictures taken with a standard lens will not appear to change the perspective of the subject. Objects at different distances from the camera appear correctly proportioned in relation to each other, and, moderately enlarged and viewed from normal distance, the resulting photograph will correspond to the view of the subject as seen by the human eye. The standard lens in no way confers its own 'atmosphere' to the picture. In general, standard lenses tend to be the sharpest in a range of similarly priced wide-angle and telephoto lenses. Most people purchase a standard lens along with the SLR body, but if you feel you would not make good use of it, then specify that you would prefer a different lens.

Wide-angle lenses

These lenses have focal lengths between 15 and 35 mm. They reduce the size of the subject on the film, and as a result you can include more of the scene than with a standard lens used from the same camera position. Wide-angles with focal lengths less than 35 mm do produce a characteristic 'feel' to photographs, and this becomes more pronounced as focal length decreases.

Wide-angle lenses appear to alter the scale of near and far objects, exaggerating the size of objects close to the camera. They are often used for outdoor scenes

when a wide panorama needs to be included. They can also be extremely useful in cramped conditions, when it is not possible to move back from the subject. This type of lens is not suited to portraiture as parts of the face closest to the camera, forehead and nose, seem to advance while other parts of the face retreat.

Depth of field (see pp. 54-9) with all apertures of a wide-angle is extensive, making focusing less critical. With some extreme wide-angles, focusing becomes virtually unnecessary because depth of field is so great. With cheaper wide-angles one problem to look out for is edge distortion. With this, straight lines near the edge of the

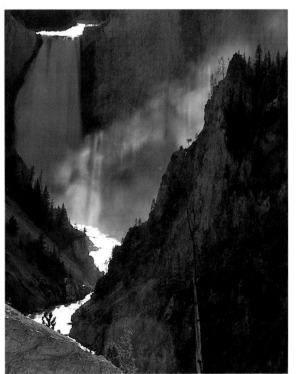

Opening out
For this twilight view of Toronto **above**, *the photographer used a 28 mm wide-angle lens. The panorama produced is characteristic of a lens of this focal length – a broad, open perspective and a sense of depth and distance.*

Closing in
In complete contrast to the shot above, the photograph on the **left**, *taken in Yellowstone National Park, USA, is a typical example of the type of perspective produced by a telephoto lens. The distinction between near and far planes has been largely suppressed and the feeling is slightly cramped. The angle of view of a telephoto lens is so small, that basically monochrome images such as this are not uncommon.*

picture area appear to bow. Better-quality lenses are corrected and should not cause a problem. The effects of camera shake are also minimized by wide-angle lenses.

A 25 mm wide-angle lens will include twice as much as a 50 mm standard lens when both are used from the same position.

Telephoto lenses

These lenses have focal lengths greater than 70 mm. Like telescopes, they magnify the subject, creating an illusion that distant objects are closer than they actually are. They also distort the subject in the opposite way to a wide-angle. They appear to increase the size of distant objects in relation to near ones and tend to produce a 'squashed' perspective and a slightly cramped feeling.

The most obvious advantage in using these lenses is that you can fill the frame with a subject that cannot be approached – animals in a zoo or in the wild, for example. A close-focusing telephoto can also be used to take quite detailed close-up studies – natural history shots of flowers or pictures of pieces of jewellery.

Depth of field is minimal with a telephoto lens and therefore focusing must be extremely accurate. In addition, camera shake can be a problem as the lens magnifies the subject and so emphasizes the slightest movement. Because of this, shutter speeds (unless the camera is mounted on a tripod) should be kept briefer than 1/125 sec with a 135 mm lens, 1/250 sec with a 200 mm lens, and so on.

Long telephoto lenses used to photograph some distant subjects may prove disappointing, especially on color film. Unless the air is crystal clear, atmospheric haze may reduce colorful scenes to a bluish-white monochrome picture.

A 200 mm telephoto lens will include four times less of a scene than a 50 mm lens used from the same position.

Zoom lenses

These lenses are optically very complex, having moving elements that make the focal length continuously variable within the limits set for the particular lens. They are

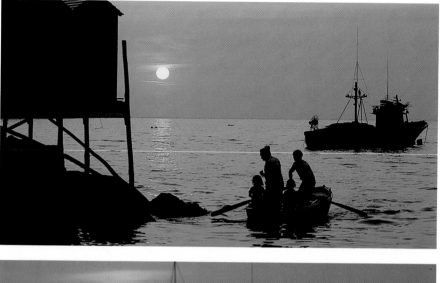

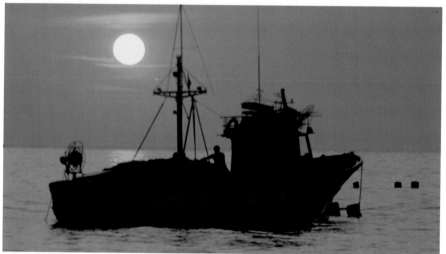

becoming available in an increasingly large variety, usually in either the wide-angle to standard range or moderate telephoto to longer telephoto. Zooms that span the wide-angle to telephoto range are few and not very satisfactory. In theory they enable you to carry fewer lenses, but zooms are much heavier than the individual lenses they replace and sharpness and contrast is generally lower than with fixed focal length lenses.

Zooming in
These two pictures illustrate the uses of a zoom. The **top** *picture was taken at the 90 mm setting and the other at 210 mm, but slightly to the right to keep the sun in shot.*

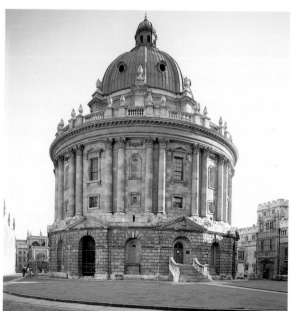

Converging verticals
A very common photographic problem is known as converging verticals. This can be seen when the camera is tilted upward to include the top of a tall building, **far left***. Because the camera is then closer to the base of the structure, that part of the building appears larger and vertical lines seem to converge toward the top. To correct this,* **left***, you can use a perspective control (PC) lens, which has movable internal elements and allows you to keep the camera perfectly upright.*

Zoom lenses are useful for framing pictures when one camera position only is available, or when you want to study the same subject from one position in many different sizes or forms of cropping. On some lenses there is one ring for zooming the lens and another for focusing. A better system, though, uses one ring only. Twisting the ring left or right focuses the lens while moving the ring toward or away from the camera operates the zoom function.

Less-usual lenses

For more occasional or specialist use, there are some other lenses that are worth considering. In general it is probably better to rent these lenses from a camera equipment store rather than buying.

Perspective control lenses mimic some of the controls

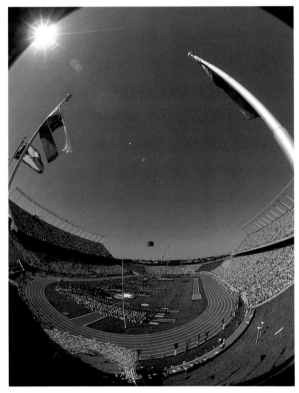

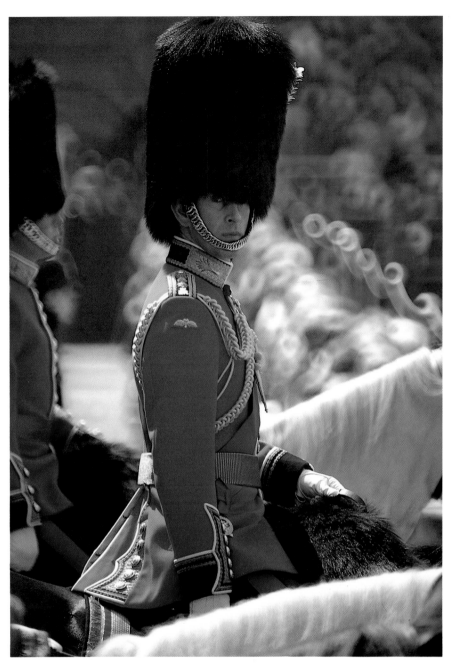

found on professional plate film cameras. As the name implies, certain elements can be adjusted to control such things as converging verticals. This is the illusion of parallel vertical lines appearing to converge when the camera is tilted upward to include the top of a building or some other tall structure.

Fisheye lenses are extreme wide-angles, with focal lengths around 8 mm. These produce a circular image and take anything up to 220° of the view. All straight lines in the picture appear curved, and their use is very limited.

A much more useful accessory, which most photographers could take advantage of, is a teleconverter. This ring fits between the lens and camera body and increases the focal length of the lens in use by 1.5, 2 or 3 times, depending on type. The best of these converters produce pictures that are almost as sharp as those of the unconverted lens. Their major disadvantage is the loss of lens speed. This is taken into account by most built-in light meters, but a 2 times converter will change an f 4 105 mm lens into an f 8 210 mm lens. Converters work best with lenses longer than about 100 mm.

Fisheye lens
*Of limited use to the general photographer is a fisheye lens. The picture **above left** was taken with a 6 mm fisheye and notice that the image is strongly bowed. Wide fisheyes such as this will produce a completely circular picture.*

Mirror lens
*The picture **above right** of Prince Charles in full ceremonial dress was taken using a 500 mm catadioptric, or mirror, lens (see **right**). This lens system always produces characteristic disk shapes of out-of-focus highlights.*

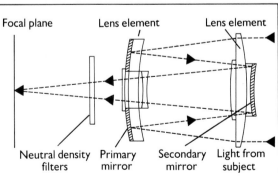

Focal plane — Lens element — Lens element

Neutral density filters — Primary mirror — Secondary mirror — Light from subject

Catadioptric lens
This type of optical system uses a mixture of refracting lens and reflecting mirror elements to produce a physically short, yet very powerful, lens. Mirrors are used to reflect light up and down the length of the barrel, so mimicking the effect of a longer lens. Mirror lenses have one fixed aperture only, and so neutral density filters are built in, as are color filters if needed.

Accessories

There are many, many accessories available to the modern photographer, but treat their acquisition with care; the majority are non-essential and will not in any way improve your photographs. Others, however, do not fall into this category, and their desirability depends on the type of camera you use.

The majority of SLRs and compacts have either built-in light meters (see pp. 16-19) or only very basic exposure controls. If, however, your camera is fully adjustable and does not have built-in metering, then a separate meter is almost essential. There are, however, some professional and amateur photographers who prefer using a separate meter, claiming that this way of working gives them more flexibility and control over the appearance of the final print or transparency.

No SLRs are made with built-in flash, so a flash unit is usually one of the first purchases made after the camera itself. The range of flash units is extensive, and the degree of sophistication required depends on how you intend to use the flash and in what circumstances.

Hand-held light meters

Light meters, whether built into the camera or separate, work on the same principle – light reflected by the subject strikes a light-sensitive cell in the meter and moves a needle over a scale to indicate how much light is present. You must first set the ASA/ISO speed of the film in use on the dial provided and you can then read off a choice of shutter speeds and apertures that would produce a correct exposure for that subject, and set the camera controls accordingly.

The commonest type of light-sensitive cell used today is the cadmium sulfide (CdS) cell, which varies its resistance to a flow of electricity in proportion to the amount of light falling on it. The flow of electricity is provided by a battery. Some meters are still made with selenium cells. These generate a flow of electricity when exposed to light – the more light the more electricity. Selenium meters, however, are not as sensitive to low light as CdS types, but they do have the advantage of not needing a separate battery. The newest CdS meters have digital displays (and therefore no moving parts) made up of LEDs, or light-emitting diodes. This type of construction makes the meter extremely robust.

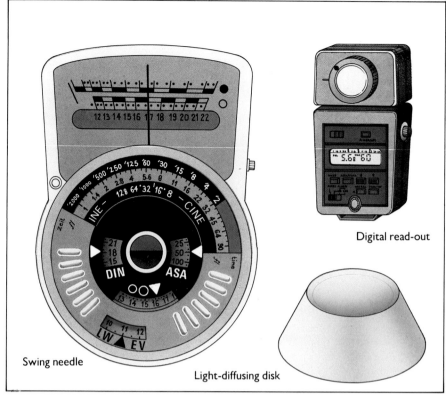

Swing needle

Digital read-out

Light-diffusing disk

Light meters
Two popular types of hand-held light meters can be seen **above**.

Using a spot meter
The very narrow angle of light acceptance of a spot meter, **below**, *is ideal when faced with the type of situation,* **left**. *In a normal light reading, light reflected from the water would have caused the flowers to be massively underexposed.*

Making a reflected light reading
In most situations, a normal reflected light reading, **below left**, *will give acceptably exposed pictures.*

Reflected light reading

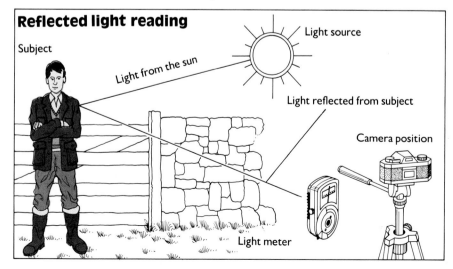

Subject

Light from the sun

Light source

Light reflected from subject

Camera position

Light meter

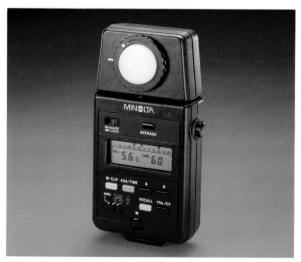

Making an incident light reading

Most light meters are sold with a plastic diffusing disk that fits over the light-metering cell. This disk reduces the amount of light reaching the cell but widens its angle of acceptance.

Using this technique, you measure not the light reflected by the subject, but the light illuminating it, and it is made from the subject position, not the camera position.

An incident light reading is more accurate than a reflected light reading when bright light is shining into the camera lens and, of course, it is only possible with the type of subject that can be approached.

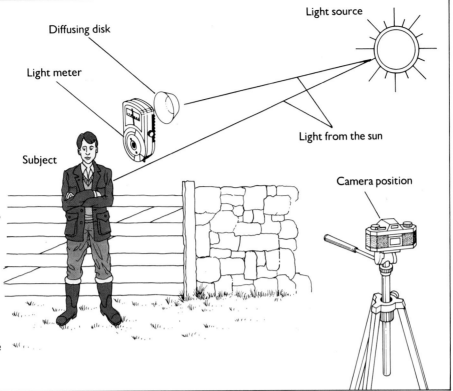

If the shoe fits
For a normal head-on shot using flash, an electrical contact on the camera hotshoe engages with a similar contact on the foot of the flash unit, **above**.

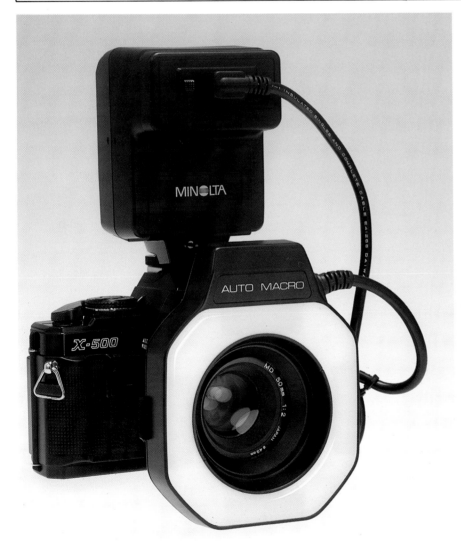

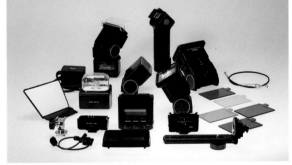

Ring flash
For shadowless studies of small subjects, a ring flash should be used, **left**, *which surrounds the front of the camera lens.*

Flash system
Flash equipment for the amateur can be extremely sophisticated, **above**, *including a range of flash heads, colored filters, bounce boards, supporting brackets and battery packs.*

Angle of view

Most light meters are sensitive to the angle of view corresponding to a standard or moderate telephoto lens, a cone of about 30° to 50°. These meters are usually used from the camera position and measure the average light reflected by the subject.

Some meters, however, accept an accessory that fits over the cell and narrows the angle of view to about 10° – the approximate angle of view of a 250 mm lens. With this attachment you can take more selective readings at a distance, or very small areas of the subject close-up, or the whole of the subject as seen by a 250 mm lens.

Selective light readings help the experienced photographer to obtain consistently accurate exposures in difficult lighting conditions, and are especially useful when used with transparency film. This film has little latitude for

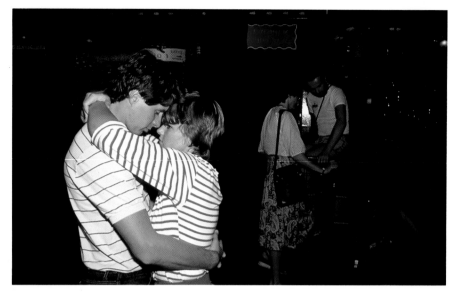

Portable flash units

The light from a flash unit is an electric spark produced in a gas-filled tube. A reflector behind the tube directs the light toward the subject. Most units now available have built-in light sensors, which measure the light reflected back by the subject and modify the light output to prevent overexposure. With some flash units, this sensor can be detached and mounted on, for example, the camera while the flash itself is positioned closer to, or to one side of, the subject.

Electronic flash units can be used when available light is too low for normal exposure or to lighten shadow areas caused by bright sunshine. Another important application is the freezing of subject movement. The longest flash duration is only about 1/200 sec but it can be much briefer – 1/30,000 sec, for example. If flash is the major light source in the picture, it will easily stop a high jumper in mid air or a speeding racing car.

error as there is no printing stage when small exposure mistakes can be rectified.

Spot meters

Instead of measuring the average brightness of all or part of the subject, a spot meter measures the light from only about 1° or less. A spot meter has its own viewfinder with a central targeted area, which indicates the part of the scene being measured.

Their main use is when working with subjects that would mislead a normal meter. An example of this could be taking a light reading of a performer's face from out in the audience with the stage lights shining toward the camera lens. The lights would lead a normal meter to indicate an exposure setting which would underexpose the main subject. A spot meter, on the other hand, would read light only illuminating the performer's face, without being unduly influenced by the surrounding bright light sources.

Flash synchronization

The flash must fire only when the camera shutter is fully open. With electronic flash, the peak of light is instantaneous, as opposed to bulb flash, which peaks slowly. A selector control is provided on the camera. With the focal plane shutter found on SLRs, two blinds move across the image area. With shutter speeds briefer than 1/60, 1/125 or 1/250 sec, depending on camera type, the second blind starts to travel before the first has finished. This means that the film area is exposed sequentially. At speeds of 1/60, 1/125 or 1/250 sec or slower, there is a slight delay before the second blind starts to move and these, therefore, must be used with flash.

Flash fall-off
*In large auditoriums, a common problem when using flash is known as flash fall-off, **top**. This occurs when there are no sufficiently close reflective surfaces, such as walls, to return light to the subject.*

Red-eye
*Another problem with camera-mounted flash is 'red-eye', **above**. This only occurs when the flash and camera lens axes are very close. In this example, the photographer has purposely created the effect, but using the flash off-camera will ensure that it cannot happen by accident.*

Mounting the flash

A common feature on many modern cameras is a 'hotshoe'. This is a clip on the top of the camera, shaped to accept the 'foot' of the flash unit. The clip contains an electrical contact, connected to the camera shutter, which triggers the flash. Using the hotshoe is convenient but the forward-pointing flash does produce harsh subject shadows and a generally flat and uninteresting lighting effect.

If your camera has a flash socket, you can use an extension lead to position the flash off-camera. This allows you to sidelight the subject or bounce the light off any convenient white- or neutral-colored wall or ceiling to produce shadowless lighting. Flash units with tilting and swivelling flash heads can be mounted on-camera and used in the same way.

Dedicated flash units

Newer SLR cameras can be fitted with a dedicated flash unit which simplifies flash photography. In these, a metering cell in the camera – rather than on the flash – measures the brightness of the flash and adjusts the unit's

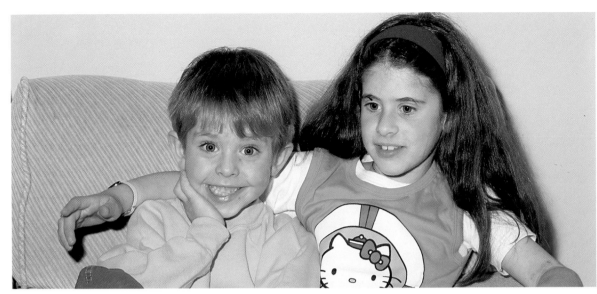

Flash effects
*Using just one flash unit you can achieve a wide range of different lighting effects. In the picture **left**, on-camera flash was used and notice that the effect is harsh and inappropriate to the subjects. In the version **below**, the flash was bounced off a side wall and, although gentler in appearance, the light has picked up a color cast from the wall itself. In the final shot, **bottom**, the flash was mounted on a flash umbrella (see illustration **bottom left**). Lighting is now very even and diffused, with no harsh shadows, much more in keeping with the subjects.*

output to avoid incorrect exposure. When the flash is fitted to the camera, the correct shutter synchronization speed is set, and when the flash is ready to fire, an indicator light comes on in the viewfinder as well as on the flash unit. This is a small but useful feature as you do not have to take your eye away from the viewfinder to see when the flash is ready. The system will also take account of any other light sources in the picture, including daylight.

Camera supports

Even when using brief shutter speeds – 1/125 sec, for example – with a moderate telephoto or shorter lens, it is good practice to adopt a relaxed, comfortable position when shooting. This will minimize one of the most common mistakes made by photographers – camera shake. Slight camera shake will appear on the final image as a loss of definition, subject detail not being as crisp as you would have liked. More severe camera shake results in blurred pictures and slides. Placing your feet slightly

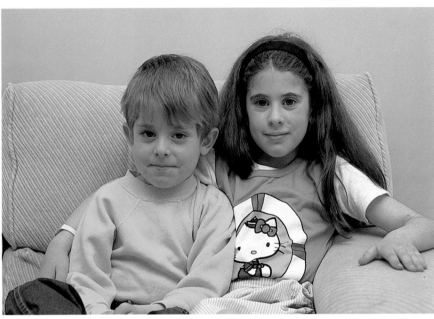

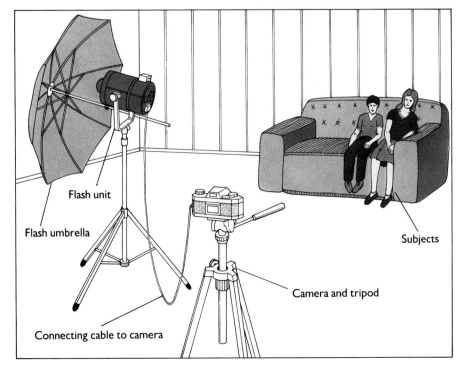

Flash unit

Flash umbrella

Subjects

Connecting cable to camera

Camera and tripod

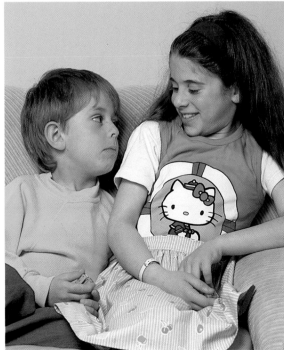

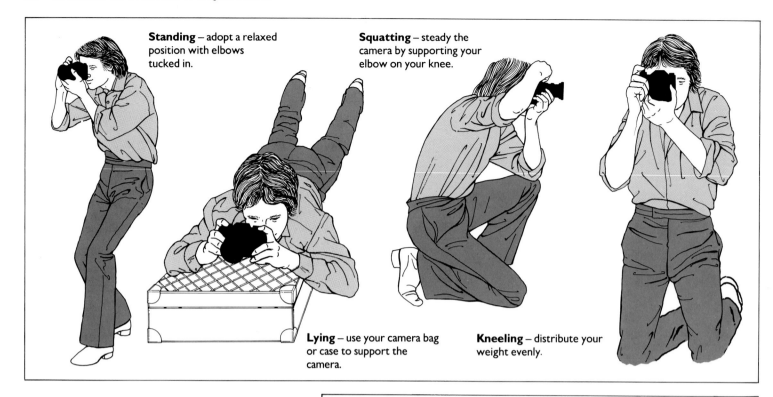

Standing – adopt a relaxed position with elbows tucked in.

Squatting – steady the camera by supporting your elbow on your knee.

Lying – use your camera bag or case to support the camera.

Kneeling – distribute your weight evenly.

apart and tucking your elbows in will help to distribute body weight more evenly and make you a better platform for supporting the camera.

For long exposures, or when using a heavy telephoto lens, a tripod is essential, and you will have to choose between similarly designed models of different weight and a variety of features.

Tripod features

The more rigid the tripod the more effectively it performs its function, but you must consider the weight of some of these heavy-duty types. If you are likely to be doing a lot of walking, a lighter model might be your best option.

As an aid to stability, better-quality tripods incorporate struts to help brace the legs. Tripod legs can be either the tubular telescopic variety with a locking ring or sliding u-shaped with a pull-down locking clip to hold the legs at the desired extension. The telescopic type is easier and quicker to use and more finely adjustable. Any

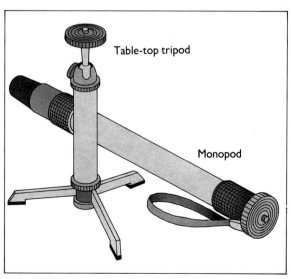

Table-top tripod

Monopod

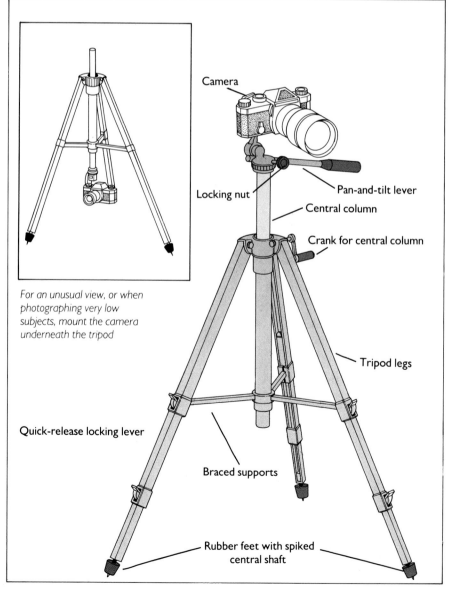

Camera

Locking nut

Pan-and-tilt lever

Central column

Crank for central column

For an unusual view, or when photographing very low subjects, mount the camera underneath the tripod

Tripod legs

Quick-release locking lever

Braced supports

Rubber feet with spiked central shaft

small adjustments to camera height are best made using the tripod's center column. Better types are geared and operated by a crank. Less-expensive models have a simple column and retaining screw, which jams the column at the desired height. Columns that can be removed and replaced upside down (from underneath the tripod) will position the camera pointing downward. This feature will prove useful if you need an extremely low camera position for close-ups of natural history subjects or shots of small objects placed on the floor.

Finally, the ends of the tripod legs are tipped with rubber feet, which stop the tripod slipping on shiny surfaces. When working outdoors, however, these rubber feet can be screwed upward to reveal spiked center shafts, ideal for extra grip when on soft ground.

Tripod heads

It is the tripod head that actually supports the camera. The baseplates of nearly all cameras have a threaded hole, which fits a screw on the top platform of the tripod head. The head, in turn, is attached to the center column. There are three major types of tripod head. The most flexible for normal use are the two-way pan-and-tilt and, better, three-way pan-and-tilt types. The very simple

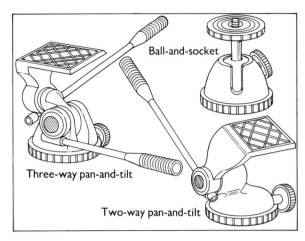

Ball-and-socket

Three-way pan-and-tilt

Two-way pan-and-tilt

ball-and-socket head offers least precision. Choose a tripod head with a platform that can be tilted on its side to allow you to take vertical (portrait-format) pictures.

Camera bags

The size of camera bag depends on the amount of equipment you normally carry. The choice of types is between a rigid, suitcase style, with compartments cut out of foam rubber, and a shoulder bag with a lid or flap.

The advantage of the shoulder bag type is that you can get at your equipment without putting the bag down. They are often designed with small compartments built into the lid and around the outside. This is a useful feature, allowing you easy access to small accessories such as film or batteries. This type of bag does not, however, offer as much protection as a rigid case.

If you are thinking of buying a canvas bag it should be weather proofed and when closed must exclude dust. A light-colored bag is best since this will reflect heat and keep camera and film a little cooler. Rigid cases are often covered with aluminum because of this. Straps and stitching should be extremely strong – the safety of your equipment depends on it.

An alternative to a bag or case is a jacket with specially designed pockets to hold a camera body, several lenses, film, a light meter and a flash unit.

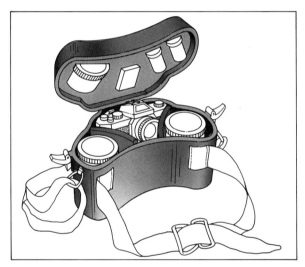

Holding the camera
Adopting the right stance, **top left**, even when using 'safe' shutter speeds, ensures a high percentage of sharp pictures. These illustrations show the best positions for a variety of different picture-taking situations.

Small camera supports
The illustration, **far left**, shows a table-top tripod, which is only really suitable for a light-weight camera and lens, and a monopod, which needs to be steadied by your own body when in use.

Tripod features
If rock-steady pictures are paramount, then you will need a good-quality tripod, such as the example illustrated, **left**.

Camera bags
Camera bags come in a huge range of styles – some purpose-built for photographic equipment, such as the example **above**, and others adapted from fishing or flight bags. Whichever type you use, make sure that there is room for expected amount of equipment you will need to have with you on location, and that the space can be divided up to stop the equipment knocking against each other.

Camera case
A rigid camera case, **right**, offers maximum protection and the foam rubber can be cut to accommodate exactly your equipment.

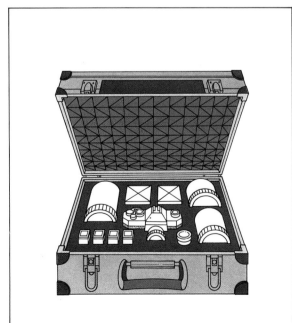

Caring for your equipment

All photographic equipment will benefit from light, routine maintenance.

★ Keep all external surfaces of cameras, lenses, flash, and so on clean and free from dust and grease. Use a lint-free cloth to remove dust.

★ Never use oil on any moving parts. Any piece of equipment that needs lubricating must be taken to a professional camera repairer.

★ After every few films remove dust from inside the camera body. To do this, open the back, hold the camera so that the dust falls away from the camera and use a tin of compressed air to dislodge dust. A blower brush can be used, but remove the brush part. Even a single loose hair can cause the shutter to jam.

★ With SLRs, remove the lens, lock the mirror in the up position and remove dust from the mirror box using a jet of air. Be careful not to scratch the interior matt black paint. This is designed to stop light from the lens scattering and causing flare inside the camera.

★ Treat your lenses with great care. Dust both front and, with an SLR, rear glass surfaces in the same way as for cameras.

★ Leave a colorless ultraviolet filter over the front lens permanently to stop dust settling on the lens surface itself.

★ Make sure that all batteries are fresh, and remove them altogether if you don't intend to use the equipment for some time. An old battery will leak corrosive acid into the electrical circuitry of your equipment.

★ Keep equipment dry at all times. Don't store it in even slightly damp conditions.

CHOOSING THE RIGHT FILM

The search to find a suitable medium on which to record permanently the action of light goes back many hundreds of years: the word 'photography' means 'drawing with light'. The forerunner of the modern camera – the camera obscura, meaning 'dark chamber' – was used by artists in the eighteenth century to project an image of a scene or person onto a flat glass screen, from where it could easily be traced off. But the elusive medium that would directly record the light entering the camera obscura was not discovered until 1826. A Frenchman, Joseph Nicéphore Nièpce, is credited with this. He used a mixture of bitumen Judea on a pewter base to produce a permanent image of the scene from his window.

Some thirty years before Nièpce made his discovery, Thomas Wedgwood, son of the famous potter Josiah Wedgwood, was experimenting with the image-retaining properties of silver nitrate solutions similar to those used in the manufacture of modern film emulsions. Although Wedgwood was successful in producing an image, he could find no way of desensitizing the silver nitrate solution, with the result that the image gradually blackened all over. This problem was eventually solved in 1839 by Frenchman Louis Daguerre, who used a salt solution to fix the image permanently.

This chapter looks at the modern descendants of these early experiments – color and black and white print and transparency films. It is not feasible to describe in detail all the different brands of film available partly because there are so many and they are improved and changed frequently, and partly because it is not possible to describe all the subtle differences that may influence your choice. It is not even possible to show these differences in this book, since the loss of quality that occurs during the reproduction process tends to obscure quite obvious characteristics of the originals.

What is helpful, however, is to divide film into categories, look at certain distinguishing features, such as 'speed', or sensitivity to light, and examine the special qualities you can expect from them. It is also helpful to compare and contrast the results obtained using films from different manufacturers. This you can do yourself or with a group of interested friends.

Film characteristics

Film, like your own skin, darkens when exposed to light. And, like skin, different types of film vary in their sensitivity to light.

Film structure

The composition of modern film is quite complex. For 35 mm film, there is an extremely thin triacetate base, which supports layers of silver halide grains suspended in gelatin. This mixture of gelatin and silver halides is known as the emulsion, and it is the silver halides that actually respond to the light entering the camera.

Between the film base and the first layer of emulsion there is an 'antihalation' layer – a dye designed to prevent light striking the base and reflecting back upward through the emulsion. Without the antihalation layer, highlight areas of the scene would record on the photograph or slide as unsharp and enlarged, effectively 'eating into' non-highlight areas and destroying image detail there. As it is, long exposure to very intense highlights still does cause a slight spreading of highlight detail, known as halation. This is usually most apparent in night exposures of many seconds of scenes containing streetlights or other bright point-sources of strong light.

All format films, black and white and color, share this same basic structure. Large pieces of film, however, such as that used in sheet film cameras, require a much thicker film base to provide a stable platform to support the emulsion layers. And because all films (apart from instant picture film) are processed in liquid chemicals, the film base incorporates an anticurl layer as well.

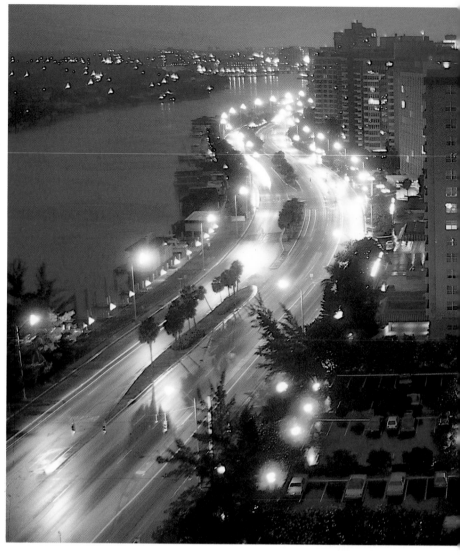

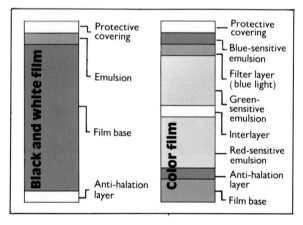

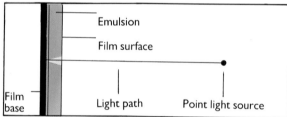

Film speed

All the categories of film are available in a range of different speeds. The speed of a lens (see pp. 23-7) refers to its ability to transmit light; film speed, however, refers to its sensitivity to light. The faster the film, the briefer the exposure to light needed to produce a correctly rendered film image. For many photographers, fast film is useful because it means that pictures and slides can be taken in relatively poor light; the faster the film, the less light needed for correct exposure.

The sensitivity of film to light is expressed as a number prefixed by ASA/ISO. ASA stands for American Standards Association and ISO, which has now replaced ASA, stands for International Standardization Organization. The actual numbers are the same for both systems and are the basis for setting the film speed dial on your camera's built-in light meter (see pp. 16-19) or hand-held exposure meter (see pp. 28-33). The higher the ASA/ISO number, the more sensitive the film is to light, or the greater its speed. The ASA/ISO number doubles as the sensitivity of the film to light doubles. An exposure, for example, of f 8 at 1/125 sec with a film of ASA/ISO 100 would be changed to f 11 at 1/125 sec (a halving of the aperture) or f 8 at 1/250 sec (a halving of shutter speed) with a film of ASA/ISO 200 (a doubling of film speed) to produce a negative or slide of the same density.

Another film speed system, DIN, is still in use. It is based on a logarithmic scale, wherein a change of +3° or −3° indicates either a doubling or a halving of film speed. (See table opposite for correlation between DIN and ASA/ISO numbers).

Film structure
As you can see from the illustrations, **far left**, modern film is amazingly complex. This is especially true of color film material, which incorporates the many different layers and color-sensitive emulsions within a total thickness of less than 1 mm. The much thicker base of black and white material makes the film more robust, but it should still be handled with care

Halation
Modern film structure incorporates an anti-halation layer designed to stop light penetrating to the film base and reflecting back, up through the emulsion, to form diffused patches of bright highlight **above left**. However, long exposures, especially at night, may still cause halation to occur, as in the photograph **above**.

Film speed systems

There are two principal film speed systems in common use – DIN and ASA. The International Standardization Organization (ISO) is trying to introduce a common numbering system throughout the world. At present, however, the old system may still be seen, and this table will help you to equate one system to another.

DIN	ASA/ISO
15	25
16	32
18	50
19	64
20	80
21	100
22	125
24	200
27	400
32	1250

Miami Beach
This night shot above of Florida's Miami Beach was exposed for 8 sec. Notice that, due to halation, all bright point sources of light have spread and become diffused.

meter that you are using a more-sensitive film than you really are, and the meter will indicate the need for less exposure (either a smaller aperture or faster shutter speed). Experiment until you obtain the results you are happy with. If, however, your transparencies are too dense they will stop sufficient light from a projector or slide viewer being transmitted and so produce a dark-looking image. To counter this, you must reset the film speed dial to a lower number, which will tell the meter you are using a less-sensitive film than you really are. The meter will then recommend a larger aperture or a slower shutter speed, and so increase the overall level of exposure. Reverse these recommendations if, of course, your prints are too dark or your transparencies too pale when projected.

Exposure latitude

There is no single precise exposure for any combination of film speed and illumination level. But the amount of exposure latitude that will still produce an acceptable result varies depending on the brand of film and the film type. With negative film, either color or black and white, exposing the film image is half the process only, because the negative must then be placed in an enlarger and

As has already been stated, ASA/ISO numbers are intended to act as a guide to setting the exposure meter, but some camera shutters are consistently fast or slow. As a result, light meters may indicate slight over- or underexposure. So if your black and white or color negatives are consistently too dense and, therefore, produce pale-looking prints, reset the film speed dial on your light meter to a higher number. This will tell the

Interpreting the film box

All the information you need to know about the film is printed on the outside of the film box itself. The first thing to ensure is that the film is

the correct format for your camera, so if you have a 35 mm camera look for a printed 24 × 36 mm (1), which are the dimensions of the 35 mm image size. Next look for the speed rating of the film (2). Sometimes film speed will be given as both ASA and DIN but usually just ISO. The number of exposures on the roll will also be there (3) as well as an expiry date (4). Always check this date carefully and don't accept film that is near to expiry. If it has been stored in a cool place

in the shop, the film may still be fresh for some time after this date. But if it has been exposed on an open shelf then both speed and, if color material, color balance may be adversely affected. It is best not to take a chance. If you are buying a few rolls of color film and want results to be particularly consistent, make sure that the batch numbers (5) are the same on all the rolls. No matter how much care manufacturers take, there are always going to be slight discrepancies.

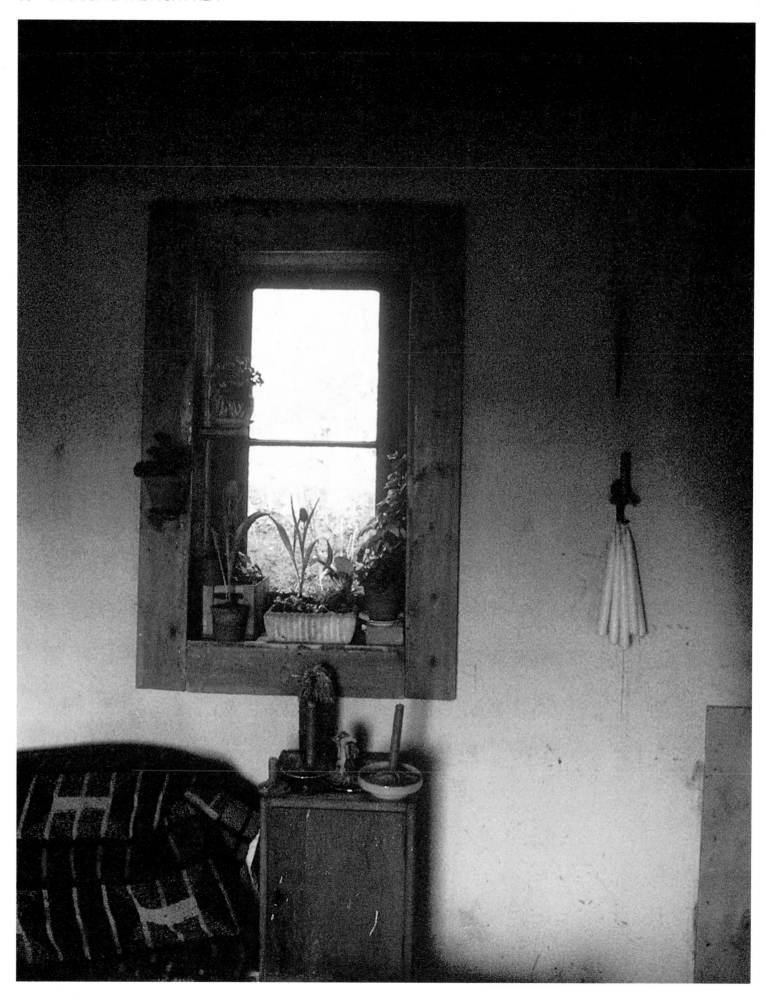

projected on to a piece of light-sensitive paper to produce a print. During the printing stage, original camera exposure errors of up to about one and a half f numbers, or stops (the latitude varies between brands), can be corrected either by increasing or decreasing the amount of time the paper is exposed to the film negative.

With transparency (slide) film, this printing stage doesn't apply and so camera exposure needs to be particularly accurate. Exposure latitude with most slide films is only about half a stop or less. If you want to test the accuracy of your light meter, it is best to run a roll of slide film through the camera.

Grain

Closely associated with film speed is film grain – the physical appearance of the silver halide crystals incorporated in the film emulsion. The sensitivity of film depends on the density of these crystals and on their individual sizes. The bigger and more numerous the crystals, the faster the film.

Grain is the unscientific way of describing the dots the photographic image is composed of. Generally, grain becomes more noticeable as film speed increases, although some manufacturers are better at keeping the grain size small and evenly patterned, which makes it less noticeable. The more the film is enlarged (either as a print or projected as a slide) the more apparent becomes the grain, especially in mid-gray areas of the subject or in light-colored areas. Wherever grain is noticeable less subject detail is recorded and slow, fine-grained films tend to produce slightly sharper results than their faster equivalents. Grain is not necessarily to be avoided and some photographers exploit its presence in a picture, or even exaggerate it, in order to create a specific desired effect.

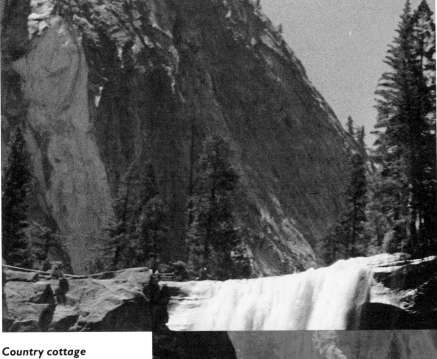

Country cottage
Grain is usually something photographers strive to minimize or suppress altogether. But it can be used to good effect, as in the photograph **opposite**. Here, it effectively evokes the atmosphere of quiet decay that this once prosperous English country cottage has fallen into.

Enlargement and grain
It is always difficult to make recommendations about the appropriate film to use for specific grain effects. As you can see from the two pictures **above and right** (one a detail from the other), so much depends on the degree of enlargement. Grain, however, is always more noticeable in light and mid-tone areas.

Types of film

The type of film you use depends on how you want to view the final results. Color and black and white negative film material is designed to produce paper prints, while color and black and white positive film material (often called either transparency or slide film) is designed to produce a positive film image to be viewed by transmitted light.

The price of transparency film often includes the cost of processing and mounting in slide holders, leaving you with no additional expense, but some do not – so make sure you ask for the type you want. The price of negative films never includes processing and printing, and so is cheaper to buy initially. But you must take the cost of processing and printing into account when comparing costs. Many independent film processing laboratories now offer inducements, such as free replacement films, if you use their services, and these can therefore substantially reduce your costs.

New developments

The high cost of photographic material is due to the presence of silver in the emulsions of films and printing papers. Commercial processing laboratories operate silver recovery systems to remove the minute traces of silver from waste solutions, and generally none is lost. But as silver becomes increasingly scarce the cost of photographic materials will inevitably rise.

An alternative method of making still photographs is being developed which makes use of magnetic tape. The technology involved is quite sophisticated and is still in its infancy. Essentially it is an adaptation of the video camera, but designed to take still pictures. The optical systems of such cameras will remain the same, but a microelectronic light receptor and a revolving magnetic disk would take the place of the traditional roll of film. As with video tape currently available, the disk will not require processing and will be reusable. However, it seems unlikely that the picture quality of such systems will ever match that from conventional film.

Canon ION
This was the first camera on the market to use a magnetic disk to record images instead of conventional film.

Color negative films

Color negative films are designed to produce color prints at a relatively low cost. It is by far the most popular medium with amateur photographers, the majority of

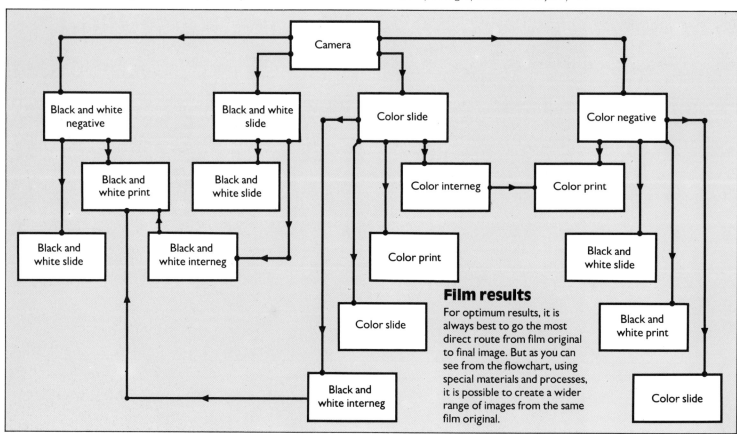

Film results

For optimum results, it is always best to go the most direct route from film original to final image. But as you can see from the flowchart, using special materials and processes, it is possible to create a wider range of images from the same film original.

Daylight in tungsten
*Although color slide and some color negative films are carefully balanced for use under very specific lighting conditions, there is no reason why you shouldn't experiment with mismatched film and light. The photograph **right** was taken on daylight-balanced film exposed to predominantly tungsten light coming from the store window. Tungsten light is deficient in blue, and so the image has a pleasant warm-orange color cast.*

whom are casual photographers only. The color print produced is also popular because it can be informally shown to friends or mounted on a stiff backing, framed and then displayed. If the quality is sufficient, prints up to about 16 × 20 in (40 × 50 cm) can be produced from 35 mm film. Alternatively, small prints can be made to fit inside a wallet. With the film negative kept safely, extra prints can be ordered at any time in the future.

With color negatives, the film (after exposure in the camera) is processed to make a negative. At the second stage of the process, the negative is enlarged to produce a color print. Quite large exposure errors can be corrected at this stage (see pp. 36-9). Most color negative films can be exposed either in natural sunlight or in artificial light, such as domestic room light. Some films, however, are specially made to respond accurately to the diminished blue and increased red content to be found in domestic 'tungsten' light. With the former type,

Tungsten in daylight
*In complete contrast to the photograph **above**, this picture **right** was taken on tungsten-balanced film and exposed in normal daylight, just before dusk. Tungsten film is designed to compensate for the low blue content of tungsten light sources and has produced this rather eerie, cold-blue image of a derelict warehouse.*

any color inaccuracies can be corrected during the printing stage of the process.

Home processing of color negative material is not difficult and with modern equipment color printing can be quickly learnt (see pp. 100-17). It is also possible to make black and white prints from color negatives, but there is usually a decrease in contrast and an increase in apparent grain. Unfortunately, color prints made from negatives are not particularly stable and tend to fade. Their display life can be extended if you keep them out of direct sunlight.

Black and white negative film

These films are designed to produce black and white prints. Only very little of this type of film is now sold compared with color negative film, but there is a solid core of photographers who prefer this medium above all the others available.

Using black and white film requires the photographer to see the world in different terms. All photography abstracts reality, turning the three-dimensional world into a two-dimensional image. Black and white further abstracts reality by removing color as well. Many ordinary scenes make good photographs because they are colorful, and very little else. Using black and white requires you to see more of the design and form features create, and learning to translate color into the subtle tones of black through white can take a long time and much practice. You will be surprised how much

more important texture, light, and composition become if you change from color to black and white.

Every stage of the process from developing the exposed film to producing the final print is well within the immediate reach of the beginner using very little equipment. If you are printing for the first time you are not going to be able to produce superb quality results, but even the novice will be able to produce acceptable results in the first session. There is something magical about seeing the image form in the developing tray for the first time.

Black and white prints can be processed for permanence without any special equipment, and because the material is extremely stable, the problem of display prints fading does not apply to the same degree as with color. Like color negatives, black and white films are very forgiving of exposure mistakes, although the best results will always be obtained if you start from the basis of the correct exposure.

Color transparency film

This film is designed to produce color slides. The film you expose in the camera is viewed by projection on a screen or in a slide viewer without any intervening printing process, and because of this it is relatively inexpensive despite the high initial film cost. It is, however, a more demanding medium than negative material, and exposure needs to be far more accurate.

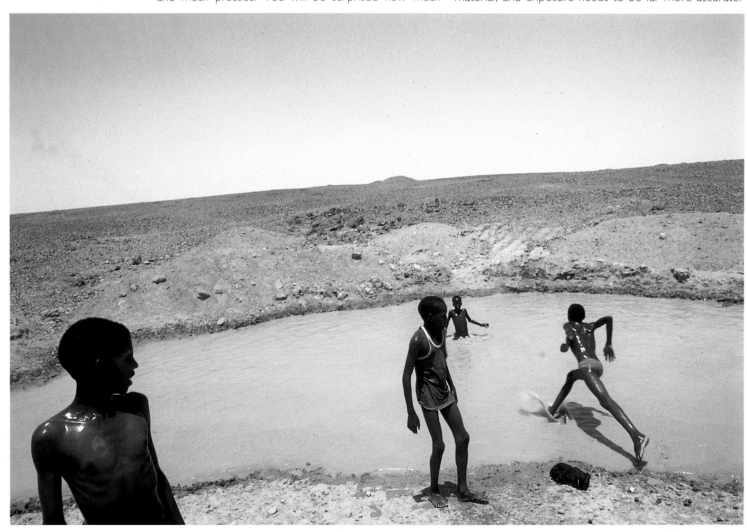

Although exposure latitude for correct exposure is only about half a stop, acceptable results can be obtained within about one stop of correct exposure with many brands of transparency film.

Unlike color negative material, which can be exposed in both natural and artificial light, slide film comes in two types – one balanced for sunlight and flashlight and another balanced for studio-type tungsten light. If you have the wrong type of slide film in the camera for the type of lighting conditions, you can use a color-correcting filter over the camera lens during exposure. You must remember, though, that all strongly colored filters remove light and increase exposure time as a result.

One of the reasons that slide film is not popular among amateur photographers is that, for optimum results, slides must be viewed by projection in a darkened room. Special daylight screens are available but the whole process still tends to be very dominating and has none of the informality of showing a friend your latest pictures just back from the processors. Small back-projection slide viewers are extremely effective and project your slides on to a small rigid screen just large enough for one or two people to see at the same time. These viewers can be used in normally lit rooms as long as you ensure that no bright light shines directly on the screen. One of the great advantages of color slide film is that very subtle color differences can be distinguished. Images also tend to be sharper and more vibrant and this material is better able to exploit the capabilities of modern high-quality lenses.

Superb quality prints can be made from color slide film on positive/positive paper (a positive print from a positive original) such as Cibachrome. This paper produces the richest of colors and is also·the most stable of all color printing papers, making the long-term display of your work more feasible. Cibachrome material can easily be processed in an averagely equipped home darkroom, and although the cost of the paper is higher than regular color negative paper, the better results more than compensate for the extra expense. Good quality black and white negatives can also be made from slides on slow film in low-contrast lighting.

Black and white transparency film

The best-known type of film designed to take black and white transparencies is Agfa Dia Direct, an ASA/ISO 32 film. This is the least expensive way of obtaining finished pictures and a good method of learning and experimenting with the principles of photography. The pictures obtained from this film can be viewed by projection greatly enlarged, which makes mistakes easy to see. Like black and white negative film, Agfa Dia Direct will force you to consider form, tone, texture and composition – a good discipline before experimenting with color. This film can also be used to copy black and white prints to make a slide show. Black and white prints can also be made from this material, although the process is difficult and special paper is required.

Color v. black and white
Often, color and black and white photographers adopt very different approaches to their work. Sometimes, however, a scene presents itself that works equally well in either medium. The color picture **opposite** *of African children playing around a muddy waterhole, was used to generate the black and white image* **below.** *Color composition is very strong opposite, with varying tones of brown drawing the viewer's eye ever farther into the picture. Once converted to black and white, however, the direction the boys are looking and the running figure on the right assume much more importance in helping to direct the viewer's eye.*

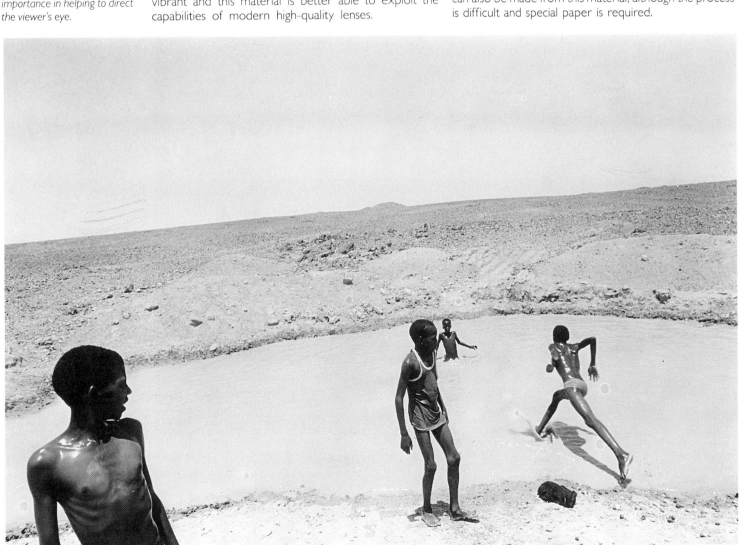

Subject and film

Most of us have an idea in advance of the approximate subject conditions before taking the camera out. If you have a home studio, then lighting and all other factors can be precisely manipulated. The ideal situation then is to match film characteristics (see pp. 36-9) to the type of subject you are expecting to encounter. But always make allowances for the unexpected, and take along two different speed films. A sudden storm, for example, can make a slow film useless as light levels plunge, but reload the camera with fast film and you may take home better pictures than you could have hoped for.

Slow films

These films are generally regarded as being between ASA/ISO 25-80, and they are capable of recording the finest detail with the least noticeable grain structure. In bright, sunlit conditions you can expect typical exposures of between f 8 at 1/125 sec and f 11 at 1/125 sec, and in dull or overcast conditions, f 2.8 and f 4 at 1/125 sec.

If you need to use a slower shutter speed than about 1/60 sec with a standard lens then you can expect to see the effects of slight camera shake or subject movement on your prints or slides; this will counter the extra sharpness these slow films provide.

The slowest color negative films generally available are ASA/ISO 100, and so are not covered in this category. Some of the black and white print films and color and black and white slide films in this group are:

Type	Name	Speed
Color slide	Kodachrome 25	ASA/ISO 25
Color slide	Fujichrome Velvia	ASA/ISO 50
Color slide	Kodachrome 64	ASA/ISO 64
Color slide	Ektachrome 50 Pro. Type A*	ASA/ISO 50
Black and white slide	Agfa Dia Direct	ASA/ISO 32
Black and white print	Agfapan APX 25	ASA/ISO 25
Black and white print	Pan F	ASA/ISO 50

*Artificial light film.

Fickle weather
*What a difference a minute makes. These two pictures, **left**, were taken within 60 seconds of each other at Windsor Castle, Berkshire, England. The picture **top** was exposed at 1/60 sec at f 5.6. As the sun burst through the cloud for the shot, **below**, shutter speed was changed to 1/125 sec and aperture to f 11 – an overall difference of three stops.*

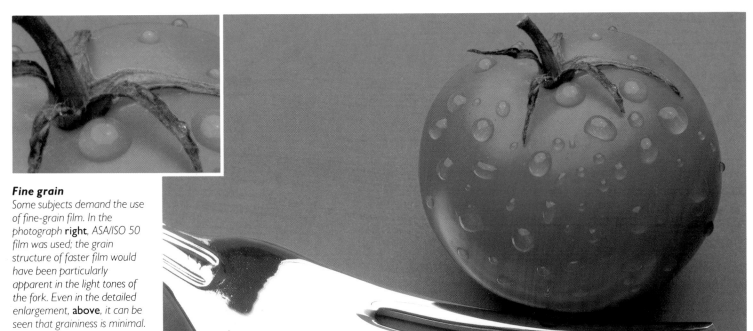

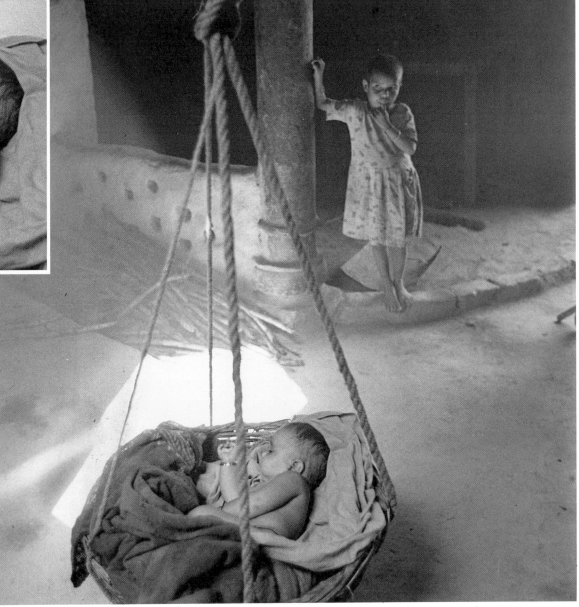

Fine grain
Some subjects demand the use of fine-grain film. In the photograph **right**, ASA/ISO 50 film was used; the grain structure of faster film would have been particularly apparent in the light tones of the fork. Even in the detailed enlargement, **above**, it can be seen that graininess is minimal.

Medium grain
Medium-speed films are an ideal choice when you are not sure just where you will be taking pictures, and in what circumstances. For the picture **right**, ASA/ISO 400 film was used. Grain is not intrusive and where it can be seen, in the mid-gray areas, it does not detract from the image (see also detailed enlargement, **above**). This category of film can be used both in the low-light conditions found indoors and in bright sunshine.

Medium-speed films

The most popular color negative films are in this group, and are about ASA/ISO 100-200. They represent a good compromise between speed, sharpness and flexibility. Slide and print films in this category are slightly less sharp than slow films, and if you look very closely at the processed results you may be able to detect an increase in grain size. The increase is so marginal, however, that it should not in most cases be a problem, and the faster shutter speeds should more than compensate for the minimal loss of film sharpness.

In bright, sunlit conditions, exposures of between f 11 and f 16 at 1/250 sec are typical, and in dull or overcast conditions, f 5.6 and f 8 at 1/250 sec. Some of the films in this group are:

Type	Name	Speed
Color print	Kodacolor Gold 100	ASA/ISO 100
Color print	Kodacolor Gold 200	ASA/ISO 200
Color print	Fujicolor Reala	ASA/ISO 100
Color print	Fujicolor Super HG 200	ASA/ISO 200
Color print	Ektar 125	ASA/ISO 125
Color slide	Ektachrome 100 HC	ASA/ISO 100
Color slide	Ektachrome 200	ASA/ISO 200
Color slide	Fujichrome 100	ASA/ISO 100
Color slide	Ektachrome 160*	ASA/ISO 160
Color slide	Ektachrome Infrared	ASA/ISO 125
Black and white print	Agfapan APX 100	ASA/ISO 100
Black and white print	Ilford FP4	ASA/ISO 125
Black and white print	Kodak T-Max 100	ASA/ISO 100

*Artificial light film.

Fast films

Films in this group are between about ASA/ISO 300-800 and they are a popular choice for documentary and candid photography. Photographic quality is not as good as with the slower films but the extra speed can make them indispensable in certain circumstances. You have, for example, the choice to work in quite low light and bright sunshine and these films generally respond well to 'push processing'. This involves rating the film at a higher film speed than stated by the manufacturer (effectively underexposing) and then extending or 'pushing' film development times to compensate. This can be done at home if you have your own darkroom, or by a film processing laboratory if you request it. An ASA/ISO 800 film, for example, can easily be exposed as if an ASA/ISO 1600 film (one f stop underexposure), making it ideal for action photography in dim lighting.

Even rated at their official speeds, however, you may notice a loss of quality with color films. Definition is softer and grain is coarser, so less detail is recorded. These films are generally selected for use in bad lighting or when fast shutter speeds or small apertures are needed. Some of the popular films in this group are:

Type	Name	Speed
Color print	Kodacolor Gold 400	ASA/ISO 400
Color print	Fujicolor Super HG 400	ASA/ISO 400
Color print	Konica Color SRG 400	ASA/ISO 400
Color slide	Ektachrome 400	ASA/ISO 400
Color slide	Fujichrome 400	ASA/ISO 400
Color slide	Scotch Chrome 400	ASA/ISO 400
Color slide	Scotch Chrome 640T*	ASA/ISO 640
Black and white print	Kodak	ASA/ISO 400
Black and white print	Ilford HP5 T-Max	ASA/ISO 400
Black and white print	Agfapan 400	ASA/ISO 400

*Artificial light film.

Obvious grain
*Working indoors, perhaps with only stage or theatrical lights, a medium-speed film will have to be 'pushed', or underexposed. The picture **below** was taken on ASA/ISO 400 film exposed as ASA/ISO 800 material. This was compensated for in processing, and grain is noticeable in the detail enlargement, **below left**.*

High-speed films

This group of films is rated at between ASA/ISO 1000-6400. In 1983 Kodak introduced an ASA/ISO 1000 high-speed color print film, which made use of a new method of manufacturing the light-sensitive emulsion. Other manufacturers, using their own versions of the technique, now produce similar color print films.

These films produce pictures of a quality previously associated with slower films. To achieve this result a way had to be found to grow the silver halide grains in a shape that intercepts the light in a more efficient way.

Kodak's film has been named 'T-grain' because of the halide's flat, tablet-like appearance. The crystals are also treated to make them more sensitive to light and the new product is regarded by some as the most important advance in emulsion technology for 50 years. This breakthrough came when many scientists considered that silver-based films had reached the practical limits in terms of speed. Now, good-quality color pictures can be produced nearly anywhere there is even a little light. Candid pictures can be taken in the home without flash and photographers using telephoto lenses can select smaller apertures and so maximize depth of field (see pp. 54-9). Another, less-usual application for this high-speed film is underwater, where light levels are always extremely low.

High-speed black and white film has been available for many years using a material originally developed for recording traces on cathode ray tubes. This film – Kodak RE2475 – is often used by the police for surveillance work and by documentary photographers working in low light where it would not be practicable to use flash. RE2475 can be rated anywhere between ASA/ISO 1000 and 6400, depending on the developer used and the type of lighting conditions at the time of exposure. It is a conventional film and extremely grainy – a quality some photographers like to exploit.

High-speed color slide films have also been introduced recently. The best known is made by Scotch (3M) and is rated as ASA/ISO 1000. A more recent film by Kodak can be rated at either ASA/ISO 800 or 1600 (a difference of one f stop) and, with some loss of quality, at ASA/ISO 3200 (a difference of another f stop). If you are not processing the film yourself, make sure you inform the laboratory of the speed you exposed the film at so that processing times can be adjusted. Some of the more popular films in this group are:

New grain structure
A way of improving the light sensitivity of silver halide emulsions was to redesign the halide crystals themselves, **above**. *The new crystals are know as T-grain because of their flat, tablet-like shape.*

Type	Name	Speed
Color print	Kodacolor Ektar 1000	ASA/ISO 1000
Color slide	Scotch Chrome 1000	ASA/ISO 1000
Color slide	Ektachrome P 800/ 1600 Professional	ASA/ISO 800-1600
Black and white print	Kodak RE 2475	ASA/ISO 1000-6400
Black and white print	Kodak T-Max P 3200	ASA/ISO 800-50,000

Utilizing grain
Although modern high-speed film will allow photographs to be taken when there is very little light, you should choose subjects, such as the example **below**, *shot on ASA/ISO 1000 film, that will benefit from the grainy appearance of the final image. The intrusive nature of the grain is particularly obvious in the detailed enlargement, shown* **left**.

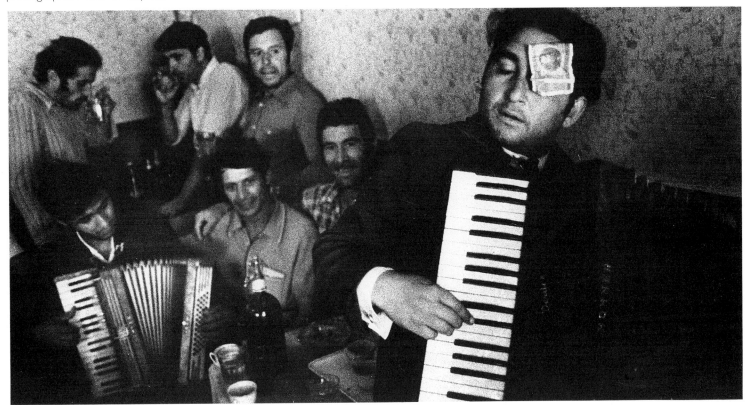

Chromogenic black and white films

This rather imposing-sounding film is based on the same techniques incorporated in color print and slide films, where dye is used to produce the final image instead of silver, which is all removed during processing. Although a black and white film, it can be processed in standard color negative chemistry, known as C41.

There is only one manufacturer who makes a black and white chromogenic film in 35 mm and 120 rollfilm sizes: Ilford. Ilford's XP1 film is nominally rated at ASA/ISO 400 but can, in fact, be successfully exposed at speeds that vary from frame to frame on the same film (see box opposite). With XP1,

Ilford have skilfully adapted the technology to produce a black and white film noticeably better than HP5 or Tri-X, the conventional ASA/ISO 400 materials.

As a rule, you should regard ASA/ISO 1200 as the film's maximum speed. At speeds above this, HP5 or Tri-X give better results when 'uprated' and push processed. You must, however, expose conventional film all at the same ASA/ISO setting. XP1 resembles FP4 (ASA/ISO 125) although pictures will not be quite as sharp. Enlargements bigger than 10 × 12 in (25 × 30 cm) made from XP1 negatives display improved definition over conventional ASA/ISO 400 films.

Because of its chemical composition, XP1 has a slightly extended red sensitivity, and pictures exposed by electronic flash, in artificial light and in dull weather are improved when compared to conventional ASA/ISO 400 films. Flash pictures of flesh tones are much improved and XP1 records the subtle changes in tone that are usually lost on conventional films.

Infrared films

Black and white negative and color slide film sensitive to infrared light, which the eye cannot detect, is available in 35 mm cassettes. These films are manufactured by Kodak for a variety of scientific purposes but they are also available through regular photographic retailers. Infrared film is particularly sensitive to temperature and should be stored in a refrigerator.

The pictures produced by this type of film are very different to conventional results and can be used to produce striking and dramatic images. Kodak black and white, high-speed, infrared negative film is usually used with a red filter over the camera lens. This absorbs most of the visible light and emphasizes the infrared effect. The ASA/ISO speed depends on the intensity of the filter; with a Wratten No. 25 filter, for example, the film has a speed of ASA/ISO 50. Film speed can be as slow as ASA/ISO 10 with a Wratten No. 87c in use.

It is recommended that this film be handled in darkness because infrared light can enter the cassette through the film slot opening. On most camera lenses you will find a second, usually red-colored, focusing index mark, intended for use with infrared black and white film. This is necessary because infrared film comes into focus at a different point to visible light.

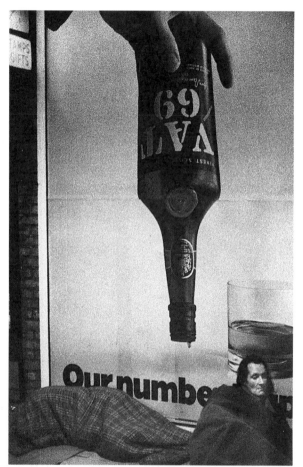

Intrusive grain
*Modern high-speed films can take pictures in almost impossible conditions – but at a price. The picture **left** was taken by streetlighting using RE2475 film exposed at ASA/ISO 3200. It can be seen that the grain pattern has started to dominate the image.*

Print comparison
*These two pictures were taken under identical conditions. The picture **far left** was shot on XP1, rated at ASA/ISO 400, and the one **left** on conventional ASA/ISO 400 film. Although differences are slight, XP1 has produced a finer grain appearance and higher resolution. These differences become more apparent as print size increases.*

Using chromogenic film

It is to be expected that a film manufactured in such a different way will also respond differently in use. The most telling difference occurs when the film is overexposed. The loss of sharpness and tonal rendering apparent on conventional film can hardly be detected on XP1. Rating the film at ASA/ISO 200 (doubling the exposure) will actually produce finer grain and retain image sharpness – the opposite to the reaction of conventional films. This is also true if the film is overdeveloped and means that pictures made on the same roll of film may all be exposed at different speed settings and given just one development time.

If some exposures on a roll of film are made at ASA/ISO 800 in low light, the film will have to be overdeveloped to compensate for the underexposure. If the rest of the roll is shot in bright light, you may rate the film at ASA/ISO 400 or even 200. Although the negatives taken in bright light will be rather dense, the photographic quality will be nearly as good as if they were exposed and processed normally. If you expose a conventional film in this way, the negatives taken in bright light and overdeveloped would look unsharp and grainy. So if you are taking pictures on XP1 at ASA/ISO 400 and suddenly need to shoot in very low light, change the film speed setting on your meter to ASA/ISO 800 or even 1200. Finish the roll and extend development time to compensate for the most underexposed (or uprated) pictures. The quality of the rest of the film will not suffer from the extended development.

Black and white infrared
Strangely beautiful images are possible using black and white infrared film, **above**. Green foliage is strongly affected by this material, as is sky, which tends to turn black. Infrared film needs to be kept cool and does not store well.

Color infrared
As with black and white infrared **above**, color infrared material also reacts strongly to green vegetation, **right**. The actual color of the final film image depends largely on the color of the filter used on the camera lens.

Comparing films

There are considerable variations in the way different films record colors and in overall color balance. Some films, for example, tend to be slightly yellow, or warm, or slightly blue, or cold, in appearance. A tendency toward blue in shadow areas is particularly noticeable on some films. You will also find that some films are sharper than others of the same speed, and that some have a more obvious grain structure. There is nothing either good or bad about these film characteristics; you must simply find the film you prefer for the type of result, or 'atmosphere', you wish to obtain. Different batches of film from the same manufacturer tend also to display slight variations in color balance and speed, but these should not be as marked as the differences between brands.

Caring for film

Modern film is extremely stable and forgiving of most minor handling and storage faults, but for best results treat your film with care.

★ Check the expiry date printed on the outside of all film cartons before purchase and refuse film that is near to expiry. This is particularly important with slide films, as the film image is viewed direct.

★ For consistent results make sure all your film comes from the same batch.

★ If you bulk buy film for use in the future, you can extend its effective life by keeping it cool. The lower compartment of your refrigerator is ideal. Keep the film in an airtight container or it may become damp.

★ Before using film that has been in a refrigerator, let it warm up slowly to room temperature before loading the camera. Condensation may form on cold film suddenly brought into a warm room.

★ Never leave a loaded camera in the glove compartment or trunk of your car. Air temperature in confined spaces can be high enough to affect the film's speed and color balance.

★ If shooting in a hot country, try to keep your film in a portable cool box, but remember to allow time for the film to come up to normal temperature before use.

★ If the air is extremely humid, don't return the exposed film to the film can. Instead keep it in an airtight box or bag with a few packets of silica gel. This acts as a sponge and absorbs any air moisture.

★ Even fully processed film and mounted slides can be adversely affected by humidity, and the emulsion can support fungus growth.

★ Keep opened cassettes of film away from chemical fumes given off by paints, solvents, glues, mothballs, photographic chemicals and insecticides, or serious emulsion damage will occur.

★ Repeated screenings by airport X-ray machines can damage film. Keep your film separate and ask if it can be visually checked instead. Special lead-lined film bags are available but these do not guarantee protection.

★ Have exposed film processed as soon as possible. If overseas, you may prefer to mail films home to your own processors. Make sure that the postal service is reliable before entrusting your films to it.

Film comparisons
To ensure as many variables as possible were eliminated, the same slide original was carefully copied on to three different popular slide films. The image **above** *has quite an obvious blue cast, which has strengthened sky color but has also given the whole scene a rather cold feeling. Copied on to another brand of slide film,* **left**, *the same scene now has a yellow cast. Everything looks much warmer, but overall color saturation is not as good as above. The final image,* **below**, *shows the original copied on to a neutral colored film. Color saturation is better than with the yellow cast but not as strong as with the bluer version. When deciding which color film to use yourself, remember that there is no right or wrong film. Color rendition is largely a matter of personal preference.*

Another variable that needs to be eliminated occurs when exposed films are processed at different times or in different laboratories. Even if you process at home, solution strengths and temperatures are never completely consistent, and so you must expect some slight variations.

Making the test

It is easiest to test color slide films, although you can use the same procedures to test color negative materials. You must then, however, make the color prints yourself under strictly controlled conditions for the results to have any validity.

To make the test, try and interest a few friends in helping – this will keep the costs down. You will need a camera with a good lens, a tripod, light box and, of course, a selection of different slide films.

The test should be made on a day when the sky is clear or slightly hazy, preferably in the late morning or early afternoon. The brightness of the light should not change while the test is underway. Ask a friend to model for you, as this will test the films' ability to record skin tones. Buy a large color test card, a Kodak neutral gray test card (18 per cent reflectance) and a piece of brilliant white card. Write the film brand being tested and the batch number on a smaller piece of white card and include this in the image area. The same camera, mounted on a tripod, and lens should be used to expose all the films, which should be processed as soon after exposure as possible.

Determine exposure in your usual way and make the picture with the meter set to the film manufacturer's recommended ASA/ISO setting. Next, underexpose four pictures at half-stop intervals and overexpose two pictures at half-stop intervals. Repeat this procedure for each of the films to be tested.

Checking results

Have the pictures returned from processing unmounted and uncut. Cut the test pictures into strips yourself with the first picture you took on each film at the manufacturers' ASA/ISO setting at the top, and view the films side by side on a light box.

Now check that the first exposure produced slides of the best density with your equipment. If not, then adjust the ASA/ISO setting to give you the best result. Look down the strips and you will see the latitude each film has (see pp. 36-9). Next look at the gray and white cards – these are the tones most difficult for color film to record. The cleaner and more neutral, the better the color balance of the film. Then look at the color chart and see how accurately these have been rendered. Finally, look closely at the skin tones. If the majority of your pictures include people, then these are the most important areas of tone to inspect.

If you have a projector, mount the best-exposed slides and look again at all the different aspects of the test. The sharpest, finest-grain film with the cleanest gray and white cards may not be the best material for your work – it really is largely a matter of personal preference. Once you have found the brand that suits you best, stick to it and in time you should be able to anticipate its results under a wide range of subject conditions.

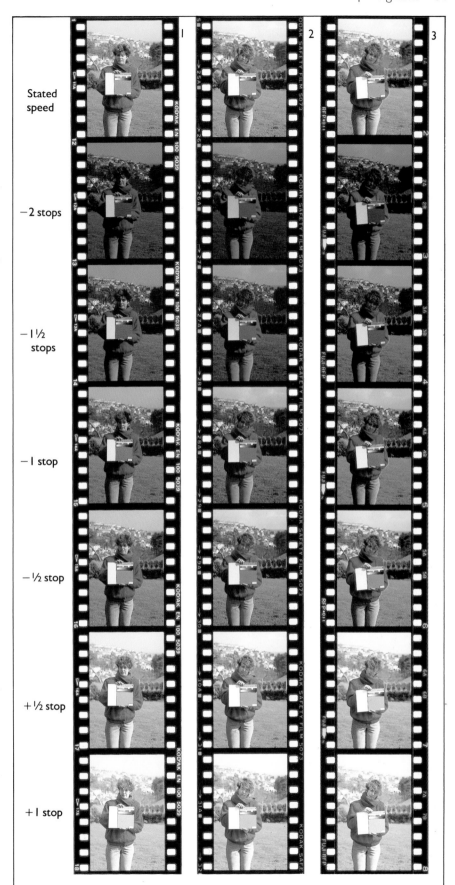

Stated speed

−2 stops

−1½ stops

−1 stop

−½ stop

+½ stop

+1 stop

Test results

In this test, the Fuji film (1) is correctly exposed at the manufacturer's stated speed. The two Kodak films, Kodachrome 25 (2) and Ektachrome 100 (3), yield a better image with half a stop additional exposure. The Fuji film produces a warmer image with a more vivid red than the two Kodak examples. Exposure latitude is about the same in all the film tested.

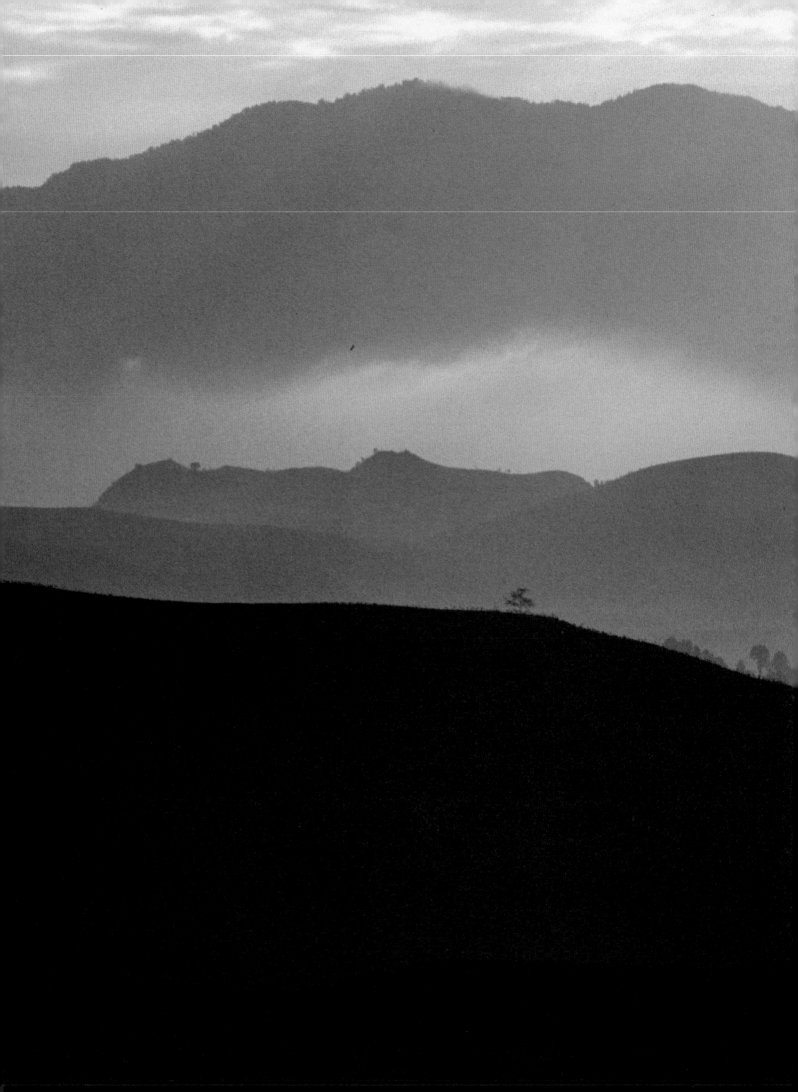

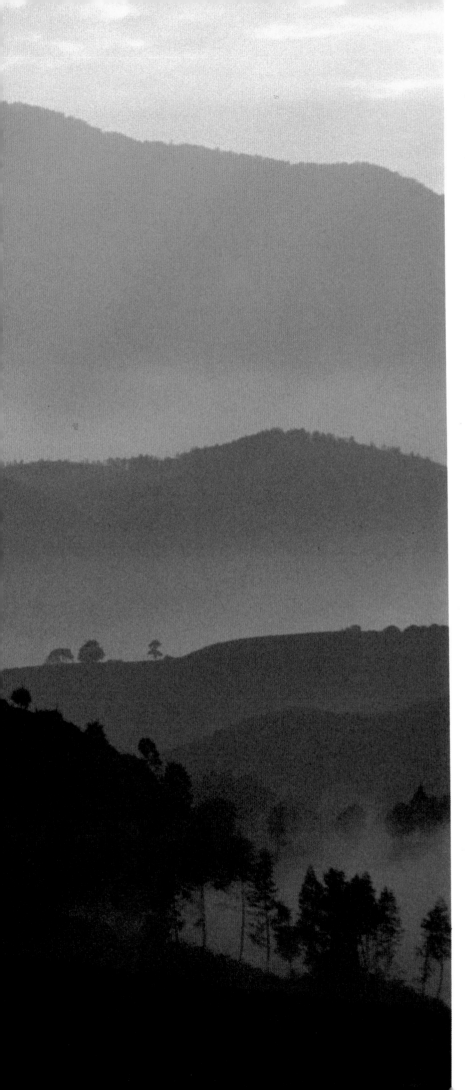

Chapter 3

THE CREATIVE CAMERA

When you look at any scene – a beautiful landscape or a room full of people at a party, for example – without even realizing it your eyes constantly flit from one element to another. Some you concentrate on, others you totally disregard and, effectively, fail to see. The human eye moves easily from pockets of shadow to areas of bright light and the impression you build up is personal, unique and very selective.

The camera, however, is an indiscriminate recording device. Point the camera at the same scenes as above and press the shutter and what you see on the film will be a faithful, static and often disappointing record of what was actually there. The power lines you had ignored looping through the middle distance of that landscape appear on your print or slide starkly silhouetted against the sky; the intimate group of friends talking at that party can hardly be recognized amidst the general clutter of competing components.

The solution is to use the camera's controls to replicate, as far as is possible, the selectiveness of vision. To see how this can be done involves going over some of what has already been discussed in the first two sections. Topics such as the function and use of shutter speeds, apertures and the effects of light on film have to be incorporated into the process of previsualizing the final image and then applied in order to create the type of picture you saw in your mind's eye.

Perhaps one of the most fascinating aspects of photography is that the camera can record what the eye cannot see. We build up impressions from a constantly altering stream of visual input, whereas the camera freezes one instant of vision and allows us a leisurely examination of what may only have lasted a mere 1/2000 sec. The camera can also be used to record many impressions of the same element on a single frame — the almost dream-like quality moving water takes on when photographed using a shutter speed of many seconds is one example. Lenses and camera position, too, can be used to make connections between different elements of a scene, which are not a true reflection of reality, while exposure can be manipulated to turn day into night and aperture to isolate one feature by defocusing the rest of the scene.

Controlling image sharpness

Two camera functions are used to control exposure. The aperture ring alters the size of the hole in the lens through which light enters the camera. The shutter speed dial on the camera body alters the length of time the light from the lens is allowed to shine on the film. A light meter, either built-in to the camera or a separate hand-held version, measures the amount of light reflected by or falling on the subject. Once you have programmed the light meter with the ASA/ISO speed of the film in use, you can read off the aperture settings and shutter speeds that will produce a correctly exposed picture, or else the camera itself carries out this setting of the aperture and shutter speed. This, basically, is how exposure is determined and controlled.

Depth of field

There is rarely just one correct combination of aperture and shutter speed that will produce a negative or slide of the correct density, but each particular combination will show the subject in a different way. So what is it that makes one aperture or shutter speed preferable to another? To begin with the choice may seem confusing, but an understanding of the effects is one of the most creative tools available to the photographer.

If you look at your own pictures, either prints or projected slides, you will notice that many display a zone of sharp focus both in front of and behind the point actually focused on. The distance that this zone extends on either side of the point in sharpest focus is known as the depth of field. The overall extent of the depth of field is influenced by three factors: the focal length of the lens, the distance of the subject, or point of focus, from the camera and the aperture selected.

A simple rule to remember is that the smaller the aperture (the larger the aperture number) the greater the depth of field, and greatest depth of field is apparent when the aperture number is large, the focal length small (a wide-angle lens) and the subject is distant.

So apart from magnifying a scene, as a telephoto lens does, or reducing it, as a wide-angle lens does, the

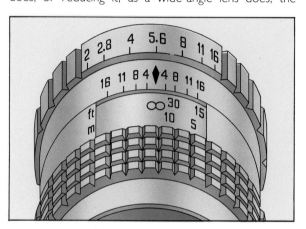

Depth of field scale
All modern focusable lenses have pairs of numbers, corresponding to the f stops used on that particular lens, engraved on either side of the focusing index mark, **below left**. After focusing on your chosen subject distance, find the two numbers corresponding to the aperture in use. The distance between these numbers, indicated by the focusing scale, is the zone of acceptably sharp focus for that lens at that focusing distance and aperture.

F stops
Originally, changing the size of the lens aperture was achieved by inserting brass 'stops', with different sized holes, into the lens. Modern lenses use an adjustable diaphragm, **below**, and changing one f stop either doubles or halves the size of the previous aperture.

Representative selection

The diagram **below** shows only a representative selection of apertures that could be found on camera lenses. Apertures such as f 1.8 and f 1.4 are reasonably common, but apertures as wide as f 1.2 and even f 0.9 can also be found. At the other end of the range, f 16 is a very common smallest aperture, but f 22 and f 32 are also possible. In all cases, the doubling or halving relationship between neighboring apertures holds true.

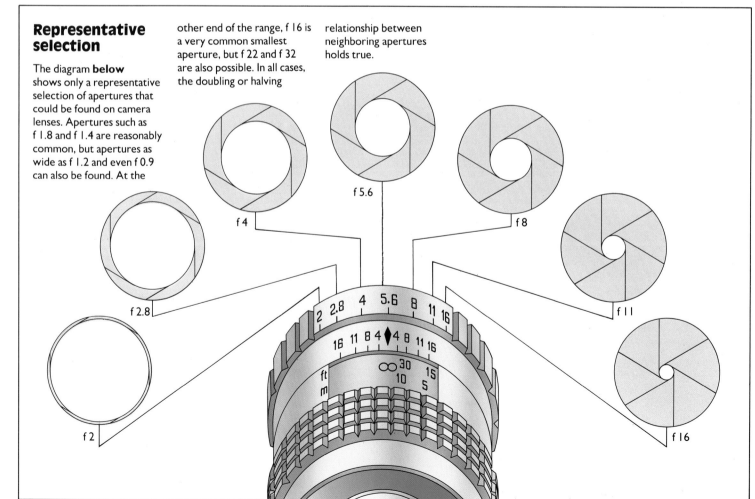

Changing apertures

Each time you change apertures you affect the zone of sharp focus, known as the depth of field, as can be seen in the diagram **right**. In the first picture **below**, taken at f 1.4, only the foreground is critically sharp. at f 8 the middle ground is now sharp, but at f 16 even the far distance is acceptably sharp. Notice that depth of field is greater behind rather than in front of the subject.

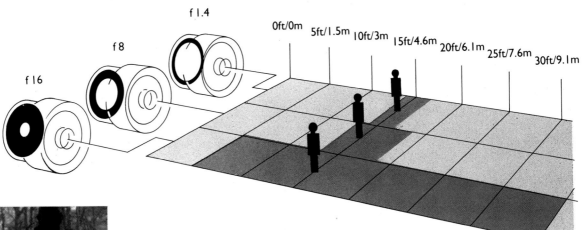

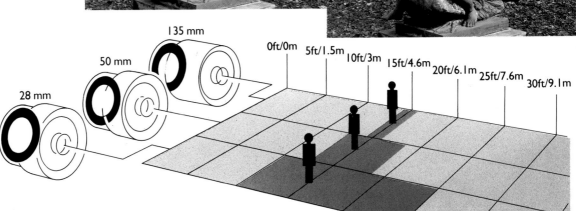

Changing focal length

Another factor affecting depth of field is focal length, **right**. In the pictures **below**, 28 mm, 50 mm and 135 mm lenses were used, all set to f 8 and the same focusing distance. Only the 28 mm lens records all elements of the scene as critically sharp.

Changing focus
The final factor governing depth of field is subject distance, right. The pictures below were taken using a 50 mm lens set at f 4, but the focusing distance was altered each time. With the lens focused on the close distance, depth of field is very shallow, in contrast to the picture with the lens set on the far distance.

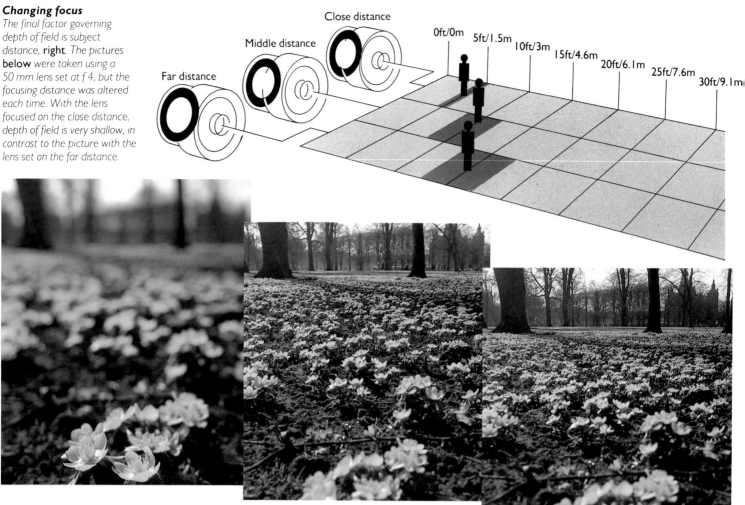

Far distance Middle distance Close distance

0ft/0m 5ft/1.5m 10ft/3m 15ft/4.6m 20ft/6.1m 25ft/7.6m 30ft/9.1m

variation in the control of depth of field is an important inherent characteristic of lenses, which may influence their suitability for a particular photograph. A figure, for example, can be highlighted in a general scene by selecting a telephoto lens and wide aperture, and making use' of the limited depth of field. Applied carefully, this technique will render out of focus and unsharp anything in front of or behind the subject.

With a wide-angle lens and a small aperture, anything from about three feet (one metre) or less to infinity may be recorded in sharp focus. This combination of lens and aperture would be chosen if you needed to show action close up to the camera position as well as detail in the background.

The zone of sharp focus can be approximately anticipated by using the depth of field scale engraved on the lens and previewed with greater precision by depressing the stop-down button found on most SLR camera bodies. This closes the lens aperture down to the one selected for exposure and the zone of sharp focus should then be visible on the focusing screen. Although this is true in theory, in practice stopping the lens down to a small aperture makes the focusing screen so dark that it is difficult to make out anything at all, let alone trying to distinguish sharp from unsharp features.

In some circumstances, however, you may find that you have little choice of shutter speed and aperture combinations. When using slow film in dull lighting, for example, your exposure meter may indicate that you use your largest aperture or an impossibly slow shutter

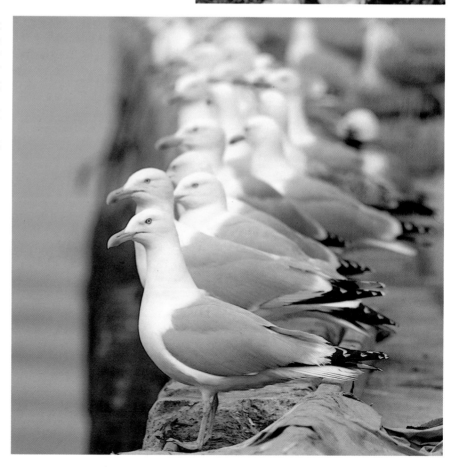

speed. Any subject movement would then show as blur. At the other extreme, when using fast film in bright light, the exposure reading may dictate the use of the smallest aperture and fastest shutter speed, forcing you to freeze all subject movement.

Armed with this information, you have the opportunity of anticipating the way your pictures will look. Instead of shooting and hoping for the best, you can begin to plan your pictures, making use of aperture and shutter speed to interpret the subject in the most appropriate way.

Zone focusing

After you have become used to using the depth of field scale on your camera lens, you can then explore a technique called zone focusing. Using this method, you focus the lens for a zone of sharp focus, rather than on a particular subject or element. With a 28 mm lens, for example, stopped down to f 22, you can focus to record a sharp picture of anything from 2 ft (60 cm) to infinity. The extensive zone of focus is less with standard and telephoto lenses. In order to zone focus, look at the depth of field scale and choose the aperture that produces the appropriate zone of sharp focus for the pictures you wish to take. You must then select the shutter speed that allows you to use that aperture. If the lighting conditions do not allow the appropriate shutter speed to be selected, you must change to a faster or slower film.

Zone focusing makes it possible to take photographs extremely easily as no time is wasted adjusting the lens. When you see the picture you want, put the camera to your eye, frame the subject and press the button. Many professional photographers, especially magazine photo-

Using depth of field
These two photographs show how depth of field can be used creatively. In the example **far left**, limited depth of field effectively concentrates attention on just one small area. In the picture **left**, extensive depth of field encourages the viewer to explore every inch of the image.

Focusing for action
These three pictures all had to be taken quickly. To do this, the camera was pre-focused each time on a set distance: from 5 to 20 ft (1.5 to 6.1 m) for the **top** image; from 3 to 20 ft (1 to 6.1 m) **middle** image; and from 3 to 30 ft (1 to 9.1 m) shown **above**.

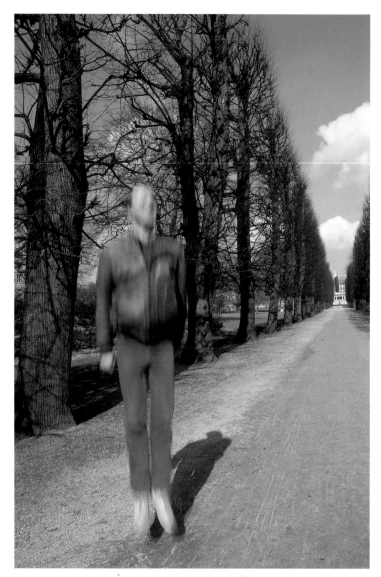

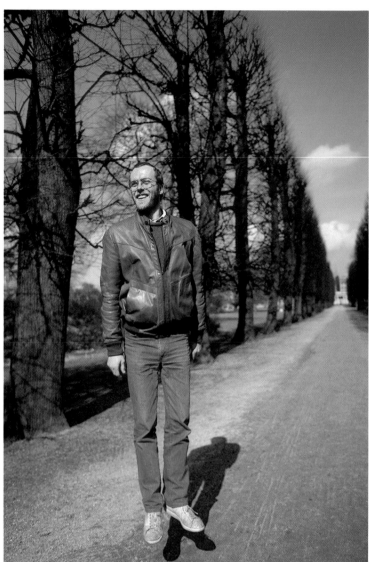

Hyperfocal distance

Many professional photographers prefocus the camera lens on the approximate distance they anticipate the action to occur. If you wanted pictures, for example, of athletes leaving the starting blocks, prefocusing would be a simple matter of focusing on the starting line. One way of ensuring your lens is adjusted to produce the greatest possible zone of sharp focus is by setting it to the hyperfocal distance. To do this, select the smallest aperture that allows you to use a reasonable shutter speed, and focus the lens on infinity. Now look at the depth of field scale and note the closest point of sharp focus to the camera. The distance from the camera to this point is known as the hyperfocal distance. If you next refocus the lens to this closest point, the zone of sharp focus will then extend from infinity to only half the hyperfocal distance. As an example, if with the lens focused at infinity and an aperture of f 11 set, with a 50 mm lens the depth of field scale might indicate a zone of sharp focus stretching from infinity to about 15 ft (4.5 m) from the camera (**1**). If you refocus for 15 ft, depth of field will then extend from infinity to only 7½ ft (2.25 m) from the camera (**2**).

Shutter speed and aperture
Often you have to make a trade-off between shutter speed, to freeze action, and aperture, to control depth of field. In the picture **above left**, an aperture of f 16 necessitated a shutter speed of 1/30 sec to obtain correct exposure, thereby blurring the jumping figure. For the shot **above**, shutter speed was changed to 1/1000 sec and aperture to f 2.8. Notice now that the jumping figure is sharp but depth of field is less extensive.

Close-ups
To obtain pictures as detailed as this, **right**, you will need to use a macro lens or some other type of close-focusing equipment. Depth of field in such pictures is always limited, and can be as little as an inch or less, so accurate focusing is essential.

graphers, rely on the zone focusing method so as not to miss those unrepeatable pictures.

A good rangefinder camera has an advantage over the SLR when practicing this technique. Because the viewfinder on an SLR indicates the focus at the widest aperture, the image on the focusing screen only appears sharp at the point actually focused on. You have to stop yourself from refocusing and learn to trust the depth of field scale instead. The viewfinder on a rangefinder camera frames the picture without indicating image sharpness. When you look into the viewfinder it is quite easy to disregard the secondary ghost image produced by the rangefinder window.

Controlling image movement

Although the different controls can be described separately, they cannot be considered as independent adjustments when taking pictures. The combined effects of aperture and shutter speed determine the way the subject is interpreted. First try to understand the functions of the controls separately then, when you come to line up the shot in the viewfinder, consider their combined effect on the image. You may want a clear objective record of the subject, or you may want to take a picture that more subtly evokes an emotional response. Technique is a tool to give perfect expression to your ideas and view of the world; it is not an end in itself. In photography the end is the picture, and it is this that makes the trouble worthwhile.

Camera shake
*Blurring of the image, such as in the picture, **top**, can be caused by too slow a shutter speed or by not adopting a comfortable shooting stance.*

Peak of action
*Even using a slow shutter speed of 1/60 sec, frozen images are possible if you shoot at the peak of the action, **above**, when the athlete is almost stationary.*

Frozen action
*A shutter speed of 1/1000 sec was used, **left,** in order to freeze completely the running figures and the spray created as they ran through the shallow water.*

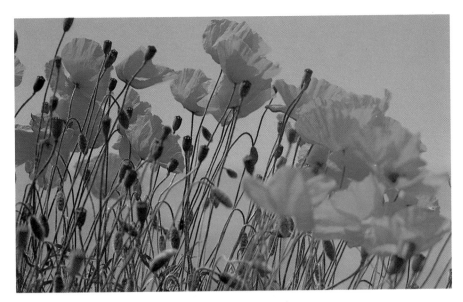

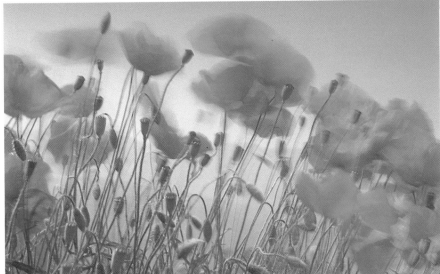

Shutter speed sharpness

The speed of the shutter determines how much, if any, subject movement is recorded on the film while the shutter is open. If the shutter speed is fast enough then all subject movement will be arrested. But even static subjects can record as unsharp if there is any camera movement during exposure, so always remember to press the shutter gently.

Camera movement is more likely at slow shutter speeds or when a heavy lens is in use. The following table can be used as an approximate guide to safe shutter speeds with certain focal length lenses:

Lens (mm)	28	35	50	100	135	200	400
Shutter speed	1/30	1/30	1/60	1/125	1/125	1/250	1/500

Lenses longer than about 300 mm are best used on a tripod (see pp. 28-33) to ensure a sharp result.

Fast shutter speeds are usually selected when you need to stop the action or when you have selected a wide aperture, perhaps to limit depth of field (see pp. 54-9), or because light levels are particularly high and you have fast film loaded in the camera.

A useful guide as to the minimum exposure times which will still produce a sharp picture is to select a shutter speed equal to the focal length of the lens. For example, a 250 mm lens could confidently be used at 1/250 sec and a 28 mm lens at 1/30 sec.

Recording subject movement

Up to this point we have been looking at ways of freezing a moving subject, but this is not an automatic requirement. Often subject movement forms part of

Subject movement
*The two pictures **above** illustrate how important it is to consider shutter speed even when taking reasonably static subjects. The first picture, **top**, is the result of using a shutter speed of 1/250 sec. For the picture **above**, a shutter speed of 1/30 sec was used and a sudden gust of wind has changed the mood of the picture completely.*

Creative blur
*A shutter speed of 1/15 sec was used to capture the billowing form of the American flag, **right**. Notice how subject movement has caused the colors to spread, creating a more interesting composition when contrasted with the hard lines of the building beyond.*

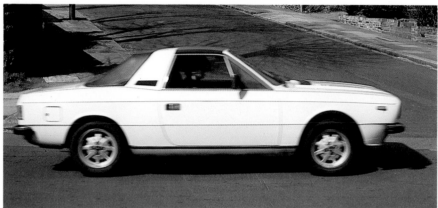

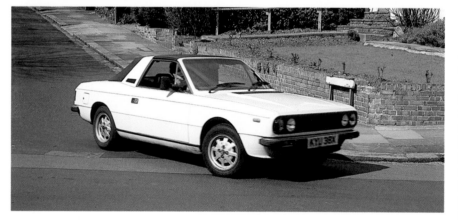

Appropriate shutter speed
These three pictures illustrate how shutter speed needs to be appropriate to the direction of travel of the subject. In all cases the car was travelling at 10 miles per hour, but in the **top** *version the car is moving directly away from the camera and, therefore, appears sharp. In the* **middle** *version the car is moving directly across the view of the camera and appears blurred, while in the version* **above***, the 45° angle of movement relative to the camera position produces just noticeable blur.*

our impression of the scene or event and is, therefore, an important and integral quality. Taken to extremes, exciting, abstract images can be created where the image is completely blurred so that only swirls of color or tone are recorded. This technique of using slow shutter speeds and subject movement has to be handled carefully – it is all too easy to rely on it as a means of creating something different. The pictures may be free of documentary content but you must work just as hard to make a powerful photograph. Possibly the composition and color or tone arrangement must be more arresting to compensate for the lack of information in the image. But try it out – on one roll of film you have the opportunity to make up to 36 separate visual experiments for relatively little cost.

The direction of subject movement

Many factors besides shutter speed control the apparent degree of subject movement as recorded by the film. One of these is the focal length of the lens in use. Apart

from the possible effects of camera shake already discussed, a telephoto lens magnifies the size of the subject and also makes any subject movement more apparent. The close-up effect is achieved but the shutter speed has to be faster.

The most obvious factor influencing subject movement is the actual speed of the subject, but linked to this is the direction of travel of the subject in relation to the camera position. A shutter speed of, say, 1/125 sec may be sufficient to freeze the motion of a car travelling at about 10 miles per hour (16 km per hour) either toward or away from the camera. The same car, however, travelling at the same speed at right angles to the camera position may require a shutter speed as brief as 1/1000 sec. Subject movement at 45° to the camera will fall between these two examples, and so a shutter speed of either 1/250 or 1/500 sec should be set. These speeds can only be suggestions, as much depends on the focal length of the lens, subject distance from the camera and the actual speed of the subject.

Panning

The advice above assumes a moving subject and a static camera. Depending on conditions, a shutter speed of, for example, 1/1000 sec may be impossible because light levels are too low for the film in the camera, or it may mean using an aperture too wide for the depth of field required for the subject. In such circumstances, a better technique is to pan the camera. Not only will this overcome the problem of too fast a shutter speed, but it often creates a more vibrant, exciting image.

Panning involves moving the camera in line with the subject so that it stays in the same relative position. Owners of SLRs are at a disadvantage when panning (see pp. 16-19) as the viewfinder blanks out during exposure

Fairground action
*This picture, **left**, shows in one frame how shutter speed and apparent subject movement are closely related. All the children are obviously travelling at the same speed on the funfair ride, but notice how those moving across the field of view are completely blurred, while those moving toward or away from the camera are relatively sharp.*

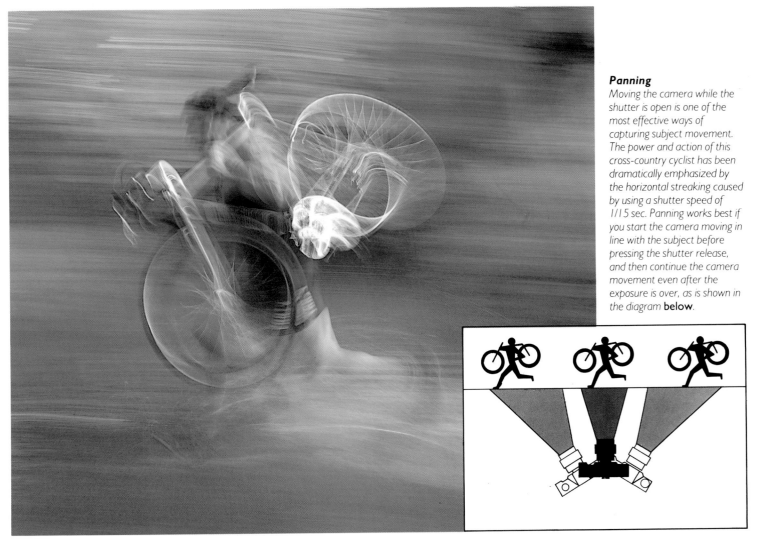

Panning
*Moving the camera while the shutter is open is one of the most effective ways of capturing subject movement. The power and action of this cross-country cyclist has been dramatically emphasized by the horizontal streaking caused by using a shutter speed of 1/15 sec. Panning works best if you start the camera moving in line with the subject before pressing the shutter release, and then continue the camera movement even after the exposure is over, as is shown in the diagram **below**.*

as the reflex mirror flips up. For successful results, line up the subject in the viewfinder and press the shutter release gently at some predetermined point and follow through with the camera even after the shutter has closed.

Determining the right shutter speed to use for this technique can be difficult. Since the camera is moving, any static areas of the scene will record as blur. This can help to contrast the panned subject, throwing it into sharp relief against the background. Fast shutter speeds will create minimal background blur and a more completely sharp subject. Slow shutter speeds will cause greater background blur and a less-sharp subject. It very much depends on the type of effect you want to achieve. The determining factor may be the aperture needed to compensate for the shutter speed selected. On a bright day, for example, with fast film in the camera, a shutter speed of 1/60 sec could necessitate an aperture of f 22 in order to hold exposure to an acceptable level – but many modern lenses only stop down to f 16, therefore making 1/125 sec the slowest possible shutter speed to use in the circumstances. On a dull day with slow film in the camera, a shutter speed of 1/125 sec may mean an aperture of f 1.4 or even wider, producing, with a telephoto lens in particular, an impossible depth of field.

Creating subject movement

Another interesting, and unpredictable, way of creating subject movement is by zooming during the exposure. For this technique you need a zoom lens and a slow shutter speed of about 1/8 sec or slower. You can start off with the zoom either at its minimum or maximum setting and because you need both hands it is best if the camera is mounted on a tripod. Ambient light levels should not be too high or overexposure could become a

problem. A steady zoom during exposure will create a continuously blurred image, but holding the zoom at any one focal length for a fractionally longer period will record the image in a more coherent form at that point.

Zoomed movement
Even quite ordinary scenes can be enlivened by changing focal lengths on a zoom lens while the shutter is open, as in the photograph **above**.

Combining aperture and shutter speed

The aperture scale of f stops is arranged so that moving the selector ring from f 2.8 to f 4, for example, reduces by half the amount of light reaching the film. This relationship remains true for each full f stop. Shutter speeds are also arranged so that each setting either halves or doubles the length of time the shutter remains open. From this you can see that, in terms of exposure, it does not matter if a little light for a long time or a lot of light for a little time actually reaches the film. If, for example, the measured light level for a particular scene indicated camera settings of f 5.6 at 1/125 sec, you can see from the table below all the other

settings that would give an identical exposure.

Aperture	Shutter speed
f 1.4	1/2000 sec
f 2	1/1000 sec
f 2.8	1/500 sec
f 4	1/250 sec
f 5.6	**1/125 sec**
f 8	1/60 sec
f 11	1/30 sec
f 16	1/15 sec
f 22	1/4 sec

Each one of these combinations would correctly expose the film, but deciding which is best depends on the effect you want and the type of subject involved. For detailed recording of everything from the closest focusing point of the lens to infinity, you should choose f 22 at 1/4 sec. If, however, you want to freeze subject movement, and depth of field is unimportant, f 1.4 at 1/2000 should be selected.

Controlling exposure

In the preceding pages, th
controls were seen to b
ness and movement, as v
the photographer contr
film. In bright conditions
speed will be indicated
aperture and slower
produce a negative or

Dealing with di

The light meter mea
combination of f sto
best result based or
the light reading
exposure correct.

The light met
measured is 'aver
predominantly
predominantly li
meter will get it
sunshine reflect
may also lead tl
Another probl
by very harsh
record detail
conditions.

Fortunatel
reasonably e
light that is n
will have t
correctly ex

Underst...

A good way to understand the problem caused by subjects of extreme brightness contrasts is to photograph three equal-sized pieces of card – one black, one white and one gray. Place them together and take a light reading of them all. Fill the frame with the cards and make an exposure on slide film. This represents an

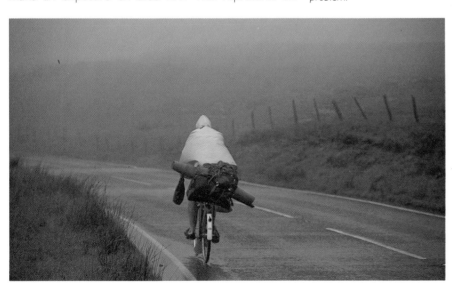

Brightness range
In the shot, **top,** *a good mix of shadows and highlights should not cause problems. The picture* **above,** *however, has above average brightness and could lead to underexposure. The gloomy, rain-swept picture* **below** *represents the opposite problem.*

average scene. Now take a reading of the black card and photograph it alone. Do the same for the white and gray pieces of card.

The picture showing all three pieces of card will show each faithfully recorded. The picture of the black card alone will, however, be recorded as gray (too light); the picture of the gray card will be recorded correctly, but the one of the white card should also be gray (too dark). Because the meter is programmed to assume that every subject is average, each recommended reading is designed to make every picture look average.

Knowing this, you should be able to suspect when you are being given misleading information and then to interpret the reading to suit the subject that is really in front of your camera lens.

Other problem areas for your meter occur when the subject is backlit. Here, the contrast range of the subject is massive – far beyond the recording capabilities of most films. The meter confronted with this scene will detect the light shining directly at the camera and recommend a shutter speed/aperture combination that will inevitably underexpose the subject, creating a silhouette. As a rough guide, with black and white and color negative film, the solution is to double the exposure indicated by the reflected light reading. The latitude of these types of film will help them cope with the situation and the extra exposure will ensure that there is some detail in the shadows. The more limited contrast range and latitude of

Backlighting

*High-contrast, backlit scenes are always difficult to record well. In the picture **right**, a highlight reading was taken and, as a result, the figure is in deep shadow. For the version **far right**, a shadow reading was taken and all sky detail has disappeared. The compromise setting **below** shows a reasonable amount of information in both shadows and highlights, but even so it is a little thin.*

slide film is more of a problem. Basically, you will have to decide if you want detail in the shadow areas only (and expose accordingly) or in the highlights. If the important parts of the picture are in the bright areas, take a light reading of the lighter tones. These will come out correctly but the shadow detail will be lost.

If the subject is approachable, a better method of taking a light reading in these circumstances is known as an incident light reading, where you measure the light falling on the subject, rather than reflected by it (see pp. 28-33). Some modern cameras also have a backlight compensation control, which basically gives the film more exposure in order to retain detail in the shadow areas.

Selective light reading

The most accurate way of determining correct exposure of difficult subjects is by making selective light readings. With small areas of intense highlights, a reading from the whole scene will be influenced by the bright points of light and indicate an exposure that will underexpose the rest of the scene. To counter this, take a reading of an area that should be recording as a mid-tone and base exposure on that. A deeply tanned face is a mid-tone, so a close-up reading of this part of the subject will give you an exposure which will record the face naturally. A landscape that includes a large area of sky will cause underexposure if the meter is not tipped downward to measure the light reflected predominantly from the ground. Pictures that contain small but important elements in a subject of a largely different brightness also benefit from selective light readings.

By necessity, lighting conditions such as harshly lit, intense highlight, deep shadow and so on are described in the most general way. Each situation in reality is a little bit different and so precise settings cannot be given to cover them all. If you are in any doubt about the best way to interpret your light meter, the ideal thing to do is bracket exposures. This may sound wasteful, but it does

Suggested exposures for difficult subjects

Subject	Film speed (ASA/ISO)		
	64-100	400-800	1000-1500
Candle-lit scenes	1/4 f 2.8	1/30 f 2.8	1/30 f 4
Indoor Christmas lights	1 f 4	1/30 f 2	1/30 f 2.8
Brightly-lit city streets	1/30 f 2	1/60 f 4	1/60 f 5.6
Neon signs	1/30 f 4	1/125 f 5.6	1/125 f 8
Shop windows	1/30 f 2.8	1/60 f 5.6	1/125 f 5.6
Floodlit buildings, monuments, etc.	1 f 4	1/30 f 2	1/30 f 2.8
Skyline at night	4 f 2.8	1 f 4	1 f 5.6
Skyline at dusk	1/60 f 4	1/125 f 8	1/125 f 11
Moving traffic (streaked headlights)	20 f 16	10 f 32	5 f 32
Fairgrounds, amusement parks	1/15 f 2	1/60 f 2.8	1/125 f 2.8
Fireworks (hold shutter open on B for a few bursts)	f 8	f 16	f 22
Lightning (hold shutter open on B for a few streaks)	f 8	f 11	f 16
Campfires	1/30 f 2.8	1/60 f 5.6	1/125 f 5.6
Outdoor night sport, athletics	1/30 f 2.8	1/250 f 2.8	1/250 f 4
Moonlit landscapes	30 f 2	4 f 2	4 f 2.8
Moonlit snowscapes	15 f 2.8	4 f 4	4 f 5.6
Indoor sport	1/30 f 2	1/125 f 2.8	1/250 f 2.8
Galleries, museums, etc.	1/8 f 2	1/30 f 2.8	1/60 f 2.8
Stage performances	1/4 f 2	1/30 f 2.8	1/60 f 2.8
Hospital delivery rooms	1/30 f 2	1/60 f 4	1/60 f 5.6
Star trails (hold shutter open on B for at least 5 minutes)	f 4	f 5.6	f 8

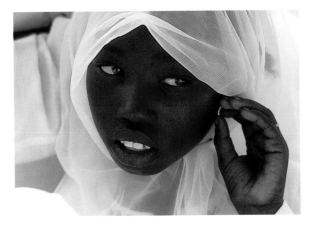

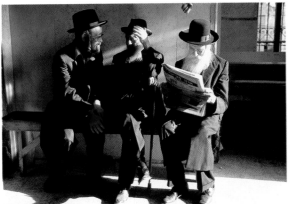

High contrast
It is important to learn to recognize lighting situations that could prove troublesome. In the picture far left, the inherent contrast between the girl's black face and white costume makes a generally detailed picture almost impossible. In the example left, strong window light has created pools of intense highlight, which could not be accommodated without sacrificing all important shadow detail.

ensure that the unrepeatable shot is not missed. To bracket with slide film, determine what you think is correct exposure and then make an additional exposure half a stop overexposed and half a stop underexposed. If, despite the increased latitude of negative film, you are in doubt about correct exposure, then make your additional shots at one full f stop above and below the one determined to be correct.

Exposure guides

The printed exposure guides that come with the film can be used successfully for the limited range of conditions described, and it is useful to keep the one for your film

with you in case the meter fails to work. One method for determining the exposure for a frontally lit subject in average sunlight is to set the aperture to f 16 and the shutter speed to the ASA/ISO number. A film of ASA/ISO 64, for example, would require an exposure of 1/60 sec at f 16. In hazy sunlight open up half to one full f stop, and if the sky is overcast open up three full f stops. Obviously exposure guides cannot take into account minor fluctuation in brightness, but they do form a good basis for bracketing.

In low light conditions the light meter, if it will register at all, cannot be trusted. In such circumstances you will have to rely on your own experience, although tables of recommended exposure settings are helpful.

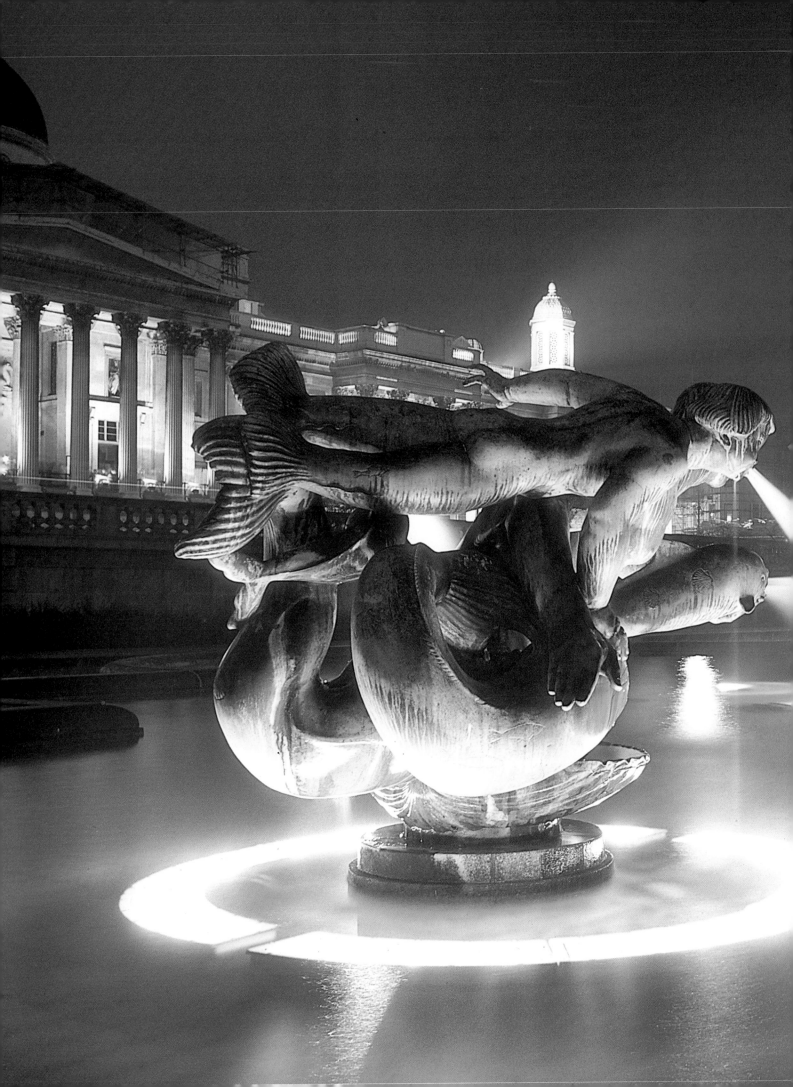

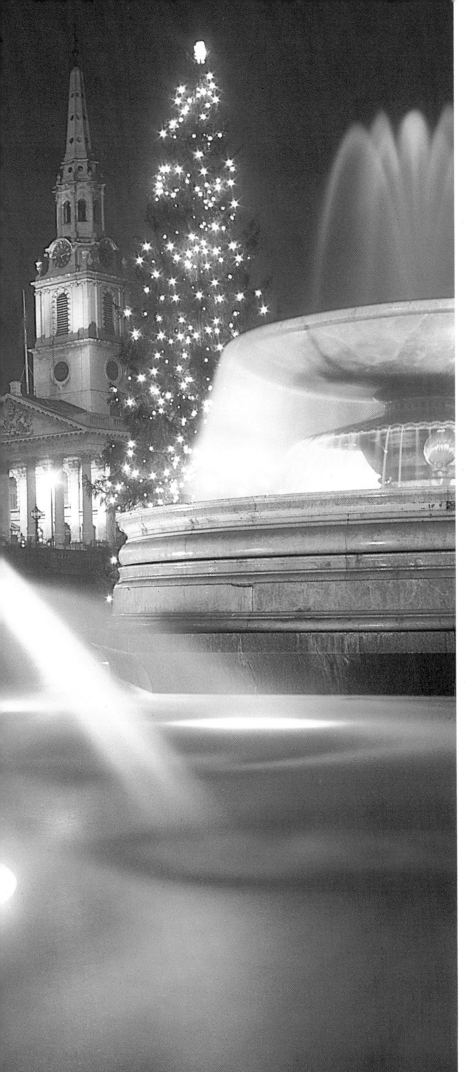

Chapter 4

USING LIGHT

Everything you do as a photographer depends on light, for it is the action of light on the silver halide emulsion of the film that actually makes the photograph. Light is a form of electro-magnetic energy that either radiates from or is reflected by objects, and thus enables us to view the world around us; when light is directed at the photographic emulsion it produces, after chemical treatment, a permanent, visible image. The light we perceive, however, is only a narrow portion of the total electro-magnetic radiation. On one side of the visible spectrum is the short-wavelength radiation, known as ultraviolet and, on the other, the much longer-wavelength radiation, infrared.

The pioneering photographers of the mid-nineteenth century worked under two severe disadvantages – slow lenses and slow film. In 1840 Josef Petzval introduced a new, f 3.6 lens, which reduced exposure time to approximately one minute, but the light source for the exposure had to be the full glare of the direct sun. Faster emulsions, which appeared toward 1850, meant that softer, less-direct sunlight could be utilized without pushing exposure times back up to unacceptable levels. The first photographic studio in the world to use electric light as the only source of illumination was opened in Regent Street, London in 1877 by H. V. de Weyde.

With modern lenses and emulsions it is possible to take photographs under lighting so dim as to be thought impossible by the Victorian practitioners, but to take good pictures requires no less skill. The first step is to observe consciously the changing quality of light and the way it affects the appearance of everything around us. This is not an exercise just when you are taking photographs, but something you do all the time. Look at the way different lighting conditions change the way your friends look, look at the building you live or work in. See how its appearance changes as the sun moves across the sky, illuminating it from different angles. Sometimes these differences become more apparent if you look at just a detail: a particular architectural feature might be invisible at midday when high, overhead light casts strong top shadows; at mid afternoon, however, more oblique lighting might throw it up into high relief.

In the city it is often difficult to stand far enough back to take in the façade of an entire building. Look instead for the time when the light most accurately reveals an aspect of the building's character. If you watch how the changing light alters the appearance of objects, you are halfway to taking photographs in artificial light and in the totally controlled environment of the studio.

Sunlight

The principal source of light for the photographer is the sun. There are many other ways of illuminating the subject, but none that gives you the freedom and flexibility of sunlight. The quality and quantity of light emitted by the sun is constant; weather conditions and the ever-changing angle of the Earth in relation to the sun alter the quality and color of this light considerably. The photographic process is extremely sensitive to these changes and matching the quality of the light to the subject is an important aspect of photography. It may be necessary to revisit a place frequently and wait until the light conveys the atmosphere you feel is most appropriate for the picture.

Time of day

In the morning or evening the sun casts long, descriptive shadows, often diffused or softened by mist or haze. Sometimes in winter, a few hours before sunset on a clear day, you see the stunning effect of a low sun, very bright in the sky creating sharp-edged shadows and glowing colors.

At midday, when the sun is overhead, short, harsh shadows are created. The traditional advice to photographers is to avoid taking pictures at this time of day. Presumably it is thought that photographers only want to take flattering or 'romantic' pictures. But there is no such thing as 'bad' or 'good' light; provided that there is enough light to make an exposure, it is either appropriate or inappropriate for the subject.

The color of sunlight
At sunrise and sunset **below**, *rays of light from the sun travel through a thick layer of atmosphere, thus causing shorter blue wavelengths to scatter and leaving red predominating.*

Winter sunlight
A low winter sun, an open blue sky and a dramatic city skyline, **bottom**, *for a perfect backdrop for this picture of New Yorkers skating in Central Park.*

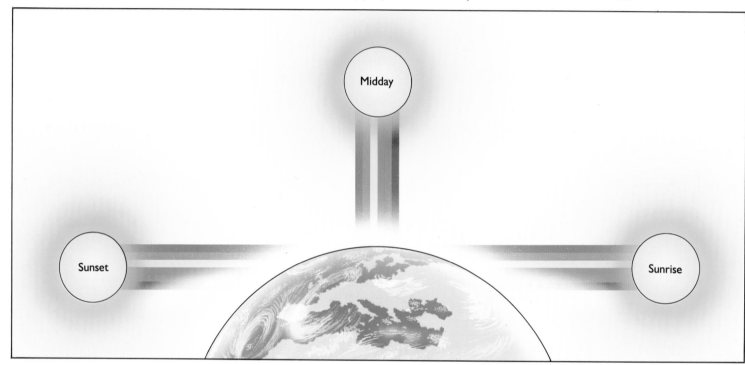

1

2

3

Light through the day
Early in the morning (1), mist and a low sun produce a soft, shadowless image. At midday (2) contrast increases and becomes more distinct. Toward sunset (3), the mist has gone and the low sun casts longer shadows. Notice, too, how colors intensify.

Removing a color cast
In certain weather conditions where, for instance, the scene is illuminated solely by blue skylight, a corresponding color cast on all light-colored objects, **above right**, is almost inevitable. Certain brands of film will also over react and accentuate this effect. Under such conditions, use an 81A filter to remove the blue cast, **below right**, and generally warm up the whole scene.

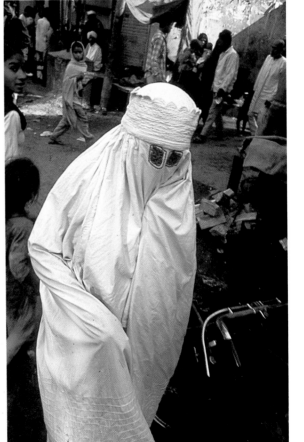

Oblique sunlight
When the sun's light rakes across an object, **right**, it is very revealing of surface texture. The design at the top of this brick structure in Burma becomes more tangible as the sun illuminates the raised areas, which, in turn, cast shadows over the lower lying parts.

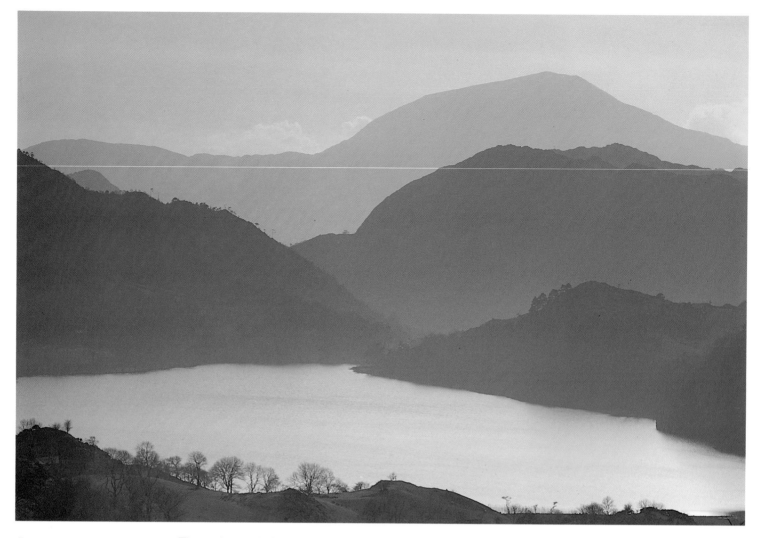

Evening light
This picture has been taken through a graduated red filter, which has darkened the hills in the middle distance and turned the distant ones a warm red. Without a filter, the distant hills would have appeared bluer and paler than those in the foreground.

The angle at which light illuminates the subject is an important factor. Light striking objects at an oblique angle will reveal any surface texture, creating tiny shadows at each minute elevation and depression. But the position of the sun is not the sole influence; by changing the camera position you can, in effect, change the direction of the light. Imagine walking around a tree late in the afternoon. At one point the light will be behind you casting shadows on the far side of the tree where you cannot see them (your own shadow, of course, will be visible). When the sun is at right-angles to you, every surface of the tree will cast complex shadows. When you look toward the sun, the silhouette only of the tree will be visible. Take great care not to look at the sun through a camera, especially an SLR fitted with a telephoto lens as you could permanently damage your eyesight.

The color of light

We are all aware of how the color of sunlight changes throughout the day, although we adjust easily to this change and tend to see objects as the color we know them to be. Unless the sun shines directly on it, a white building, for example, appears white at any time of the day and in any weather. If, however, you photographed the same building on slide film in late afternoon sunlight, it would look quite yellow in color. In midday sunshine it would look white and on a cloudy day, more blue.

In the morning and evening the low angle of the sun means that light must pass through a greater volume of

the atmosphere, which tends to absorb and scatter the shorter blue wavelengths, leaving the longer red wavelengths of light almost unaffected. Clouds produce the opposite effect – absorbing red light and leaving a greater proportion of blue light.

Light and film

If you are using color transparency film you may want to filter the light in order to reduce excessive color casts or, less often, to increase them. Daylight-type color transparency film is manufactured to reproduce a subject's colors naturally when it is lit by a noonday sun. Transparencies taken in the morning or evening, therefore, show the more reddish coloration of the light at that time of day. This effect is usually quite pleasing and deliberately sought by photographers. Not so pleasing, however, is the blue cast often associated with dull days or when the sun has set. If you want to convey more the way dull weather appears to the naked eye, then you must filter out some of the blue light using a reddish filter (see pp. 90-1). Even on bright days, shadows in pictures are lit almost exclusively by blue skylight and not by the 'white' light of the sun. Again, filters can be used to produce a more realistic picture without too strong a blue cast.

In coastal areas and at high altitudes, a blue color cast can be created by excessive ultraviolet light. On black and white film the effect of ultraviolet light makes distant mountains appear slightly unsharp. This is because only

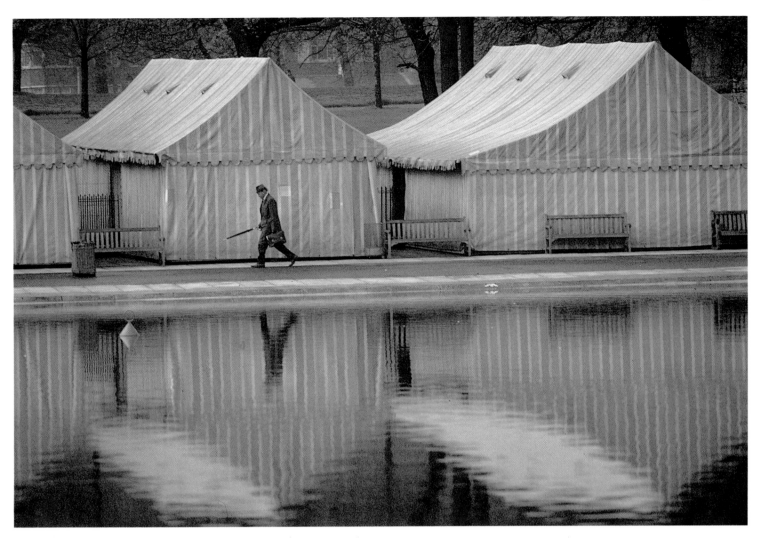

the film's top blue-sensitive layer records UV. The other layers, which form records of green and blue light, are unaffected – causing a shift toward blue when there is a lot of UV. The color cast associated with ultraviolet light is usually strong enough to destroy subject detail.

To a degree, the color rendition of modern slide film is dictated by fashion. Although manufacturers state that slide film is balanced for accurate color reproduction in midday light, they soon discovered that their customers preferred pictures that made white skin look suntanned. Since then, amateur slide films have been weighted slightly to produce this result.

Coping with the weather

The changes that occur as the sun moves across the sky are predictable; the other major influence on the light – the weather – is not.

When light passes through a layer of thin cloud, tiny drops of water within the cloud scatter the rays of light. This softens the hard edge of shadows and reduces the brightness of highlights. Thus, the difference between the lightest and darkest parts of the subject is reduced. As the cloud thickens, the light becomes softer, or less contrasty until shadows eventually disappear. The sky, in effect, acts as if it were a giant reflector. Instead of light coming from one point – the sun – the whole of the sky illuminates the subject. As a result, objects appear less three-dimensional and surface texture is not as readily revealed as it is in sunlight.

These are the conditions that can produce wonderful pictures. Once you have worked in this soft, muted light, you will lose forever the notion that photography is a 'fair-weather hobby'.

At certain times of the year, mist is quite common and has the effect of softening the outlines of objects. As well as softening shape, mist also diffuses color, making it appear to glow in a sometimes unearthly manner. In heavy mist or fog visibility is greatly reduced, so only objects close to the camera will record, and these against a background receding into gray. Exposure can be a problem in these conditions. Light meters tend to read the scene of scattered white light as being much brighter than it in fact is.

If you are photographing in hot, arid parts of the world, dust-storms can be a problem. Sometimes the direction of the wind is indicated as streaks across the photograph. The degree of visibility can change rapidly – one minute you will not be able to see your feet and then, suddenly, visibility may open up briefly as the wind veers and backs.

In such conditions, your prime concern must be to protect your camera. Dust, especially when driven by the wind, can penetrate the camera body. If you are suddenly caught in a dust-storm, immediately wrap something around the camera or place it inside your clothing. If you expect to encounter these conditions, complete camera protection can be had using specially designed plastic bags intended as under-water housings for still cameras. Do not, under these circumstances,

Overcast light
*With the sun's form-defining rays obscured by thick cloud, as in the photograph **above**, the scene takes on a delightfully flat, two-dimensional appearance. Color is suppressed also as scattered blue light illuminates the whole view.*

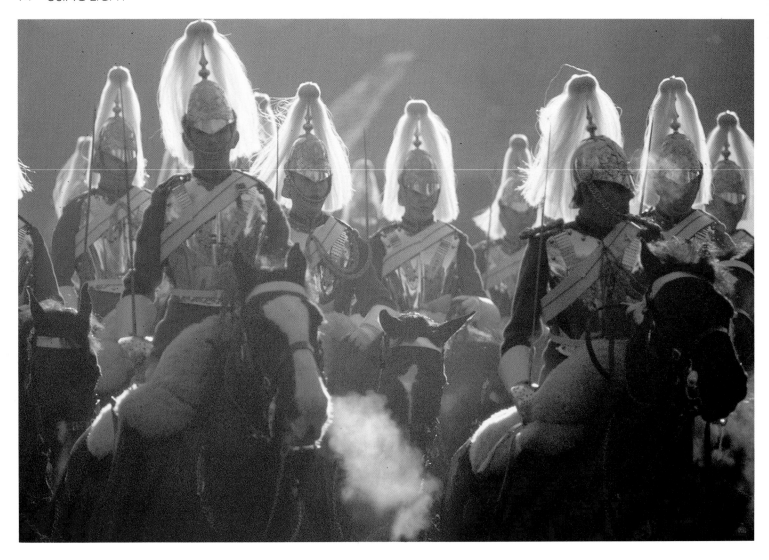

Early morning mist
The first rays of the sun backlight plumed helmets as soldiers, in full ceremonial uniform, ride out across a misty Hyde Park, London.

open the camera to change films or change lenses.

When the rain starts most people put their cameras away and move inside, but if care is taken to protect the camera, beautiful pictures can be taken at these times. Rain softens the light and lowers visibility, but you cannot always tell when looking at a photograph that it was taken in the rain. Slow shutter speeds are most likely to record rain as streaks across the picture. More revealing can be close-ups of rain splattering into puddles or lakes and ponds, breaking the surface and creating ripples. Rain on window panes can also be evocative, and in cities or towns the wet roads and pavements can reflect and return the light of shop windows and illuminated signs, forming reflections in totally unexpected places.

Snow is easier to record than rain, since the snowflakes are larger, slower and reflect back more light.

Rain
As long as you take reasonable precautions, there is no reason why you shouldn't take pictures in the rain. A sudden downpour caught this Indonesian, with his tricycle heavily laden with timber, pedalling furiously through the near-deserted streets of Jakarta.

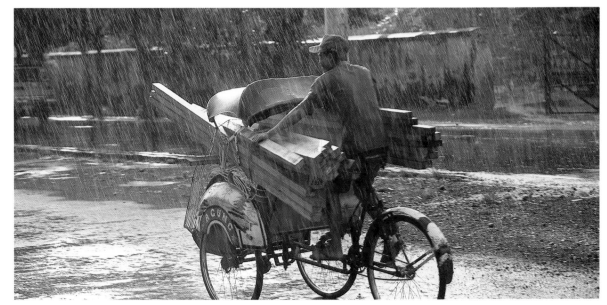

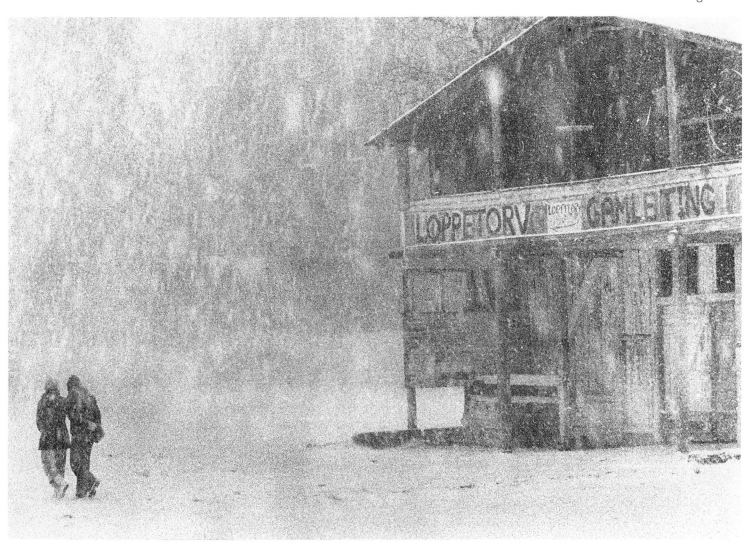

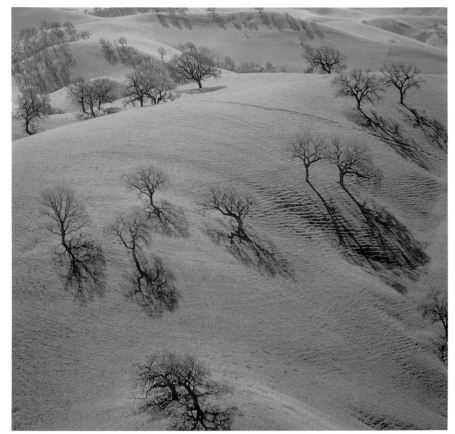

Interesting effects can be achieved by using flash and daylight combined. The flash light records the snowflakes near the camera as sharp but farther away from the camera, where the flash light is weak, they record as streaks illuminated by daylight. As with mist and fog, light meters tend to give misleading readings of snow scenes, and it is best to give half a stop more exposure than is indicated.

So far in the book, shadows have been discussed as being part of the picture only, which, if too deep, cause contrast problems for the film. Sometimes, though, the entire picture will be in shadow, which can for many subjects be a beautiful type of illumination. Shadow light is extremely even and surface texture is suppressed. You have to rely instead on the tones and colors of the subject to make an interesting composition. Most photographers do not explore the qualities of this type of light, which should make your attempts even more eye-catching.

Shadows
Often, shadows can be as important in a photograph as any other subject element, as in the scene on the **left**.

Snow
Pictures taken in falling snow, **above***, are usually brighter than you imagine and can cause metering problems.*

Window light

The major advantage of using window light, or existing room lights, is that you can work unobtrusively without flash or studio lighting. The problem with window light is that it tends to be extremely uneven.

Film and eye difference

When you look at a room you can accept large differences between the light and the dark areas because you only examine small areas at a time – you can look into a shadow and then at a highlight and see detail in both. The information is then put together to construct what seems like a continuous impression of the room.

The film, on the other hand, has to record both bright and dark areas simultaneously and, compared to your own impressions of the same scene, the results seem to exaggerate the uneven nature of the lighting. For this reason it is more difficult to evoke the atmosphere and appearance of an interior view compared to an outdoor subject illuminated in a more general way.

If you are not looking for entirely natural or realistic photographs, your experiments with window light should be aimed at emphasizing the differences between film results and normal vision. The best way to understand the problems associated with interior natural light is to take photographs by window light in your own home and then compare the pictures with the same view in the same or similar light. Choose a room lit with bright sun shining through a window and another room lit by a window facing away from the sun. Use an ASA/ISO 200 color negative film and take a picture from the back of the sunlit room looking toward the window. Take a reflected light reading and expose as indicated by the meter. Take a second picture from the same spot, but give two stops extra exposure. Take a third picture and give this an additional two stops exposure (four stops more than the first). Now stand with your back to the window looking into the room and take a picture in each room at the exposure indicated by the meter.

In the first picture of the sunlit room looking toward the window the interior will be very dark and the view outside the window will be correctly exposed. In the second picture (+2 stops) the view outside the window will be too bright. The interior will also look lighter but it will still be darker than you experience it. In the third picture (+4 stops) the interior will appear a little more natural but the areas lit by the sun will be completely bleached out, featureless white. None of these three pictures actually describes the room as you saw it; either

Excessive contrast
The three pictures **right** *illustrate the problems of dealing with high-contrast window light. The* **top** *picture was exposed for the outside view. An extra two stops,* **center,** *has brought out some interior detail, but another two stops,* **bottom,** *was necessary to record the room accurately.*

Reduced contrast
The two pictures **opposite** *show how standing with your back to the window light can reduce contrast between highlights and shadows and produce much more revealing and satisfactory results.*

the light areas are too bright or the darker areas too dark. The picture taken with your back to the window will look much more natural. Reorientating the camera in this way has reduced the contrast between the darkest and lightest areas and, as a result, the film is able to record them both quite accurately.

Next look at the picture taken in the room lit by indirect sunlight. It will probably have a slight blue cast, and you might be surprised by how well it came out, despite the long exposure required. The quality of light will be distinctly different to that in the first room, and it is this softer, more gentle light that is so popular with photographers and painters.

Evaluating the test results

It is worth making this test because it shows clearly the different ways camera and film and the eye and the brain see the world. Your results will vary a little because the size of the windows and the colors of the walls will influence the lighting. You will also have the chance to compare photographic color reproduction with the real thing. You will probably be surprised at how different they are; although viewed away from the subject they will probably look acceptably natural. The variation in lighting quality at both camera positions will be clearly shown in the pictures.

Use this test to help you choose a camera position that will avoid disappointing results. By studying the results you should be able to make better decisions about where to position family or friends in their home environment when taking photographs. The newcomer to working in this type of light is inclined to photograph people where the light is strongest – adjacent to a sunlit window, for example. This test suggests that a better position might be at either the back of a sunlit room or near a window lit by indirect sunlight. In both cases, the light may be weak and shutter speeds slow, necessitating a tripod. The introduction of high-speed color films, such as ASA/ISO 1000 and 1600 types, however, should allow reasonable exposure times even in this light. The photographer using black and white has had the advantage of film of this speed for many years (see pp. 44-9).

Coping with window light

If you include a sun-filled window in the picture, care is needed with the exposure. A close-up or selective reading of an important subject area will give an accurate indication of exposure. If you are taking pictures at the front of the room you can soften the effects of the light by drawing net curtains if available; alternatively you can wait for a cloudy day which will also reduce contrast. If you are taking a portrait or still life in contrasty light, you can improve results by making use of a reflector, which can be as simple as a piece of matte-surfaced white cardboard. Position the card on the dark side of the subject so that it returns light into the shadows and so brightens them a little.

In the type of room lit by indirect sunlight things are much simpler, and you have the chance to take fine pictures with no more equipment than your basic camera. The light near this window is similar to that found in a north-facing studio. Studios were traditionally

illuminated by roof windows facing the northern sky, and a large window illuminated by indirect skylight has a similar quality. Renowned photographer Irving Penn wrote in the introduction to his book *Worlds in a Small Room*: "I share with many people the feeling that there is a sweetness and constancy to light that falls into a studio from the north sky that sets it beyond any other illumination. It is a light of such penetrating clarity that even a simple object lying by chance in such a light takes on an inner glow, almost a voluptuousness... Electric lights are a convenience, but they are used, I believe, at the expense of that simple three dimensional clarity, that absolute existence that a subject has standing before a camera in a north light studio."

Your north-facing studio does not have to be indoors – you could just as well photograph outdoors against a north-facing wall. There will be more light outdoors and it may be easier to hang a backdrop if this is required. The most practicable backdrop is a roll of cloth placed behind the subject. The width will depend on the type of pictures you intend to take.

Window light portraiture
Directional window light was used to take the portraits **above left.** *The first picture shows unacceptable contrast, which was reduced for the second shot by use of a reflector held on the shadowy side.*

Large windows
The warm glow of evening light streaming in through particularly large stair windows has not created too severe a contrast problem, except in the very highest corners, **far left.**

Dancers
In large rooms, the directional quality of window light can act as a spotlight, **left,** *isolating your subjects.*

Color or black and white
For indoor candid shots in public places, you will almost certainly have to rely solely on window light. Choice of color or black and white depends on the type of atmosphere you want to convey — film speed shouldn't be a problem with either type. Both these pictures, **above** *and* **right,** *have used the bright highlight window areas as effective compositional elements.*

Compensation processing

Film development times can be adjusted to compensate for unusually hard or soft light conditions, and this is dealt with in greater detail on pp. 96-9. An explanation is given here because an adjustment to development time to compensate for these lighting conditions also requires an adjustment to the film exposure times.

Development times for all types of film assume a subject of average contrast. If development times are increased, the negative or slide will be more contrasty and dense. If development times are decreased the negative or slide will be softer and less dense. In harsh or contrasty light, you can improve the quality of the final picture by reducing the development times.

To compensate for the lack of density of the final film image, however, you must increase exposure. Negative films, black and white and color, used in contrasty light should be given twice as much exposure by rating the ASA/ISO speed at half the manufacturer's recommended setting. Color slide film can be half a stop overexposed.

If you process your own films, see the chapter on the darkroom to determine the new development times. If you use a photographic laboratory, tell them how much extra exposure you have given the film.

If the lighting at the time of exposure is particularly soft, you should reduce exposure by half with all types of film and then increase development times. The extra development will help to increase image contrast and provides additional density.

In soft, low light, the gain in film speed may be as important as the increase in image contrast. When working in soft, low-light conditions, you can 'up-rate' the film speed to allow a more suitable exposure. Films designed for use at ASA/ISO 200 and 1600 may be up-rated by two-thirds of a stop and with extra development there will be more density in the shadows, mid-tones and highlights. Using special developers you can decrease the exposure by two stops, changing an ASA/ISO 400 film to ASA/ISO 1600, but there will be an increase in density of the mid-tones and highlights only. The shadow areas will not record any extra detail. It is important to take this into account when you compose the picture. The additional development times will increase the grain size, but this is often quite suitable for certain subjects photographed in low light.

Unusual light sources

The availability of high-speed color and black and white films means that there is now virtually no light source too dim or unusual for the photographer to take advantage of. If you use color transparency film balanced for daylight you must expect color casts on your resulting slides, but these can be considered an attractive feature if associated with an appropriate subject. Though color negative film will always give best results when used with filters matching its sensitivity to the light source in use, it is usually sold for use with either daylight or artificial light; any color casts are corrected at the printing stage. Black and white photographers are not concerned with such matters.

Household light bulbs

If you use fast film, household light bulbs provide sufficient usable light. You will probably obtain the best results if you limit your view to an area close to the bulb. Because of the color differences between household bulbs (which look orange on daylight-balanced slide film) and daylight, you have to take care not to mix both light

Fluorescent tubes
The green color cast is typical of this light source, **below.**

Car headlights
Don't ignore any light source for unusual effects, **right.**

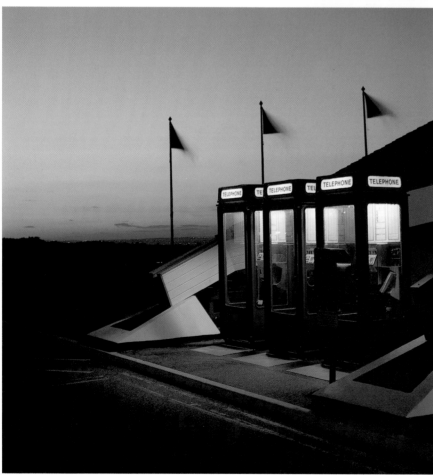

sources in the same picture, unless you want an unrealistic effect.

For natural-looking color slides you should use a film balanced for tungsten (studio) light, such as 3M 640T. Pictures on this film illuminated by household bulbs will be slightly orange. This cast is usually quite pleasing, but it can be removed using the appropriate blue filter over the camera lens (see pp. 90-1).

Fluorescent tubes

This type of lighting is now common in many public places and in areas of the home that require bright, even illumination. From a photographic point of view, the problem with fluorescent lighting is that it does not produce a continuous spectrum of colors as the sun and most other artificial light sources do. Instead it produces bands of colored light that look white to our eyes but not to color film. Tubes of different manufacture give different color casts and so only partial correction by filters is possible. Color negative film can be corrected at the printing stage, but for color slides, a 30 Magenta color correction filter is usually necessary for acceptable results.

Street and fire light

Both of these sources of illumination produce unpredictable results and require the use of a fast film. Street lights vary considerably in their color content and it is difficult to recommend any brand of color slide film that will

cope with all the variations adequately. If you get the chance, it is worth running a test film through the camera of different street light sources in your area. Kodak's RE2475 black and white high-speed film is a good choice because it has an extended sensitivity to red light, which is often a large component of street lighting.

Fire light can produce exciting images, but you must remember that brightness diminishes rapidly as you move away from the fire itself. The best pictures will probably be of people arranged around the fire.

Moonlight

Impressive pictures can be taken by the light of the moon on a clear night. If there is sufficient light to register a reading on your meter, hold a piece of white card so that it receives the same amount of light as your intended subject. Measure the light reflected from the card and make your first exposure three stops more than the light reading indicates. Follow this with two more pictures, increasing the exposure by one stop each time. A tripod will be essential and a small torch may be useful to allow you to see the camera controls.

If you wish to take a photograph of the moon itself, bear in mind that it is a sun-lit object and a brighter-than-average subject. Therefore, increase exposure to record detail and prevent it looking gray, in much the same way as you must increase exposure for snow scenes. Take one picture giving half a stop more than the indicated reading and another giving one full stop more.

The moon often appears much smaller in the picture than the photographer expects. Its actual size on the negative or slide can be determined by the following rule: the focal length of the lens divided by 100 equals the size of the moon in millimeters on a 35 mm negative or slide. With a standard 50 mm lens, for example, it will only be 0.5 mm in diameter; with a 500 mm lens it will appear as a disk 5 mm in diameter. A long focal length lens extended further with a tele-converter will produce a good result, although telescopes can be attached to an SLR camera with a special adaptor.

Full moon is, however, often not the best time to take pictures of the lunar surface with a telescope. The bright, frontally lit surface will appear flat and uninteresting. The oblique lighting provided by the sun as the moon waxes and wanes is more revealing of surface features.

Mixed light sources
For the picture of the Moulin Rouge, Paris, **top**, colored fluorescent tubes and domestic tungsten seem to symbolize the fun and gaiety of this famous venue.

Stage lighting
This form of lighting, **above**, is always unpredictable, but shots such as this are well worth taking a chance on.

Studio lighting

Once you take direct control of lighting it is possible to influence the key element of the picture. There are many specialized fields of studio lighting and the approach suggested here is one designed to help you develop your own style of portrait and still-life lighting.

Our whole concept of studio lighting is conditioned by our experience of working with the sun to take photographs. There is no need to imitate slavishly the lighting qualities produced by the sun, but it is a good basis for your first experiments.

Equipment

Either electric lamps or flash equipment can be used. The obvious difference between them is that electric lamps provide continuous light while flash produces a rapid burst of light. Color 'temperature' also differs. This describes the proportion of red to blue light. With studio tungsten light, the blue end of the spectrum is suppressed and red predominates. With flash the spectrum more .closely conforms to that of sunlight and has a higher blue content.

Working with a flash unit, it is not possible to see how the subject has been illuminated since flash duration is so short. Expensive studio flash units have built-in lamps which do not affect exposure but do give an indication of the lighting effect. With low-cost simple studio lamps you have the advantage of being able to see immediately if the effect is what you want and that there are no unattractive shadows being cast.

As a first purchase, a floodlight (which produces a wide beam of light) and a spotlight (which produces a narrow beam of light) are your best choice. You will need adjustable tripods or stands for both these lights. Make sure the lamps provide light of the same color

Color cast
This picture was lit by a daylight-balanced spot and tungsten-balanced flood.

Lighting equipment
All the main pieces of studio lighting equipment can be seen **right.**

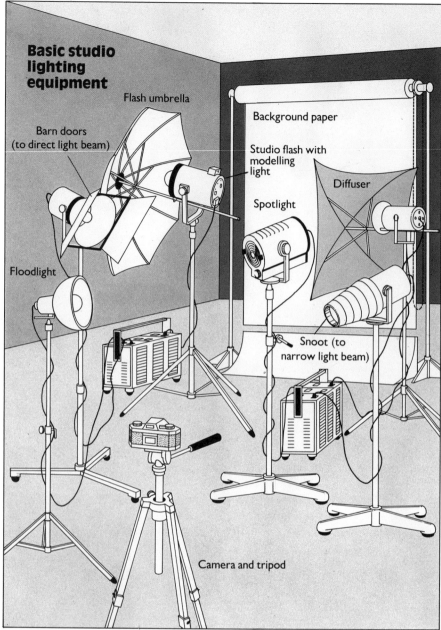

Basic studio lighting equipment

Flash umbrella

Barn doors (to direct light beam)

Background paper

Studio flash with modelling light

Diffuser

Spotlight

Floodlight

Snoot (to narrow light beam)

Camera and tripod

temperature, or when you use them together in the same shot you will notice color casts. A 'warmer' lamp describes one that is redder in output. In addition, you will also need two rotating frames – one to hold an A2 sheet of white card and the other to hold a similar-sized piece of tracing paper. These frames you can make yourself to save money, and the tripods can be replaced by lamp stands if you prefer.

The white card, which should be matte rather than glossy, is used in two ways. First, it can be placed on the shadow side of the subject at an angle that reflects light into the shadows to lighten them. This reduces the contrasts between the lightest and darkest parts of the subject. Second, the card can also be used to soften the principal light. The spot or flood is directed at the card, which reflects the light at the subject. This is known as bounce lighting, and is softer and more delicate in its effect. The degree the light is softened depends on the distance between card and lamp. When the whole of the card is evenly illuminated, the light will be at its softest.

The tracing paper held in the frame is used to diffuse the light. It is placed between the lamp and subject so

Basic lighting schemes

A surprising number of lighting effects are possible using a floodlight, spotlight, diffuser and reflector. Using a single floodlight (1) from the right-hand side of the model produces excessive contrast, which has been largely relieved by the addition of a diffuser (2). A better-balanced picture results from using direct floodlight with bounced light from a spot reflected into the shadows (3). With the spot used as the only light source (4), contrast is impossibly high, and a much better picture is obtained by bouncing the spot from a reflector (5). For the final shot (6), fill-in floodlight was added and now the face is probably a little overlit. These are very basic schemes that can be experimented with in any home studio.

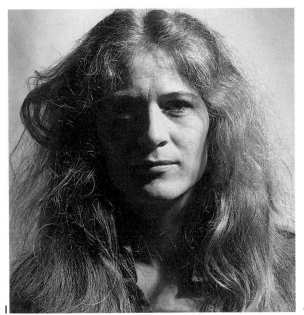
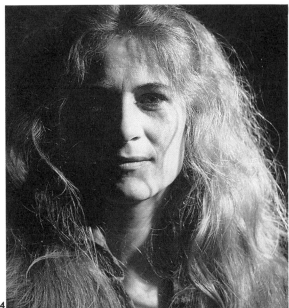
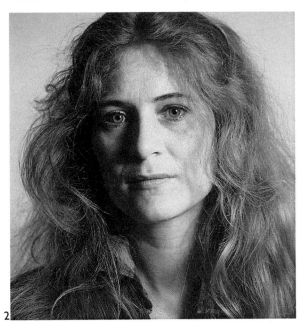

Unusual pose
*One of the challenges of portraiture is to bring out the character of the sitter. In the example **opposite**, a broad lighting scheme allowed the subject the freedom to move around the set and choose his own, rather unorthodox pose.*

High-key lighting
*By restricting the tonal or color range of your picture, as in the example **below**, you can make more of an impact by using just a little contrasting color.*

that the light shines through the paper. The effect is similar to sunlight passing through cloud. You can add extra layers of tracing paper to soften further the effect. Take care not to place the paper too close to the lamp. Studio lights produce a lot of heat, which can cause the paper to burn or singe.

If you wish to photograph still-life or portraits against a colored or neutral background you will also need a back cloth or a roll of special background paper and the supports to hang it from. If you do not anticipate using this equipment frequently, you could share the costs with interested friends. Most people find it useful working in a small group while they learn the basic skills of studio lighting techniques.

Lighting techniques

If you have formed a group you can practice studio lighting techniques by taking portraits of each other. Three people is a good number – one to pose, one to stand at the camera position and one to move the lights. Do not use a camera to start with, just look at the different effects you can obtain by moving the lights.

Take it in turn to sit at the camera position, about 6 ft (2 m) in front of the model. The 'assistant' should hold the lamp about 3 or 4 ft (1 m) above the model's head and move the lamp in an arc from side to side. The person at the camera position should look for the moments when the lighting angle most compliments the model's face and expression. Later on the lamp will be repositioned at these places for the picture.

Next, make a second arc around the model about halfway between the model and the camera and note the effects. Finally, stand immediately behind the camera position and move the lamp in an arc about the camera lens axis.

With just these three basic lighting positions, a wide range of lighting effects should have been observed. Now choose one of the lamp positions you liked and place the lamp on the stand at the angle to the subject – this is now the main light. If you intend to use other lights, these should not be strong enough to cast a second shadow on the subject or set.

You next have to assess the contrast of the light, and again bear in mind the limited ability of the film to record detail in a wide range of tones. The light from a flood aimed directly at the subject will create dense shadows lacking in detail. Make an exposure using this set-up – there may be occasions when it is appropriate. If you have a hand meter, take a reading with the incident attachment over the cell. Studio photographers often prefer this method but a normal reflected light reading with a built-in meter will be just as good if a selective measurement of an important subject area is made. Make a careful record of the position of the lamp and write this on the print later. For these experiments, a black and white ASA/ISO 400 film is adequate.

To soften the light, place the tracing paper diffuser between the lamp and subject so that the beam of light illuminates the entire screen of tracing paper. Take a second picture to demonstrate the effects. Then place the white card on the shadow side of the subject so that it reflects light into these areas and take your third picture. The closer the card is to the subject, the lighter the shadows become, but make sure it stays out of view of the camera.

The spotlight as main light

The spotlight used directly on the subject produces extremely harsh results. It can be used when you want to suppress detail and produce black and white tones only; bounced off a white card it gives more conventional results. Place the white card at one of the positions you favored when experimenting with the floodlight and then direct the spot at the card so that it illuminates the subject. For a more three-dimensional effect you will have to lighten the shadows a little, and the floodlight can be used for this. The flood has now become the fill-in light, and it should be placed at a distance far enough from the subject so that it does not cast its own shadow. The fill-in can be improved by diffusing the light through tracing paper.

Experiments with studio lights can continue indefinitely. Sadly, many people learn to rely on a few lighting angles and use them regardless of subject. It is necessary for the photographer to be curious and to explore new lighting effects each time a picture is made.

Flash effects
A slow shutter speed, high ambient light levels and flash were used above to combine blurred and frozen subject detail.

Flash head
The back of a modern flash head displays all the information you need.

Flash lighting

Flash light has many applications, from taking pictures in the dark to freezing subject movement. Unlike studio tungsten lighting (see pp. 82-5), flash light is the same color as daylight and it can, therefore, be used in conjunction with daylight for a variety of effects.

When an ordinary sunlit picture contains important detail in both highlight and shadow areas, flash can be used to reduce subject contrast. Used in this way, it is possible to record detail in both highlights and shadows of the subject and the resulting photograph will more closely resemble our impressions of the scene. Flash can also be combined with daylight to produce a less realistic impression of the subject. If, for example, you select a slow shutter speed on a reasonably bright day, you can use the freezing power of flash to record a sharp image of a moving subject as well as allowing the ambient light levels to record image movement while the shutter is still open. A sense of movement is suggested by the blurred detail, while the sharp record of the subject relates the picture to the real world.

Calculating exposure

Read your camera manual to find the maximum shutter speed that will synchronize with flash. This speed is often printed in red on the camera's shutter speed dial, or marked with an 'x' or a lightning bolt. Most flash units have an automatic exposure facility, which measures light reflected back from the subject. All you need do is set the camera to the aperture indicated by the calculator on the flash and when enough light has been received to produce a correctly exposed picture at that aperture, the flash is quenched.

Better flash units have an aperture selection dial. This allows a range of camera apertures to be selected when the flash is being operated in the automatic mode. A calculator dial on the flash will indicate the maximum flash-to-subject distance at each aperture setting. If you select a small aperture for maximum depth of field, the flash will not be able to illuminate subjects as distant as a larger aperture setting would have allowed.

To check that the flash unit is producing enough light for a correct exposure, position the flash and subject for the shot you intend and press the 'open flash button'. This will manually fire the flash. Now look to see if the

'sufficient light indicator' glows; if it does, then the flash is powerful enough for correct exposure. It is especially important to check this when you bounce flash because of the greater distance the light from the flash has to travel to reach the subject.

In the same way as a light meter, the automatic exposure control will give incorrect results when the subject is not of average reflectance. If you are taking photographs of lighter-than-average subjects open up the aperture by half or one full stop. With darker-than-average subjects, reduce the aperture by the same amount.

Flash guide numbers

When you use the flash unit on manual, the flash fires at its maximum output and to control exposure you must use the aperture ring. Apart from synchronizing the moment the flash fires, shutter speed has no effect on film exposure. As well as using the flash-to-subject indicator on the flash unit itself to work out the correct aperture, you can also use the flash unit's guide number, which will be found in the user's manual. This is relatively simple; all you need do is divide the distance from the flash to the subject into the guide number. If, for example, the flash guide number is 110 and the subject-to-flash distance is 10 feet, the correct aperture will be f 11. The guide number alters with the ASA/ISO film speed. Guide numbers are quoted in feet or meters – make sure you measure subject distance using the correct units.

Flash on-camera

Using the flash on-camera emphasizes the harshness of the light, producing sharp, clear-cut pictures that do not resemble in any way the mood and atmosphere of the scene as viewed by the photographer. These qualities can be used to good effect if anticipated. Direct flash obliterates most natural lighting effects and it does not

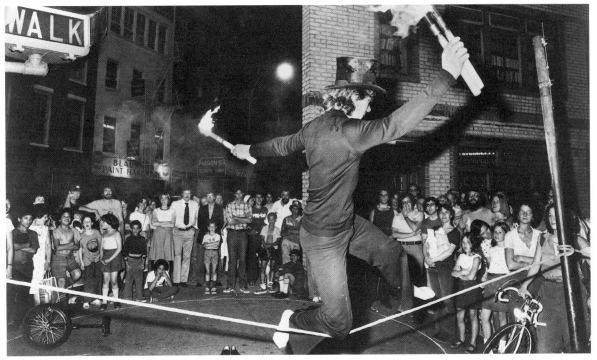

Flash as fill-in
*One of the problems of working with a high midday sun is unattractive shadows, **top**. This has been solved in the version **above** by using weak, diffused flash to lighten the shadow and, therefore, reduce contrast.*

Direct flash
*Outside at night with no reflective surfaces to return the light, **left**, direct flash, although harsh, may be the only way to throw enough light on to the subject.*

Dominant flash

In overcast weather, contrast tends to be extremely flat. One way to enliven pictures taken in such conditions is to use flash as the main source of light, as in the shot **above***.*

flatter or disguise any minor skin blemishes, for example, on your subjects.

For a softer light while using on-camera flash, you can place a wide-angle diffuser over the flash head or you can bounce the light off a reflector that attaches to the flash unit. Both these accessories (see pp. 28-33) alter the light slightly, producing a more gentle quality and a more evenly illuminated foreground and background. Flash units with automatic exposure control work just as well when the flash is pointed directly at the subject or bounced. Because the beam of light spreads and illuminates a larger area when bounced, it is a good idea to test-fire the flash from the lighting position in order to

check that sufficient light will reach the subject. The sufficient light indicator will glow if there is enough light. If it does not come on, set the aperture selection dial to utilize a larger aperture and alter the camera lens accordingly; alternatively, you can shorten the flash-to-subject distance.

Flash as fill-in

This technique allows you to take full advantage of the fact that daylight and flash light have the same color temperature. Its primary use is to reduce contrast in

harshly lit outdoor scenes when you want to use the sun as the main light and the flash to fill in a little detail in the more shadowy parts. Using flash as a fill-in often makes photographs appear more natural, since the eye can accommodate more contrasty scenes than film can.

First, take a light reading of the brighter areas of the scene and set the camera's aperture and shutter speed (taking care to select a shutter speed that synchronizes with flash). If you took the picture now the bright areas would be recorded correctly but dark areas would lack detail in your picture. The idea is to now use the flash to lighten the dark areas so that detail is recorded, but without losing the shadows altogether. You can do this in two ways. With the flash on automatic, use the aperture selection dial on the flash unit to choose an aperture one stop less than the lens aperture. For example, if the camera is set to f 8 at 1/60 sec, set the aperture selection dial on the flash to f 5.6. With a manual-only flash unit, you can achieve the same effect using your unit's guide number. Take a light reading of the brighter areas as above and divide the guide number by the aperture you have set the camera lens to. This will give you the flash-to-subject distance for an exposure where flash and daylight are approximately the same strength. Used like this, however, the shadows would be too light for a natural result. To counter this, move the flash gun back half as much again from the subject. This will effectively underexpose the shadows by one stop. So if the camera were set to f 8 at 1/60 sec and the guide number were 80, you would divide aperture into guide number to obtain 10 as your result. Next add half as much again to this result (5) to obtain a flash-to-subject distance of 15 feet. The flash at this distance from the subject will leave the shadows looking like shadows but it will lighten them sufficiently to reveal detail in a realistic way. With an extension lead, the flash can be used off-camera if you wish to move in closer to the subject.

Invisible flash

With infrared black and white film it is possible to take 'invisible' flash pictures. To do this you need a Kodak Wratten 87 filter, Kodak High-speed Infrared film and your usual flash unit. Carefully cut the filter to the size of the window of the flash head and tape the filter in place so that the window is completely covered. Test-fire the flash with the filter in place and you will notice a dull, red flash, which will hardly be noticeable at night. The filter absorbs the visible light emitted by the flash and transmits only the invisible infrared wavelengths, which reflect back from the subject in the normal way to expose the infrared-sensitive film. Remember that when using infrared film that the subject is focused slightly farther away from the lens. To compensate for this, most lens manufacturers print an infrared focusing index on the lens barrel. After focusing the image by visible light, note the distance focused on and turn the focusing ring until the infrared compensation index lines up with the prefocused distance. When using a normal or wide-angle lens at a small aperture, the inherent depth of field will compensate for any minor focusing errors.

Black and white infrared pictures have an intriguing quality, which resembles our impression of the scene when viewed in low light. The film records much less detail when compared to ordinary black and white film. Infrared film is about as grainy as ASA/ISO 1600 film and because infrared light is reflected back from the wet layer of the skin just below the surface, skin tones are particularly attractive. Faces seem to glow as they do in candle light or low-powered domestic tungsten lighting. Another important application of infrared film and flash is when photographing shy, night-time animals. Assuming you can set up your equipment without the animals realizing, you should be able to take flash pictures without the subjects being aware of your presence.

Invisible flash
To take pictures of shy nocturnal animals without alarming them, or simply to change an ordinary domestic scene into something special, as in the example **below***, you can tape a Kodak Wratten 87 filter over your flash window and shoot on black and white infrared film.*

Filters

Although light is at the very heart of photography, by using filters it is possible to influence some of the qualities of the light source. Photographic filters fit on the front of the lens. The simplest and most common filter is colorless and designed to absorb ultraviolet radiation, which both black and white and color film respond to, but which is invisible to the naked eye. Ultraviolet filters improve the clarity of distant views and can be left on the lens permanently to protect the delicate front element from dust and abrasion.

Filters for color

The human eye is very tolerant of different types of illumination. A sheet of white paper viewed in the yellowish light of a tungsten lamp will appear just as white as when viewed in daylight. Daylight slide film, however, will record it as yellowish in tungsten light and as white in daylight.

In color photography, filters are often used to alter the color balance of the light entering the camera so that it matches the type of color film in use. These are known as light-balancing filters and they will allow you to use a daylight-type film in artificial light or, using a different colored filter, tungsten-balanced film in daylight.

You can also use filters to improve the rendering of colors when pictures are taken in indirect light or in

1

2

3

4

Polarizing filter

*A polarizing filter is one of the few filters you can use with color film without creating a special effect. In the example **left**, you can see an unfiltered picture of grass in a peaty stream. Reflections from the water's surface have obscured nearly all detail, producing rather an indifferent result. For the next picture, a polarizing filter was added to the camera lens and has eliminated all surface reflection, increased contrast and created a much crisper image. Using an SLR, look at the focusing screen while you rotate the filter in its mount, and you will be able to see when the filter is correctly orientated.*

Filters compared

With black and white film, you can use strongly colored filters to produce tonal changes in specific parts of the image. In the unfiltered shot (1), contrast is just sufficient to separate the clouds from the blue sky. With the addition of a yellow filter (2), sky and cloud contrast has strengthened a little and foreground vegetation is better rendered. The next shot (3) is with an orange filter and contrast is stronger still. For the final picture (4) a red filter was used and the blue sky is now very dark and the clouds are looking almost ominous. Foreground vegetation, however, is too dark and lacks detail.

shadow. Photographs taken in shadow, which are illuminated by predominantly blue skylight, will show a blue cast unless a suitable filter is used. Generally, it is better to eliminate too much rather than too little blue; slightly warm colors tend to be more acceptable.

With color negative film, which permits correction of color balance during printing, you have only one problem – that of mixed lighting. It is not possible to make a realistically colored print from a color negative exposed to both tungsten and daylight.

Filters for black and white

In black and white photography, filters are used either to produce pictures that more accurately record the tonal values in the original scene or to emphasize tone for dramatic effect. The guiding principle is that colors similar to that of the filter will be rendered as lighter tones and complementary, or opposite, colors as darker tones. A red filter will darken blue sky and green foliage, for example, but lighten red-colored brickwork. The over-sensitivity of black and white film to blue light presents one of the commonest photographic problems – blue skies will be overexposed and record as white, making clouds almost invisible on the final print. Yellow, orange and red filters, in that order, absorb increasing amounts of blue light, producing a darker tone to represent blue on the final print so clouds are light in contrast.

Filter factors

All filters are graded according to the amount of light they hold back, and the 'filter factor' indicates the amount of exposure increase required to ensure that a picture is exposed correctly. To take an example, a filter marked with a filter factor of × 2 will require twice the exposure, or one extra stop. Or, if you prefer, you can divide the film speed by the filter factor and set the meter accordingly. But remember that cameras with through-the-lens metering automatically allow for the necessary extra exposure. If you can completely cover the cell of an unattached meter with the filter, a similar compensation will be made.

A lens hood should always be used with filters. It will prevent side light flaring off the filter surface.

Special effects filters

Of limited use is the large range of special effects filters. Filters of this type include starburst patterns, parallel multiple images, rainbow effects, soft focus and dual-color filters. Of more practical application is the polarizing filter, which can be used with black and white and color films. It will darken a blue sky, for example, without affecting other parts of the picture and will eliminate reflections from many different types of surface. A useful feature available from some filter manufacturers is the universal filter holder, which fits all 35 mm camera lenses. Once in place on your lens, all you need do is slot the effect filter of your choice into the holder.

Filters for black and white

Filter type	Exposure increase	Effect
Yellow	1–1½ stops	Lightens yellow; darkens blue. Increases sky contrast for more pronounced cloud effects. Removes slight haze by absorbing ultraviolet light. Improves shadow contrast and texture of snow scenes.
Orange	2–3 stops	Lightens red, orange and yellow; darkens blue and green. Lightens the tone of wood, making the dark areas of grain stand out. Penetrates heavy haze and turns blue sky almost black. Subdues skin blemishes and freckles. Enhances surface texture of brick and stonework.
Red	2½–3½ stops	Lightens red and yellow; darkens blue and green. Used for dramatic sky effects – blue sky records as black, particularly when the camera is pointed away from the sun. Cuts through heavy haze. Excellent for buildings against the sky.

Filters for black and white or color

Polarizing	1½ stops	Use to eliminate unwanted reflections from glass and many polished surfaces. Water can be darkened or lightened by rotating the filter. It has good UV absorption and so penetrates haze.
Neutral density (gray)	1–3½ stops	A range of filters in different strengths used to reduce light intensity without affecting tones or colors. Enables exposures to be made at wider apertures or slower shutter speeds. Good UV absorption.
UV and haze	None	Helps prevent slight blue cast on color film without affecting other colors in distant scenes, mountain pictures and snowscapes. These filters only absorb UV light, leaving other tones and colors unaffected.
Skylight	None	Stronger action than haze filters. Removes blue cast in situations as described above and adds a slight warm color to slides.

Conversion filters for slide film

Filter name	Exposure increase	Function
Wratten 80A	2 stops	Use with daylight film balanced for 5,500K exposed in 3,200K tungsten light.
Wratten 80B	1⅔ stops	Use with daylight film balanced for 5,500K exposed in 3,400K tungsten light.
Wratten 81A	⅓ stop	Use with tungsten film balanced for 3,200K exposed in 3,400K tungsten light. Used with daylight film it will correct slight blue cast in open shade or on an overcast day, caused by clouds filtering out warmer colors. Also absorbs excess blue light from electronic flash.
Wratten 82A	⅓ stop	Use with tungsten film balanced for 3,400K tungsten light exposed in 3,200 tungsten light.
Wratten 85	⅔ stop	Use with tungsten film balanced for 3,400K exposed in daylight.
Wratten 85B	⅔ stop	Use with tungsten film balanced for 3,200K exposed in daylight.

Chapter 5

THE DARKROOM

Exposing the film emulsion to light in the camera alters the chemical structure of the silver halide crystals. This change is so minute at this stage that the image carried on the film is invisible, and is known as a 'latent image'. The chemical procedures carried out in the darkroom are designed to amplify the latent image into a visible one, familiar to all photographers as either a black and white negative or, after a slightly more complicated sequence of chemical steps, a color negative or slide.

In the early days of photography, known as the wet plate era, between the mid and late nineteenth century, the photographer had to carry a portable darkroom wherever pictures were taken. Before the camera could be loaded, the light-sensitive emulsion had to be mixed and coated on to a glass plate, and the picture had to be taken before the emulsion dried and then processed immediately afterwards. Taking and processing the picture was all part of a single process.

Fortunately, we can now divide photography into three phases – exposing the film, developing the film and, with a negative film, enlarging the negative to produce a print. Ansel Adams, relating photography to music, said that "the negative is the score and the print is the performance".

Developing film, either black and white or color, is a matter of routine. If you keep carefully to the processing times and use the solutions at the correct temperatures you will produce perfect negatives or slides.

Making prints from these negatives or slides is one of the special pleasures of photography. It is not difficult to learn the skills necessary, and with very little practice you will be able to produce prints that are far better than those churned out by automated commercial photographic laboratories.

It is not even necessary to have a darkroom in order to process film. You can use a special photographic changing bag to load the film into a light-tight developing tank; all processing steps can then be carried out in normal room light. A darkroom is necessary, however, for printing, and you can either convert a room into a temporary darkroom or, if you have the space, build a permanent darkroom in any spare room in your home. Your main considerations are that the room be light-tight and, especially with color chemicals, well ventilated.

Although doing your own processing and printing is time-consuming, the control you can exercise over the way your work finally appears is immensely satisfying and well worth the extra effort. If you can form a group of like-minded friends, savings can be made by always buying the largest quantities of paper or biggest bottles of chemicals practicable. The cost of buying equipment can also be shared as well as the experience of other members of the group.

Printers proof 1/5 R Hamilton

Converting a room

If you can find space in your home for even a small permanent darkroom, this is obviously a better option than rigging up a temporary darkroom each time you want to print your latest negatives. Taking over a room normally used by the rest of the family for an evening or on the week-end can be the cause of domestic conflict.

Building a permanent darkroom

You need two benches in a darkroom – the wet bench and the dry bench. You place the dishes of chemicals on the wet bench and reserve the dry bench for the enlarger. Running water is not essential but it does make printing easier. If possible install a sink in the wet bench even if you cannot plumb it in to begin with. If space is limited, or water pipes not convenient, you can do without this facility.

The size of the wet bench determines the maximum size of the prints you can make. The following dimensions will allow you to make archivally processed folio-sized prints, measuring 12 × 16 in (30 × 40 cm) in Europe and 11 × 14 in (28 × 35 cm) in the USA. Archival print processing extends the processing sequence to give maximum possible stability to the finished photograph. For this, the wet bench needs to be 2 ft (0.6 m) wide by 6½ ft (2 m) long. If you want smaller prints and are not concerned with archival processing, the bench can be 1½ ft (0.5 m) wide and 3½ ft (1 m) long – this is sufficient to accommodate three dishes large enough to process 8 × 10 in (20 × 25 cm) prints. This is the minimum print size because contact prints have to be made on paper this size. Again, you can extend this shelf to include a sink or you can keep a washing-up bowl on the floor and use that to rinse your hands in.

The wet bench can be L-shaped if this fits the room

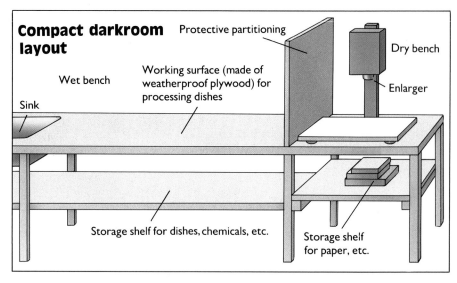

Compact darkroom layout

Protective partitioning
Dry bench
Working surface (made of weatherproof plywood) for processing dishes
Wet bench
Enlarger
Sink
Storage shelf for dishes, chemicals, etc.
Storage shelf for paper, etc.

Simple darkroom layout
The simplest type of darkroom layout is a single, straight bench built against a wall, above. Once constructed, you will need to install partitioning in order to separate the wet from the dry sides of the bench. If you have sufficient space, and pipes are conveniently located, a sink can be incorporated into the bench surface.

Archival processing
The wet bench, below, for archival processing needs to be longer to accommodate the extra dishes. From the right, the dishes are: developer, stop bath, fix, fix and hypo clear.

better. Weatherproof plywood is a good material to use throughout and this should be coated with a good-quality protective surface, such as yacht varnish. The bench should be about ½ in (1.5 cm) thick and supported on battens about 2 × 2 in (5 × 5 cm). A single row of ceramic tiles glued to the wall above the bench will act as an effective splash-back and protect the wall from chemical spillage.

The second bench – the dry bench – is smaller and is used to support the enlarger. It is preferable to construct a separate bench for this, but if your space is long and narrow, you can extend the wet bench and partition off the two areas to prevent any chemical splashes reaching the enlarger.

An area 2 × 2 ft (60 × 60 cm) is sufficient for the dry bench, provided you include at least one shelf below the bench for materials. If space allows, 2 ft × 4 ft (0.6 × 1.2 m) is a more convenient size. Build this bench to the same height as the wet bench. It should be securely fixed to the walls provided there is no vibration caused by nearby traffic or trains. Any vibration of the enlarger during use will cause unsharp prints, in the same way as camera shake does when exposing the film.

Building a temporary darkroom

If there is insufficient space in your home for you to set aside a permanent area, then you will have to convert a room for temporary use as a darkroom. The choice is usually between the kitchen or bathroom. Bathrooms usually have smaller windows and so are easiest to convert. If you use the kitchen, however, you may be able to make use of existing tables and work surfaces, but make sure they are well protected from chemical spillage. You must also take great care not to contaminate any food stuffs in the kitchen and thoroughly clean all surfaces after the printing session. On balance, the bathroom is the better choice.

Make the wet bench from ½ in (1.5 cm) weatherproof plywood protected with yacht varnish. The size of the bench is determined by the size of the bath. Measure the width and length from the wall to the opposite inside edge of the bath. The bench itself should be about 1 in (2.5 cm) smaller in both dimensions so that any chemicals will drip into the bath. Any chemicals that do spill into the bath must be rinsed away immediately in case the surface

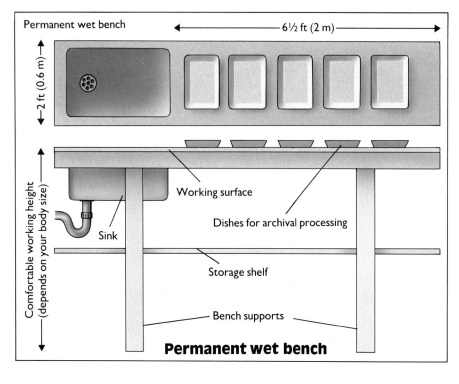

Permanent wet bench
6½ ft (2 m)
2 ft (0.6 m)
Comfortable working height (depends on your body size)
Working surface
Dishes for archival processing
Sink
Storage shelf
Bench supports
Permanent wet bench

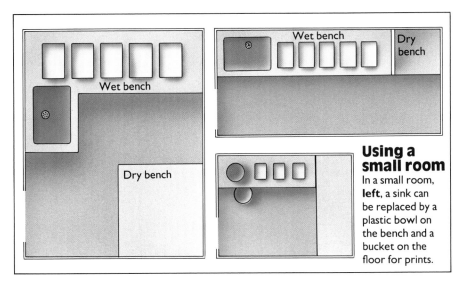

Using a small room
In a small room, **left**, a sink can be replaced by a plastic bowl on the bench and a bucket on the floor for prints.

Alternative layouts
*The three plans **above** are suggested alternative darkroom layouts – the actual design will depend on the shape of your room and its size.*

Converting a bathroom
*First, measure the size of your particular bath (1) as in the illustration **below**, and construct a bench with splash-back just smaller than the size of the bath (2). Attach battening firmly to the walls above the bath (3) using long screws. Finally, attach the bench to the battening, secured by a sturdy chain and clamp (4). For the enlarger, you can build a simple table over the hand basin (5).*

of the bath is stained. Screw and glue a strip of 3 × 1 in (7.5 × 2.5 cm) wood along the edges of the bench that will be in contact with the wall. This will act as a splash-back.

To support the bench above the bath, screw a 2 × 2 in (5 × 5 cm) batten to the wall at a height comfortable for you to stand and work at, taking the thickness of the bench itself into account. Finally, screw a stainless-steel hook into the bench and wall and buy a length of chain to support the edge of the bench farthest from the wall. A small carpenter's clamp will secure the other edge of the bench to the batten. You will need another bench for the enlarger, and you may have room to bring a table into the bathroom when you print or you can design a bench that fits over the sink or toilet as shown in the illustration below.

You will need a source of electricity in the bathroom for the enlarger and any other electrical items, such as safelights. In some countries, it is against building regulations to have a permanent socket in the bathroom and so you will have to run an extension lead to the room instead.

Black-outs and ventilation

Excluding all outside light from the darkroom is vital. In a permanent darkroom, windows can be boarded up and the cavity sealed with heavy black tape. Lightproofing the door is a bit more difficult as you will need it for access. An effective method is to use 2 × 2 in (5 × 5 cm) battening long enough to screw all the way round the inside of the door frame. The door should close tightly against the wood and the edges should be painted matte black. Block up the keyhole and fix an opaque flexible plastic or rubber strip to the bottom of the door so that it brushes against the floor. Draught excluders are often suitable for this. If you want to handle unprocessed film, hang a heavy black curtain so that it overlaps the door frame and lies in a fold on the floor.

There must be a flow of fresh air in the darkroom. Air should enter on the dry side through a lightproof vent. An exhaust fan mounted above the wet bench will blow the moist, chemically contaminated air out of the darkroom. Special lightproof fans can be purchased at good photographic equipment shops.

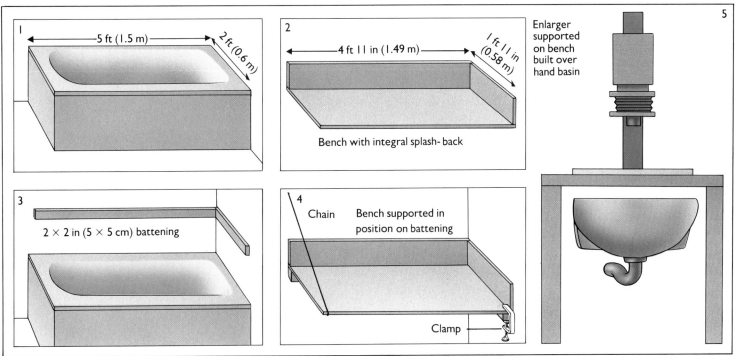

1 ← 5 ft (1.5 m) → 2 ft (0.6 m)

2 ← 4 ft 11 in (1.49 m) → 1 ft 11 in (0.58 m)
Bench with integral splash-back

3 2 × 2 in (5 × 5 cm) battening

4 Chain Bench supported in position on battening
Clamp

5 Enlarger supported on bench built over hand basin

Processing black and white negatives

If your darkroom is completely lightproof and has running water, you have the ideal place to process films. If your darkroom does not meet these conditions, don't worry; total darkness is necessary only when the film is loaded into the developing tank, and this can be done in a lightproof changing bag. You put the processing tank and film container inside the bag and your arms through special sleeves and then load the film on to the inner reel of the developing tank. With the reel inside the tank and the lid screwed on, you can start the chemical processing in normal room light.

Negative formation

The film image is created by light reflected by the subject. Light-sensitive silver halide crystals in the emulsion that are struck by light are chemically changed, although, at this stage, there is only an invisible, latent, image on the film. When the film is placed in contact with developer, the crystals darken. The crystals that were not struck by light (those corresponding to dark areas of the subject) are not affected by the developer. Even after development they remain sensitive to light, so before you can look at the film these crystals have to be dissolved by a chemical, known as fixer. The fixer does not affect the crystals that have been darkened by the developer, and so after the film has been fixed, the parts of the picture that did not receive light from the subject (the shadow areas) are clear; the bright parts of the subject are recorded as black on the film and the mid-tone areas are recorded as gray.

The photographic process

1 Light from the sun strikes the subject and is reflected toward the camera.
2 Halides not exposed to light remain unchanged and the unprocessed film now carries an invisible, latent image.
3 After development process, unexposed halides are dissolved leaving clear film, while

exposed halides are fully black.
4 In the darkroom, light from the enlarger shines through the fully developed negative and on to the paper.
5 Light passing through the clear areas of film produce a latent image on the printing paper, which is developed to full black during processing.

Black areas of film stop light reaching other parts of the paper, and halides corresponding to these areas are dissolved during processing leaving the paper white. The print is now a negative of a negative and tonal rendition should correspond to that of the original subject.

The processing chemicals

Film processing chemicals can be purchased in ready-to-mix powder form or as concentrated liquids. Chemicals in powder form are cheaper.

A wide range of developers is available and some of these slightly alter the film's characteristics. A fine-grain developer, for example, minimizes grain size, acutance developers enhance edge sharpness and high-activity developers are suitable for film that has been uprated (exposed as if faster than recommended by the manufacturer).

In practice, the difference to be seen in prints of the same subject, exposed on the same film but processed in the different developers is slight, often impossible to detect. For most situations, it is perfectly acceptable to use a general-purpose developer, such as Kodak's D76, which is internationally available. Kodak, however, only publish developing times for their own films, so you may

Processing equipment

Here is a list of the equipment you will need to process your film:

★ A changing bag, if you don't have a darkroom.

★ A developing tank, either stainless steel or plastic. The tank has a light-trapped lid, which allows you to pour chemicals in, and contains the reel. The smallest tanks take only one film, but larger tanks are available. The reel holds the film in a spiral that allows the processing solutions to circulate to all parts of the film. Plastic reels are usually adjustable

so that 35 mm and 120 films can be processed in the same tank.

★ A photographic thermometer.

★ Four plastic storage bottles to hold the chemicals for the developing tank. The storage bottles should be of the accordian type, which can be compressed to exclude air.

★ Four measuring flasks large enough to hold at least the volume of solution required for the developing tank.

★ A 100 cc measuring flask, to measure out small quantities of concentrated chemicals.

★ Scissors.

★ Can opener, used to open the top of the 35 mm cassette.

★ Squeeze tongs, used to remove excess water from the film surface after processing.

★ Film hooks to hang the film up while it dries.

★ A film drying cupboard, or a dust-free corner, where the film can hang for a few hours.

★ A plastic bowl, large enough to hold the four measuring flasks.

★ A clock with a sweep seconds hand. A special darkroom processing timer is easiest to use.

Fine-grain developer

High-activity developer

wish to use a general-purpose developer manufactured by an independent company, which states developing times for all major film brands. An example of an independent, general-purpose developer is Aculux, made by Patersons.

The next chemical to consider is the stop bath. As its name implies, its purpose is to halt the action of the developer. It is sold only as a concentrated liquid, which you must dilute as indicated on the label before use. It is important that this solution has a sufficient level of acidity to counteract the developer, so choose one that changes color when chemically exhausted.

The fixer is designed to dissolve away the unexposed silver halide crystals in the film emulsion. The best type to choose is one with a hardener (this will be indicated on the label). The purpose of the hardener is to toughen the emulsion and help prevent damage from abrasion.

The final two chemicals you need to know about are hypo clearing solution and wetting agent. Hypo clearing

Photomicrographs
The pictures above are photomicrographs of the grain structure of ASA/ISO 400 film exposed at its stated speed and developed in fine-grain developer, and the same type of film exposed at ASA/ISO 3200 and processed in a high-activity developer. Magnification is × 140.

Water jacket
A simple plastic bowl, above right, filled with hot water is sufficient to keep your processing solutions at the correct temperature.

Push processing

Push processing involves overdeveloping film to compensate for underexposure. You can use a standard developer, such as Kodak D76 or Ilford ID11, but better results will be obtained from a special high-activity developer, such as Paterson Acuspeed or Ilford Microphen. These developers list the development times for various speed films. The greater the increase in film speed, or the more you push the film, the longer the development time.

Pushed process negatives will not produce the same quality prints as normally exposed and processed negatives. Shadow detail will be lost and grain size will be larger. Detail in the mid-tones and highlights will be well recorded, although the negatives will be more contrasty.

Color negative and slide films can also be push processed, and the modified development times are included with the processing kits.

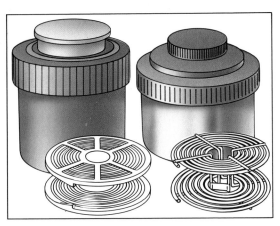

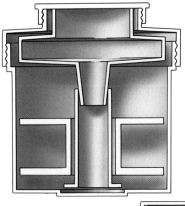

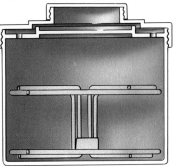

Developing tanks

Film developing tanks are available in either plastic or metal, **above**. Once the film is inside, and the top is in place, chemicals can be poured in through the lid in normal room light, see cut-aways **right**.

Plastic tank — Chemicals enter the tank through a central core, which drains out into the main film chamber, and envelops the film.

Metal tank — Chemicals enter the tank and are immediately directed to the sides, where outlet holes allow the liquid into the main film chamber.

Loading the film reel

This is the most skilled aspect of film processing. Before you can begin to process, you must first wind the film on to the reel. If you have not done this before, practice with a length of old film in daylight. When you feel that this is going smoothly, try it with your eyes shut tight. Don't attempt to load a film for actual processing until this is problem-free.

I *When using a plastic developing tank, first adjust the width of the reel to suit the size of film being processed.*

2 *Cut the film leader square and then, in total darkness, open the cassette and feed the film on to the outermost groove of the reel.*

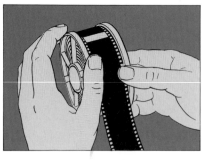

3 *Rotating the two halves of the reel will draw the film on to the reel. If you feel any resistance, stop and try again.*

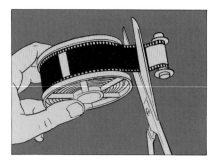

4 *When all the film has been taken up on to the reel, cut off the empty cassette and tuck the last piece of film into the groove.*

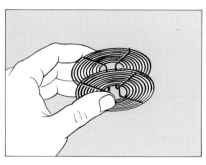

I *When using a metal developing tank, first make sure that the reel is correctly orientated to accept the end of the film.*

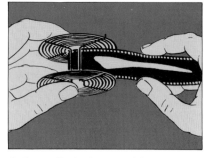

2 *Cut the film leader into a slight taper, turn of all lights before opening the cassette and attach the film to the clip at the reel center.*

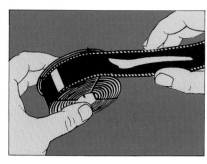

3 *Bow the film slightly and turn the reel to feed the film on to the grooves. If you feel any resistance, stop and try again.*

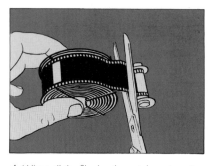

4 *When all the film has been taken up on to the reel, cut off the empty cassette and tuck the last piece of film into the groove.*

solution helps to remove all traces of fixer from the film and cuts down on the amount of time you will need to spend washing the film. Any fixer left in the film will, in time, degrade the image. Wetting agent is a pure soap solution, which helps prevent drying marks forming on the film surface.

Mixing the chemicals

If you have bought ready-to-mix powdered chemicals you must first dissolve these in water to make what is known as the stock solution. Usually, this stock solution is too concentrated to use, but it is a convenient way to store chemical solutions. Some developers, however, can be used at stock-solution strength. For those that cannot be used like this, the chemical solution must be further diluted with water to make a working-strength solution.

Always read and follow carefully the mixing instructions that accompany the chemicals. Make sure the measuring flasks and storage bottles are clean, and take special care not to contaminate the developer with any of the other chemicals. It is advisable to wear rubber gloves when mixing up the chemicals as some people may develop a mild skin rash. Inhaling chemical dust should be avoided also. To prevent the powder getting into the air, cut the corner off the packet and hold it close to the water as you pour the contents in.

To minimize the risk of chemicals contaminating each other, use four measuring flasks – one for each chemical. Label the flasks: DEVELOPER, STOP, FIX, HYPO CLEAR. Read the instructions that come with your developing tank to find the volume of solution required to process the film and calculate how much stock solution and water is needed to make up each of the four processing solutions to working strength.

Solution temperature

The temperature of the solutions is critical because it affects processing times. It is especially important that the developer be used at the specified temperature. The standard temperatures for black and white film processing is 68°F (20°C). Allow for a drop of about 1°C when you pour the developer into the tank by preparing the solution at 70°F (21°C).

To keep the chemicals at the correct processing temperature, use a plastic bowl filled with water at 21°C. Place the measuring flasks in the water jacket provided by the bowl, making sure that the level of water in the bowl is slightly lower than the level of chemical solution in the flasks; otherwise they will tip over. Maintain the temperature of the water jacket during processing by adding warm water as necessary.

Chemical preparation

If you have bought a general-purpose, ready-to-mix developer, such as D76, you can use it at stock strength or dilute it with an equal volume of water. If you use it at stock strength, you can return the developer to a storage bottle after use and add a small amount of replenisher to restore chemical activity of the used solution. This method works well for large-scale users, but it is difficult to obtain consistent results when only a few films at a time are developed. A better method for the home

Film processing

At this stage the film is in the tank and the chemicals are diluted to working strength at the correct temperature. There is only one further calculation to make before beginning. Refer to the four instruction sheets and write down the processing times in order of use: developer, stop, fixer and hypo clearing solution. Make sure the developer time is for the film in the tank and the temperature and dilution you are using. Sometimes, different development times are given for diffuser and condenser enlargers. Condenser enlargers are more common, but if you are in doubt, refer to your enlarger manual.

I *Pour the developer at the right temperature into the tank.*

2 *With the lid in place, agitate the tank as recommended.*

3 *If using a one-shot developer, discard after development time.*

4 *Pour in the stop bath solution at the correct temperature and agitate.*

5 *After the recommended time, pour the stop back into its storage bottle.*

6 *Pour in the fix solution at the correct temperature and agitate.*

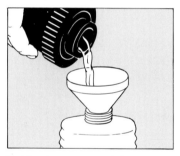

7 *After the recommended time, pour the fix back into its storage bottle.*

8 *As with all the main solutions, pour the hypo clearing agent into the tank.*

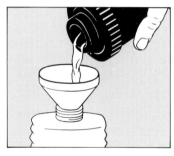

9 *After the recommended time, pour the hypo back into its storage bottle.*

10 *Remove the top of the tank, insert a hose and wash the film.*

11 *After washing, put a few drops of wetting agent into the water.*

12 *Attach a film clip to one end and carefully draw the film off the reel.*

13 *Remove excess water from the film using clean squeeze tongs.*

14 *Attach a film clip to the other end and hang the film up to dry.*

darkroom is to dilute the stock solution and when development is complete, discard the solution. Development times are slightly longer this way, but it is a small price to pay for consistent results.

Here is an easy method of bringing this type of developer to the correct temperature. Assuming your tank requires 500 cc of solution, pour 250 cc of stock solution into the correct measuring flask and check the temperature. If it is, for example, 14°C, subtract this from 21°C (the correct processing temperature), leaving a shortfall of 7°C. Add the 250 cc of water, which dilutes the developer to working strength solution, at 28°C (7°C more than the processing temperature). In this way, the overall temperature of the 500 cc of solution will be 21°C. Place the flask marked DEVELOPER in the water jacket while you mix the remaining solutions.

Dilute the stop bath to working strength in the flask marked STOP and bring it to the correct processing temperature before placing the flask in the water jacket. Working strength stop bath keeps well and can be reused until it changes color. Using the flask marked FIX, dilute and bring to the correct temperature the fixer solution. The number of films the working-strength solution will treat is given in the instruction sheet. Do the same for the hypo clearing solution, remembering to use the flask marked HYPO CLEAR. Read the instruction sheet to see how many films it will treat before it must be discarded.

Processing color and chromogenic films

Color negatives and color slide films are processed in different chemicals, although the method is similar for both types of film. Chromogenic black and white film can be processed in color negative chemicals, but for optimum quality Ilford XPI chromogenic film should be processed in XPI chemistry, which is a modification of the standard color negative process. XPI processed in ordinary color negative chemicals will produce negatives of slightly lower sharpness and a less-tight grain structure.

Standardized processing

Color films are designed for mass-production processing – negatives in a process known as C41 and slides in E6. Kits of these chemicals can be bought for home processing and, with care, results identical to those obtained by photographic laboratories can be had. Also available are processing kits tailored to the needs of the home user. They provide extremely good results and are easy to use. The well-known Photocolor kits have a high reputation in this field, and the processing sequence for these kits is described here.

Apart from a few films in Eastern Europe, there are two important films not compatible with E6 or C41 – Kodachrome color slide film, which demands the use of a continuous processing machine, and Kodak Ektachrome InfraRed Film 2236, which has not been adapted to E6 and, for marketing reasons, is unlikely to be changed. Both these films must be processed by Kodak or at specially designated laboratories.

Some color films are sold at a price that includes the cost of processing and, obviously, if you intend to do this yourself, you should choose a non-process-paid film. Whereas black and white films can be processed in many different developers, with every type and brand of film requiring a different development time, all color negative films, regardless of film speed, are developed for the same time in the appropriate chemistry, and all slide films for the same time in their appropriate chemistry.

Temperature control

The main problem you are likely to encounter when processing color and chromogenic films is the high temperatures that must be maintained throughout development – 38°C for color negatives and chromogenic films and between 35° and 38°C for color slide films. This can be inconvenient, but once a routine has been established, color processing is nearly as easy as black and white, although less forgiving of mistakes.

The detailed instructions that come with Photocolor and all processing kits explain the processing methods, which do not need to be repeated here. An outline of the process where it varies from black and white is described. If you have processed black and white film (see pp. 96-9), the only additional equipment you need is a spirit thermometer, which reads temperatures up to 50°C. The film is loaded into the tank as with black and white and the chemicals diluted according to instructions.

To reach the recommended developing temperature of 38°C for color negative films, you should warm the tank by filling it with water at 40°C for one minute immediately before development begins. The developer, stop bath (not supplied with the Photocolor kit) and bleach/fix should already be warmed to 38°C and be ready for use in the water jacket containing water at 40°C. The measuring flasks should be clearly labelled to avoid any risk of using chemicals out of sequence. When the tank is warmed, pour the water out and the developer in. Dislodge any air bubbles that can form between the film spirals by tapping the tank on the edge of the darkroom bench, and agitate the tank for the first 20 seconds, and then for 5 seconds at half-minute intervals throughout development.

At 38°C the development time for color negative films

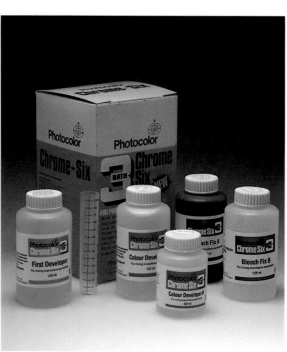

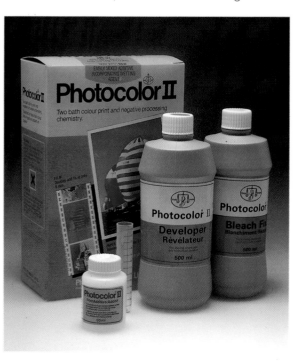

Processing kits
*Most easy for the low-volume home color film processor to use are the ready-packaged kits, of the type illustrated **left**. Make sure you buy the kit that suits the film you are processing – C41 chemistry kits, designed for color negative films, contain fewer solutions than do E6 chemistry kits, which are designed for color slide films.*

is 3¼ minutes. After one minute take the temperature using a spirit thermometer, which only takes ten seconds to give a reading. If the solution temperature has dropped slightly, consult the graph that comes with the kit to see by how much you should extend development time to compensate. This facility means that you do not have to worry about minor fluctuations in temperature that occur during processing. Ten seconds before the end of development, start to pour the developer back into its measuring flask. The developer and bleach/fix can be reused and the instructions indicate the number of films they will treat and how long the solutions can be stored and still remain fresh.

Although it is not essential to use a stop bath, it is good practice. Photocolor recommend their own product but any brand of stop bath will do as long as it is used at the same temperature as the developer. The bleach/fix solution should not be less than 35°C and not more than 40°C. Films of ASA/ISO 400 and faster require a longer treatment in this solution. The times for different speed films are given in the instruction sheet.

Film washing

Washing is an important part of the processing sequence and must be done thoroughly. The recommended temperature for the wash water is between 30° and 35°C. In practice hot tap water is too hot and cold tap water is too cold. This problem can be overcome if you have a mixer tap, but you should use a filter to remove the tiny particles present in all tap water. These form white specks when enlarged on the print. Alternatively, you can fill a bucket with water at the correct temperature and then fill and empty the tank six times, with ten seconds agitation each time.

As a final step, rinse the film in water to which wetting agent has been added and wipe the surplus liquid from the film surface using squeeze tongs. Then hang the film up to dry as you would black and white film. Color and chromogenic black and white films have a milky appearance when wet, but this will disappear as they dry.

Chromogenic films

Agfa Vario XL and Ilford XP1 films can be processed in C41 chemistry or a Photocolor negative kit. For best results with XP1 film, however, it is recommended that you use an XP1 processing kit. Ilford suggest that you process XP1 film at 38°C in XP1 chemicals and that you pour the developer into the tank at 40°C. They also publish a time and temperature chart and it is a good idea to measure the temperature of the developer after two minutes and adjust the processing time if there has been a drop. No stop bath is used and the bleach/fix time is the same as the development time – five minutes at 38°C. In other respects, processing chromogenic film is the same as for color negative materials.

Color slide films

The major difference, as far as the user is concerned, between processing color negative and color slide films, is that slide films are developed twice in two separate solutions. Using Photocolor Chrome Six chemistry,

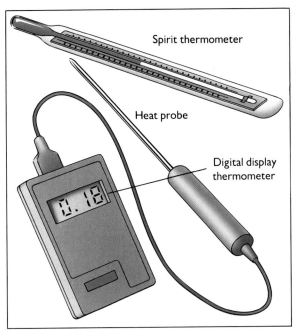

Spirit thermometer

Heat probe

Digital display thermometer

Thermometers
An accurate thermometer is essential when processing color films – both negatives and slides. The thermometer must cover the range of temperatures recommended for the particular type of chemistry you are using, and it should be accurate to within approximately ¼° C. It is also important that the thermometer displays quickly the correct solution temperature, so choose an easy-to-read spirit thermometer or a digital display type.

processing times for all E6-compatible films are the same and, again, a temperature of 38°C is recommended, although you can process at temperatures between 20°C and 45°C. Processing at below 35°C will result in slides that have a slight yellow cast and at temperatures above 38°C they will be slightly blue. Best results are obtained between 35°C and 38°C. The most critical step when processing slides is the first development; any errors of timing at this stage will result in slides being either too light or too dark.

Photocolor recommend the same method of ensuring correct processing temperatures described for color negative processing. No stop bath is used, but you need enough water to fill and empty completely the developing tank seven times – four times between the first and second developers and three times between the color developer and the bleach/fix. The water should be at the processing temperature.

Storage systems
The more care you take of your films the more good prints you will be able to make. Special envelopes to accommodate single large frames (1) are available. So too are envelopes for short strips of 35 mm film (2). A very convenient storage system is a ring-back file, which will accommodate a 36-exposure 35 mm film and its corresponding contact sheet (3).

Storing negatives

Many of the popular brands of negative storage envelopes available from photographic stores will, in fact, damage negatives. The chemical fumes given off by some of the plastic sheets will oxidize the image and, in some cases, will abrade the surface of the film. If you want negatives to last in good condition you must use acid-free paper envelopes. Neither negatives nor finished prints should be left in the darkroom where chemical fumes and rapidly changing levels of humidity will seriously degrade the emulsion.

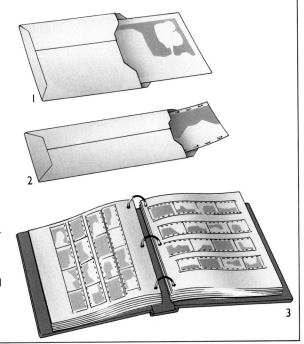

1

2

3

Black and white printing

Printing techniques are not difficult to learn and unlike film processing, which is rather mechanical, printing requires you to make a series of aesthetic judgements. You can, for instance, control the brightness and contrast of the print or choose to enlarge a part of the negative only or the whole frame. Other forms of control, known as 'burning in' and 'holding back' allow you to alter the brightness of local areas of the image, and you can also choose the color tone of the print from warm black to neutral black. If you have never seen a print develop before, then you have a treat in store.

Printing equipment

Because black and white prints are developed in open trays or dishes, a darkroom is essential. If your darkroom is a small, closet-type area then you will need only one **safelight** – a larger darkroom may require two. For making contact prints you will need **three dishes** designed to process 8 × 10 in (20 × 25 cm) paper. For archivally processing folio size prints you will need **five dishes** to take 12 × 16 in (30 × 40 cm) in Europe or 11 × 14 in (28 × 35 cm) prints in the USA. If you process your own negatives then you will be able to use some of the same equipment – **measuring flasks**, **thermometer** and **timer**, for example. To avoid getting the processing chemicals on your skin, it is best to wear a **rubber glove** or use a special **print tong**.

Purpose-built **contact print frames** are available, which have slots to hold the strips of negatives, a hinged glass lid and a base for the printing paper to rest on. A **sheet of plate glass** measuring 9 × 11 in (23 × 28 cm) with rounded corners will do the job just as well and for less expense.

After you have made and processed the print, you will need washing equipment to remove all traces of

chemicals from the paper. If your darkroom does not have running water you will need a **plastic bucket** to keep prints in before transferring them to a **print wash tank** or **print siphon unit**. Finally, have a **plastic bowl** in the darkroom to rinse your hands or print tong in when each print has been processed.

The enlarger

The central piece of equipment for print making is the enlarger. It consists of a rigid column fixed to a baseboard carrying an enlarger head which contains the lens and light source. The light shines through the

Black and white enlarger

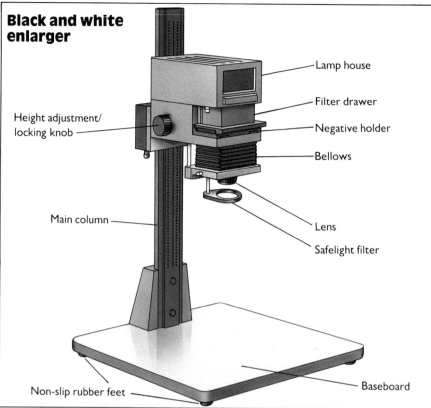

Lamp house
Filter drawer
Negative holder
Bellows
Lens
Safelight filter

Height adjustment/ locking knob

Main column

Non-slip rubber feet

Baseboard

What to look for
When buying an enlarger check that construction is firm and rigid – any movement of the head on the column will cause blurred prints. Also make sure that the head can be lifted far enough away from the baseboard to produce the size enlargement you will want to make. Some enlarger heads can be swivelled so that they project the negative on to a side wall or on to the floor.

What you need
The basic items of print processing equipment for black and white work can be seen left.

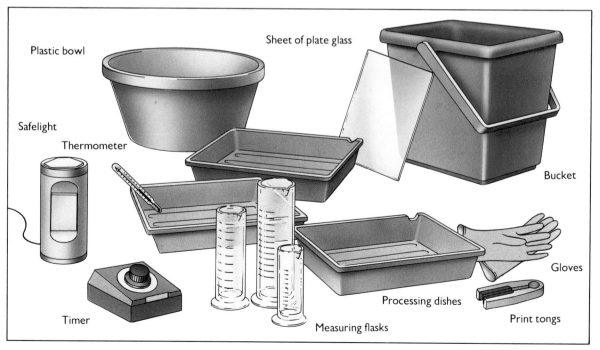

Plastic bowl
Sheet of plate glass
Safelight
Thermometer
Bucket
Timer
Gloves
Processing dishes
Print tongs
Measuring flasks

negative, held firmly in a special negative holder between the lamp and lens. The lens can be moved toward or away from the negative to achieve focus, and the enlarger head can be moved up and down the column to alter the size of the image being projected down on to the baseboard.

There are several different designs of enlargers. If you expect to make color prints you should choose an enlarger with a filter drawer positioned between the lamp and negative holder. Different strength color filters are placed in this drawer to control the color balance of the print. More expensive enlargers have built-in filters, the strength of which you change by adjusting a series of dials on the enlarger head. Color enlargers are perfectly suitable for making black and white prints.

Light systems

Two systems of delivering light to the negative are available. A condenser enlarger focuses the light from the enlarger lamp onto the negative through one or two condenser lenses. This produces a print of maximum sharpness for the lens in use. However, it also emphasizes the contrast in the highlight areas of the print and tends to bring into sharp focus any slight scratches or dust spots on the negative itself.

The second type of enlarger uses a diffuser instead of condenser lenses. The diffuser is an opalized screen directly above the negative. This system does not produce prints with quite the same sharpness, but nor does it emphasize contrast in the light or dark areas of the print or show up dust and scratches as sharply.

The differences between these two types of enlarger are slight in terms of print quality, but photographers can be extremely enthusiastic about one system or the other. If you are thinking of buying a second-hand enlarger, check that the bellows are not damaged and that the head moves smoothly on the column and locks securely into place. Also, there should be no slackness in the focusing knob.

Enlarger lens

There is little point in spending a lot of money on the best possible camera lens if you don't match this with an equally good enlarger lens. The optics and range of apertures on this type of lens are basic and so will not cost as much as a camera lens of equal quality. Ask a trusted photographic dealer for advice if in doubt, and if you are thinking of buying second-hand, then check for any scratches on the glass surfaces and that the aperture dial is not loose.

Enlarging easel

This piece of equipment is designed to provide a surface on which to size up and focus the image and then to hold the paper flat while the exposure is being made. Most easels provide some way of adjusting the white border around the picture by means of movable metal arms on two sides (see right).

This is an important piece of equipment and it is perfectly possible to make one for yourself. First, buy a piece of sheet metal a few inches larger than the largest print you intend to make. Cover one side with

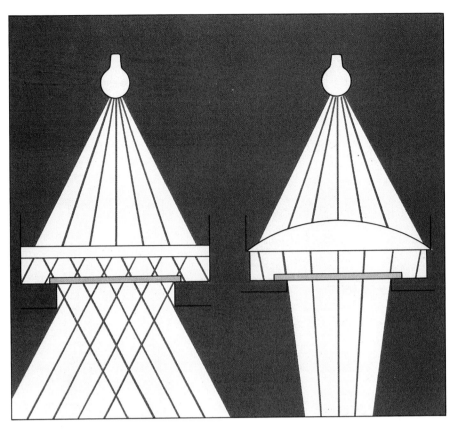

self-adhesive white plastic and glue a sheet of ¼ in (6 mm) thick foam rubber to the other side to prevent it from sliding on the enlarger baseboard. Draw and cut out rectangles from stiff, black cardboard corresponding to the different sizes of printing paper you use. If the rectangles are slightly smaller than the paper size in use, you will automatically produce white borders around your prints.

Dodgers

These home-made printing aids are used to hold back selectively the light from part of the print. The more light the paper receives the darker it becomes. In a contrasty negative, for example, you may want to expose part of the paper, corresponding to a highlight, a little longer than part of the paper corresponding to a shadow area.

Dodgers are easily made from black cardboard, cut to the shape suitable for the area being held back, and attached to stiff wire.

Light systems
*To give even illumination over the entire negative, enlargers can use either a diffuser lens, **above left**, or a condenser lens, **above right.***

Useful accessory
An enlarging easel (or masking frame) is a very useful darkroom accessory. It is designed to hold the printing paper perfectly flat during exposure and its side arms are adjustable to suit many different sizes of paper. They also shield the edges of the paper during exposure, producing a neat white border.

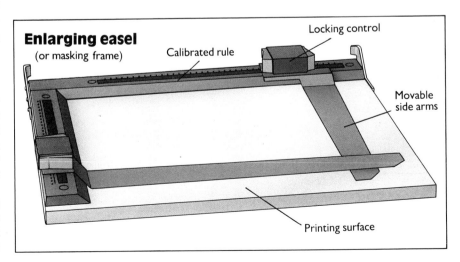

Enlarging easel
(or masking frame)

Locking control

Calibrated rule

Movable side arms

Printing surface

Black and white printing papers

Whereas different brands of black and white film of the same speed produce similar results, black and white papers of different manufacture show quite distinct characteristics. All enlarger papers consist of a thin layer of light-sensitive emulsion coated on a paper base. Resin coated (RC) printing papers incorporate a thin layer of polyethylene plastic over the paper base. This means that the processing chemicals are not absorbed into the paper, which allows for quicker washing and drying, and also stops the paper curling when dry. Since 1974 just about every manufacturer has switched the bulk of its production to RC papers.

Resin coated or fibre based

Resin coated papers are ideal for contact prints, rough prints and prints made for publication. Most people agree, however, that the photographic image on RC paper is not as good as that produced on fibre based paper. Resin coated papers of different manufacture vary less than fibre based papers, so your choice will probably be dictated by the availability of certain brands. Agfa Portriga Speed is an exception. It is a resin coated paper that yields a warm, slightly brown-black image. Most other RC papers produce a neutral black image.

Fibre based papers are still made because they are capable of producing a better quality image and because prints will last very much longer than those made on RC paper. Different brands of fibre based paper vary considerably and your choice of paper and developer will affect the quality of the picture. It is probably a mistake to use just one paper for all your pictures. The following describes some of the better-known enlarging papers but it is well worth making your own tests.

Choosing between papers is often a matter of deciding between the varying tones produced by the papers. In this context, tone describes the variation in color of the picture from cold, or blue-black, to warm, or brown-black. Other characteristics that will affect your choice are the richness (maximum density) of the black, the number of shades of gray (tonal range) and the paper surface (smooth, matte, or textured, for example).

Quality products

The Agfa fibre based enlarging papers and chemicals are world-famous for their high quality. They all give a high maximum density and show excellent tonal gradation. At present they produce papers known as Brovira, Record Rapid (not widely available outside Europe) and Portriga Rapid.

Agfa Brovira yields a cold black image with good highlight detail. The tone of the print can be altered only slightly by the choice of developer. Detail in the shadows is not as evident as it is with Agfa's other papers. Record Rapid produces a variety of warm tones depending on the type of developer used. Shadow detail is extremely good and images printed on this paper almost seem to 'glow'. Portriga Rapid is nearly the same emulsion as Record Rapid, but it is coated on a paper that has a slight ivory tint. This gives prints a warmer tone than Record Rapid while keeping the other characteristics the same. Agfa also make a range of developers that can be used to produce a full range of tones in Record and Portriga Rapid (see box on p. 106).

Ilford manufacture an exhibition-quality enlarging paper called Galerie. This paper yields an image color somewhere between Record Rapid and Brovira. The image tone cannot be much altered by the choice of developer. Detail in the highlights is extremely well recorded. Kodak have also introduced an exhibition-quality paper called Elite. This paper produces a neutral-black image with an extended tonal range. The paper base is somewhat thicker than either Agfa or Ilford papers.

Paper surfaces

Apart from emulsion choice, you also have a choice of paper surface. All papers are available in a glossy finish, which dries to a smooth, reflective surface and produces the fullest range of tones and detail in your print. Resin coated glossy paper dries with a high-gloss, almost glazed

Print appearance

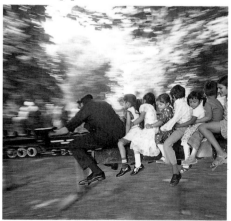

Using Record Rapid you obtain a warm-toned print and a clean, crisp image.

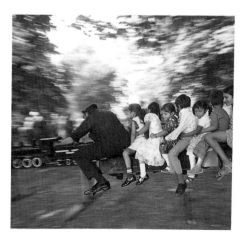

Portriga Rapid paper has an ivory base tint and produces a much warmer looking image.

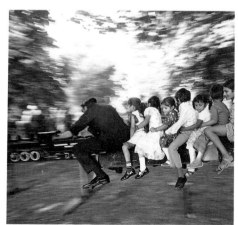

Brovira gives a cold, blue-black result and there is less separation in shadows and highlights.

Paper grades

Grade O – On this softest grade of paper, the overall appearance is flat and 'muddy' looking.

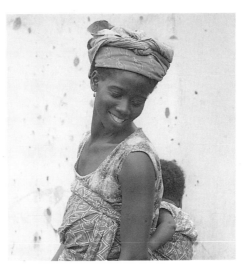

Grade I – Even at this next hardest grade, half-tones are not sufficiently separated.

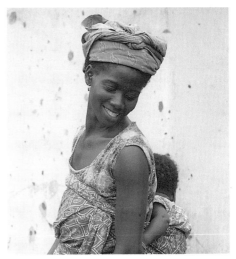

Grade 2 – The print is now taking on a better appearance, with half-tones beginning to separate.

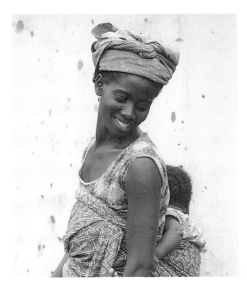

Grade 3 – This grade of paper has produced the crispest print with good tonal separation.

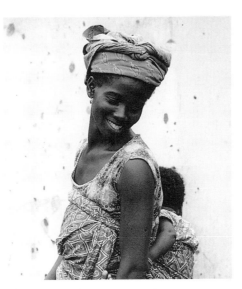

Grade 4 – Half-tones are now beginning to disappear and detail is being lost.

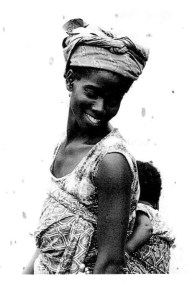

Grade 5 – This is the hardest grade and notice now that the print is basically just black and white.

finish, which many people like. Fibre based glossy paper needs to be separately glazed on a special machine and the finish produced is almost mirror-like in quality. Other surfaces, variously described as pearl, smooth lustre, semi-matte, and eggshell, all diffuse the light reflected from the print to slightly varying degrees. The blacks do not appear so rich and shadow detail is slightly masked. Because of its popularity, you are likely to find all these surfaces more easily available on resin coated paper.

Paper grades

To accommodate negatives of varying degrees of contrast, enlarging papers are sold in three or more different contrast grades. Another system comes in one grade only, but its contrast is altered by changing the color of the enlarger light with a set of filters. This selective contrast paper is convenient because you can print all your negatives on paper from the same packet. The alternative is to match the negative to the appropri-ate grade of paper, assuming you have that particular grade in the darkroom.

The difference between paper grades lies in the number of tones, or shades of gray, they can produce. A soft paper, usually known as grade I, produces the largest range of tones, and grade 5, the hardest, produces the least tones. These grade numbers are not standardized – manufacturers use their own judgement about numbering and so direct comparison between brands is difficult.

In general, a soft negative with a lot of gray tones would be matched to a hard paper in order to produce a normal-contrast print. A contrasty negative – one with few shades of gray – would be matched to a soft paper, which emphasizes the mid-tones and creates a more balanced print. You can, of course, use these papers to distort the tonal range of the original subject. By printing a normal-contrast negative on hard paper you can, for example, produce a photograph that records the subject in blacks and whites, with few, if any, intermediate tones.

	Soft paper	Normal paper	Hard paper

Soft negative

The combination of soft negative and soft paper has produced a flat print.	The soft negative on normal paper has sharpened up a little more.	Using the hardest paper grade has given the best print with good blacks and whites.

Normal negative

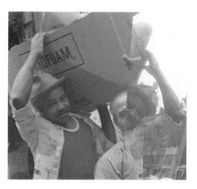 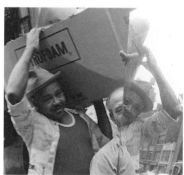 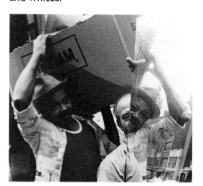

The normal negative on soft paper appears a little too soft and murky.	Using normal paper for this negative produces the best result.	On hard paper, the normal negative starts to lose detail as half-tones disappear.

Hard negative

Soft paper has produced the most acceptable print from this hard negative.	Using normal paper, print detail is beginning to merge into solid black or featureless white.	The combination of hard negative and hard paper has produced impossible contrast.

Matching paper and developer

Three Agfa paper developers are available designed to fit together with their papers to form a system, which can be used to manipulate the image color of the print. Neutol BL produces the coldest tones, Neutol NE produces a neutral tone and Neutol WA the warmest tones.

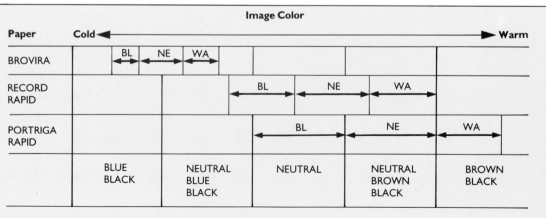

Paper	Cold ◄———————— Image Color ————————► Warm				
BROVIRA	BL ◄► NE ◄► WA ◄►				
RECORD RAPID			BL ◄——► NE ◄——►	WA ◄——►	
PORTRIGA RAPID				BL ◄——► NE ◄——►	WA ◄——►
	BLUE BLACK	NEUTRAL BLUE BLACK	NEUTRAL	NEUTRAL BROWN BLACK	BROWN BLACK

Reproduced by kind permission of Goldfinger Ltd, specialist Agfa dealers.

Making a contact sheet

Once your negatives are dry and cut into strips, the next step is to make a set of contact prints on a single sheet of printing paper. This allows you to see a positive image of all the negatives from the same film on one sheet of 8 × 10 in (20 × 25 cm) paper. From the contact sheet you can select the most promising images and make small 'proof prints' from which to select the final images for enlargement. Resin coated papers (see pp. 104-6) are usually used for contact and proof prints, but for the enlargements a fibre based paper is best.

Setting up

To make your contact sheet you will need a normal-grade, glossy-surface printing paper. You can contact print color negatives on black and white paper for editing, but you will then have to use a hard, grade 4 or 5, printing paper. Using resin coated paper, you will obtain the best results with the developer manufactured for that specific paper.

These paper developers are sold as concentrated liquids, which you must dilute for use. Mix enough chemicals to fill your processing dishes to a depth of about 1 in (2.5 cm). The processing temperature for all chemicals is 68°F (20°C). Prepare the stop bath and fixer and arrange the dishes in order of use – developer, stop bath and then the fixer. If you do not have running water, fill a bowl with warm water so you can rinse your hands

or print tongs at the end of the process. You will also need a bucket of water to store the processed prints in before washing them. With everything in place, turn the enlarger on and move the head up or down the column until it illuminates an area slightly larger than 9 × 12 in (23 × 30 cm). Mark the corners of the illuminated rectangle, open the lens to its largest aperture and turn the enlarger off.

Making a test strip

To discover the exposure time for contact printing and enlarging, you need to make a test strip. With the room lights off and the safelights on, open the enlarging paper and remove one sheet. Cut this into four equal-sized strips and return three of them to the packet. Put the strip of paper on the baseboard emulsion side up (the emulsion side is smooth and glossy) within the area that will be illuminated when the enlarger is switched on.

Next, take three strips of negatives and place them emulsion side down over the enlarging paper. The emulsion side of the film is dull and matte. Now place the glass over the negatives. Make sure the glass is perfectly clean and then turn the enlarger on for exactly 5 sec. Turn the enlarger off and hold a piece of cardboard over one-third of the paper about ½ in (13 mm) above the glass. Turn the enlarger on for 5 sec more, keeping the cardboard still. Turn the enlarger off and move the card so that it now covers two-thirds of the paper and turn the enlarger on for 10 sec more.

You have now made three exposures on the same strip of paper. The first third received a total of 5 sec, the second third 10 sec exposure and the final third a total of

Exposing a test strip

1 Place a sheet of printing paper, emulsion side up, on the baseboard of the enlarger where it will be evenly illuminated by the light from the enlarger lamp.

2 Place the strips of negatives, emulsion side down, in contact with the paper and cover with a sheet of clean glass. Turn on the enlarger and expose for 5 sec.

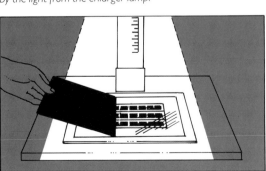

3 After 5 sec, cover one-third of the paper with a sheet of black cardboard and expose for another 5 sec, making a total of 10 sec altogether.

4 Now cover two-thirds of the paper with the cardboard and expose for another 10 sec. You will now have three separate exposures – 5 sec, 10 sec and 20 sec – on the same sheet.

Developing a test strip

I *Tilt the developer dish, place the paper in (emulsion side down) and allow the solution to wash back over the print – covering it all at once.*

2 *Turn the paper over and then start the timer. Rock the dish from side to side to ensure that the developer comes into contact with the paper.*

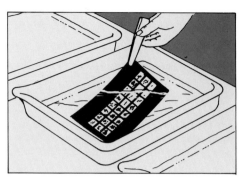

3 *When the print is fully developed, lift it out carefully by one corner, drain off excess developer and immerse it in the stop bath.*

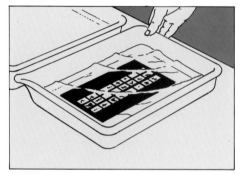

4 *At the end of the recommended stop time, lift the print, drain as before and place it in the fixer. After agitation you can turn the ordinary room lights on.*

5 *After fixation is complete, drain and then wash the print. Washing time depends on paper type. Ensure a constantly changing supply of fresh water.*

6 *When the print is fully washed, place it on a flat surface and, using a clean sponge, soak up excess water. Full drying time depends on paper type.*

20 sec. Exceptionally light or dark negatives might not fit into this range of exposures, and if this is the case you will have to make a special test strip for them – stopping the lens down one or two apertures for thin negatives or making longer exposures for dense negatives. Color negatives contact printed on black and white paper require longer exposures; the first third for 30 sec, the second for another 30 sec and the final third for 1 min.

Test strip

When first learning the basics of printing, it is a good idea to make a test strip, even for a contact sheet. The three bands of different density visible on the print, **right,** *are the result of exposing sections of the paper for 5 sec, 10 sec and 20 sec. As you gain more experience, test strips at this stage can be omitted.*

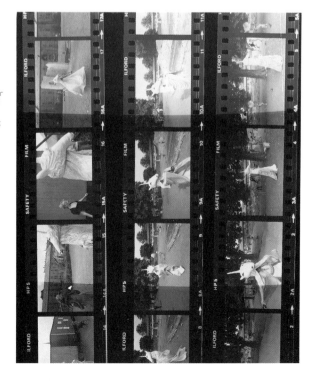

Developing the test strip

To prevent the processing chemicals coming into contact with your skin you can either wear a rubber glove or use a print tong. Set the timer to zero and put the exposed paper, emulsion side down, into the developer in one quick movement, wetting the entire emulsion surface at the same time. Then turn the paper emulsion side up and start the timer. Rock the dish gently backward and forward and from side to side to ensure even development. After a few seconds you will see the image begin to appear, as if by magic, and after 1 min (this time will vary depending on the paper and developer – see the instructions accompanying these products) you will have a fully developed test strip.

Remove the paper, letting the excess developer drain back into the dish for a few seconds, and then immerse it in the stop bath and agitate for 30 sec. Drain the paper and place it in the fixer. Agitate it for about half the recommended fixing time (this varies from brand to brand) and you can now switch on the print viewing light. After the complete fixing time, remove and drain the paper and choose the most satisfactory exposure. If one strip is too light and the next too dark, choose an exposure somewhere in between.

Having made a decision about exposure, place all the strips of negatives over a whole sheet of paper. The negatives should be arranged so that the pictures are all the same way round. Expose the whole sheet and process in the way described for a test strip. It is important not to leave prints in the fixer longer than is recommended, so when this stage is reached transfer the print to the wash tank, if you have running water in the

darkroom, or place it in a bucket of water. At the end of the session, you can wash all the prints in the kitchen or bathroom. Resin coated paper needs only about 5 min washing in running water.

Editing a contact sheet

You will need a magnifying glass and two differently colored chinagraph pencils – any color except red, which will not be visible under safelighting. Choose one color to mark the pictures that first catch your eye, and the other color to mark your final selection for printing. It is a good idea to let a friend look at the sheet as well. A second opinion does not hurt and it is easy to miss a good picture. For this reason, it is a good idea to re-examine them yourself with a fresh eye from time to time.

The contact prints you want to proof print should be marked clearly with a line drawn right round the frame. Write a reference number on the back of the contact print and the same number on the negative envelope. Most people incorporate the year in the reference number. When you have made your final selection you are ready to start proof printing. These postcard size prints are made on normal-contrast enlarging paper. Place one of the negatives in the enlarger negative holder with the emulsion facing the baseboard and the numbered edge of the film furthest away from you. Adjust the masking frame to the correct paper size and switch the enlarger on. Size up the image and focus the image with the lens at maximum (and hence, brightest) aperture. Stop the lens down to f 8 and make a test strip as previously described. Develop this in the normal way and select the best exposure. Take a whole sheet of printing paper and write the negative frame and film reference numbers on the back with a soft pencil. Expose and process the print and, after fixing, check that it is to your liking. With a bit of experience you will be able to omit the test strip before making each proof print, unless the negatives are extremely unevenly exposed. These prints are for reference only, and so do

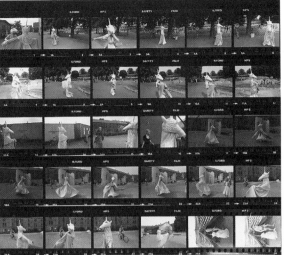

Final contact sheet
Using the information gained from making the test strip, **opposite**, *this final contact sheet was exposed for 10 sec with the enlarger lens aperture set to f5.6.*

not have to be of the highest standard. If you can detect a difference in the brightness of the image on the baseboard, compensate by adding or subtracting exposure.

Wash and dry the proof prints and you now have a set of postcard size prints of your best pictures. Look at these carefully and decide which ones you will want to enlarge to the highest standard.

Look to see if any of the prints need to be cropped. This means enlarging part of the negative. Some photographers disapprove of this practice, preferring always to print the whole frame as they saw it in the viewfinder of the camera. Obviously it is best to frame the picture to best advantage when you take it, because when you print from the whole negative area the best print quality will be obtained. It seems equally obvious, however, that if you can occasionally improve a picture by cropping one or all the edges, it would be a waste not to do so. A convenient method of previewing the way a picture will look when cropped is to cut two L-shaped pieces of card and move them over the picture until you find the best area to enlarge.

Proof print
Once you have finished making the contact sheet you can start to edit your pictures. Look carefully at each one and decide which are worth taking to the proof stage. The photograph **below** *can be seen as negative 3A on the contact sheet. At present it is only a rough print still (see pp.110– 13).*

'Safe' light
The dual density visible on the picture, **left**, was caused by leaving a fully exposed but unprocessed print on the darkroom workbench. Half the print was covered with a piece of cardboard and the other, darker, half left for 5 min in the light from the safelight. Try this experiment yourself to see whether your safelights are really safe.

Making an enlargement

For contact sheets and proof prints it is perfectly adequate to use resin coated paper. Your best pictures, however, will be much improved by being printed on one of the fibre based papers (see pp. 104-6). You will need a few extra items of equipment – two additional developing dishes and a print drying rack or heat dryer. For best results, the drying rack is recommended.

Setting up

Choose a paper and developer combination you wish to experiment with and mix the correct dilution of developer and stop bath. For more efficient fixing and, hence, longer print life, two dishes of fixer should be used. If you use Kodafix, mix the concentrated liquid with seven parts of water. Divide this volume between the two dishes and fix the prints for between 2½ and 5 min per dish. The contents of the first dish of fix should be discarded after you have treated 32 square feet (3 square metres) of paper per liter. The second bath is then used first and a fresh second bath of fix made up. After four such changes discard both baths and start again. Take care not to extend fixing time beyond the manufacturer's recommendation. Fibre based prints absorb the processing chemicals, and to ensure efficient washing you should use a hypo clearing solution after fixing. If you use this solution and extend washing to one hour, you will remove more residual chemicals than is possible by washing alone.

Before starting to print, test your safelights to make sure they are not too bright, or they may fog the printing paper slightly. Switch the safelights off and expose a sheet of printing paper to a negative containing a large highlight area. Place the exposed paper at your normal working distance from the safelights, and cover half the paper with a piece of cardboard. Now turn the safelights on and leave the paper for 5 min. Switch the lights off and process the print. After fixing examine the print closely to see if the uncovered area is darker than the covered area. If it is, you will have to move the lamps farther away from the working area or else fit a dimmer switch and reduce the output of the lamps.

The printing sequence

Now you are ready to make a print. Put the negative in the enlarger and size up the image on the easel and focus on a scrap piece of printing paper. When the image is sharp, stop down the lens to f 8 and turn the enlarger off. Cut a piece of printing paper in half and place this on the easel over a critical area of the picture – a face or prominent building, for example. Make a test strip in the same way as for a contact sheet (see pp. 107-9). Develop the test for the maximum time recommended by the paper manufacturer, usually 3 min. This will ensure that the black areas of the picture are fully developed. When the test strip is fixed, turn the print viewing light on and assess the exposures. Fibre based papers are slightly darker when dry. Choose the best exposure, take a whole sheet of paper and expose it for the time indicated by the test. Resist the temptation to pull the print out of the developer early because it looks too dark in the dim safelighting. Just be patient and reserve

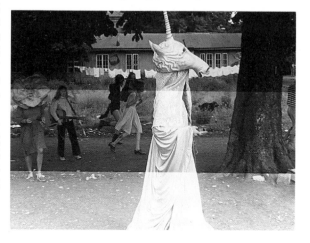

Test strip
The size of the actual area sampled for a test strip is not particularly crucial, as long as it contains the most important tones for that image – in this example, the robes of the unicorn. The three exposure times for this test were (all with the lens at f 5.6): 10 sec (bottom), 15 sec (middle) and 25 sec (top).

Full enlargement
For this full print of the test strip on the previous page, an overall exposure of 15 sec at f 5.6 was used, corresponding to the middle band of density on the test. Although generally a good print, there is room for improvement. This same picture has been reproduced smaller below, with a fully corrected version bottom.

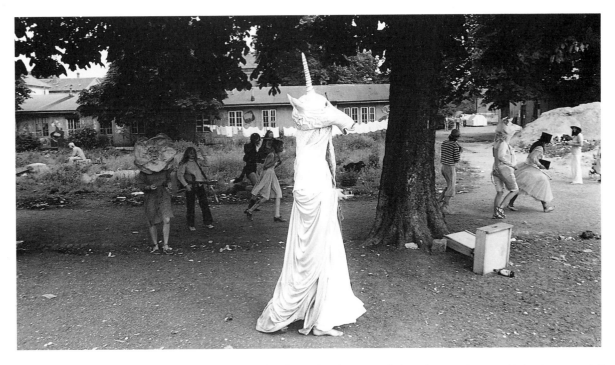

judgement until the print is fixed. Complete development is necessary before the full tonal range appears, so let the exposure control the density of the print.

With the print viewing light on, look critically at the print. There will almost certainly be improvements you can make, so check these points:

* Now that you can see the whole print, is the exposure really correct?
* Have you printed on the grade of paper that best suits the tonal range of the negative?
* If the overall exposure is correct, see if there are any local areas of the picture that could be improved if printed lighter or darker.

Most prints require some balancing of the tones, either to bring out detail in the shadows or to print in (known as burning in) tone and detail in the lighter areas of the print. Manipulating the picture in this way helps the viewer read the picture as a whole. Very bright or very dark areas, which attract undue attention, can be blended with the rest of the picture (see box). With practice, you will be able to see the weakness in the picture and be able to assess the changes needed in order to improve it.

Uncorrected

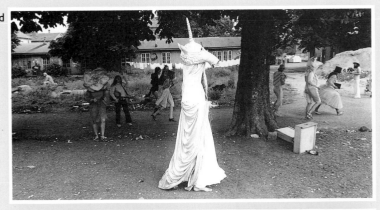

Corrected

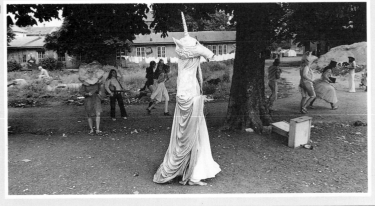

Controlling local density

If the general exposure of the print is correct, but there are dark areas that could be improved by 'holding back', or light areas that could be improved by 'burning in', you will need to make the simple cardboard shapes described below.

To hold light back from a dark area you wish to lighten, we will assume an overall exposure of 15 sec. After the first 10 sec of exposure, introduce the dodger into the light path of the enlarger so that it casts a shadow over the area of the print to be lightened. Keep the dodger moving constantly or you will see a distinct line dividing the two print densities. The higher you hold the dodger, the larger and more diffuse will be the shadow it casts. Switch the enlarger off after a total of 15 sec. Process the print and inspect the treated area to assess whether it requires more or less exposure.

If, on the other hand, you wish to darken an area of the print that is too light, we will assume again an exposure time of 15 sec. After this time has elapsed, introduce a piece of cardboard large enough to shield the entire print from the enlarger light. This card should have a hole cut out of it corresponding to the area of the print requiring extra exposure. Again, you must keep the card on the move throughout the additional exposure time. Process the print and decide if further treatment is necessary.

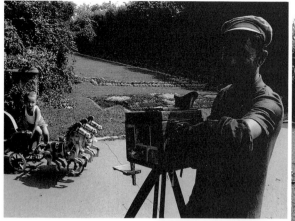

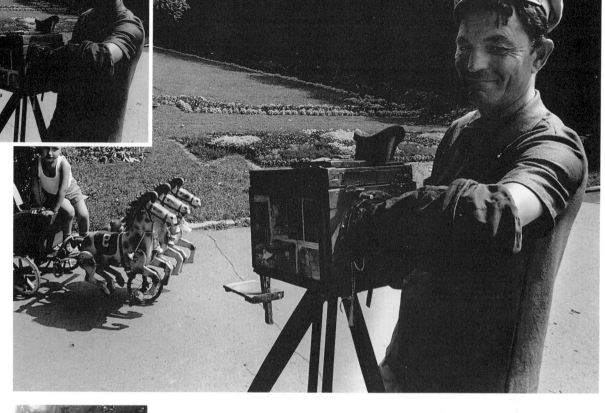

Midday sun

In the picture **above**, strong midday sun has caused excessive top shadow, almost completely obliterating detail on the man's face. In the corrected version, **right**, the overall exposure was the same – 20 sec – but the man's face received only 12 sec and his body 15 sec. The print is now much better balanced, and much more as it would have appeared at the time.

Flash lighting

One of the problems of using flash outdoors is uneven lighting. In the picture **above**, you can see that the foreground figures nearest the flash are too well lit compared with the rest of the scene. To overcome this, **right**, the costumed figure on stage was given an additional 3 sec exposure, over the basic overall exposure of 16 sec. The two figures nearest the camera were given an extra 4 sec, making 20 sec in total.

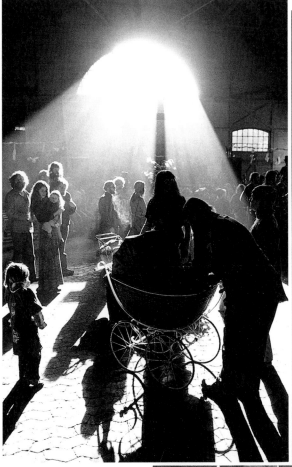

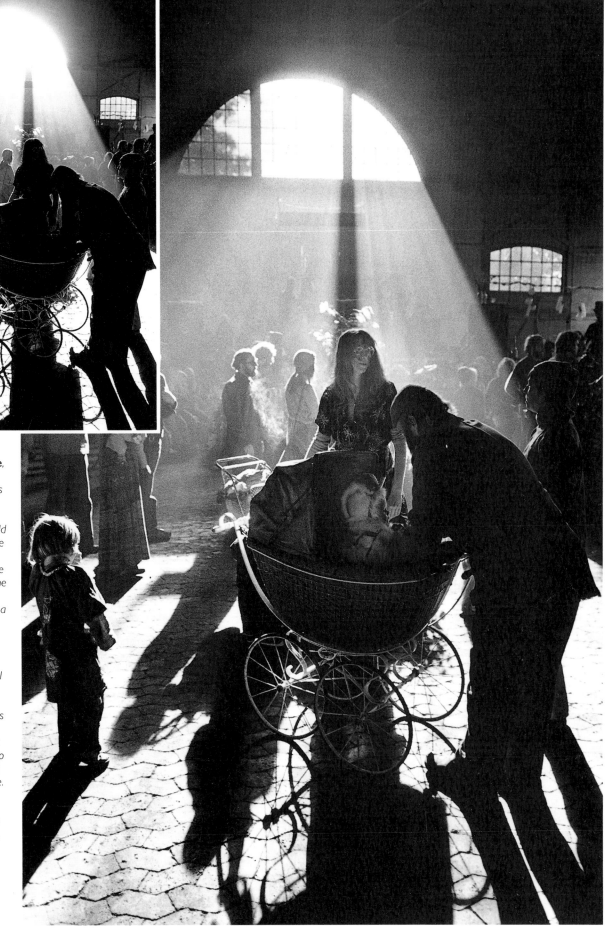

Window light

A scene such as the one **above**, with window light shining directly into the camera lens, is impossibly contrasty for any film to cope with. If you don't do your own printing, you would have to decide either to expose for the highlights only and let the shadows go solid, or expose for the shadows only and let the highlights burn out. For the corrected version, **right**, quite a complicated printing scheme had to be devised. Overall exposure was 30 sec, but the top bright window was given another 90 sec, making a total of 2 min. The top third of the picture had an additional 30 sec, making a total of 1 min, as did all the bright foreground highlights in order to bring out detail in the tiled floor. The two figures and the pram received only a total of 23 sec exposure.

In order to work out the correct exposures for such a picture you might well have to make three or four test prints.

Color printing

Color prints can be made from color slides as well as color negatives. Color printing is a little more complicated than black and white printing because, in addition to finding the correct exposure, you have to filter the enlarger light to produce correctly balanced colors in the picture. Particularly important in color printing is the timing of the print in the developer and the temperature of the solution. Because of the sensitivity of color materials, color printing paper has to be handled in almost total darkness.

None of these difficulties is hard to overcome and, with a little practice, you will be able to produce high-quality prints quickly. If you have already tried black and white printing you will need very little additional equipment.

Color printing equipment

If your enlarger has a filter drawer, you will have to buy a set of color printing (CP) filters. These come in three colors – yellow, cyan and magenta – and in varying degrees of intensity. The number printed on the envelope, 05, 10, 20, 40, refers to the intensity of the filter color; the higher the number the more intense the filter color. The capital letter after the number refers to the color of the filter – CP 20Y, for example, is a 20 yellow color printing filter. You will also need to buy an ultraviolet (UV) filter, such as a Kodak Wratten 2B. If your enlarger is equipped with a color head, the filters are built in, and you can control their intensity by adjusting the dials on the outside of the color head. The filters in a color head are much less likely to fade with time and are easier to use.

Some enlargers come supplied with voltage stabilizers, which smooth out the fluctuations in the electricity

Color enlarger

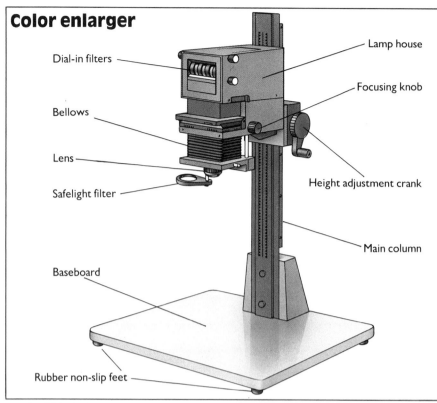

- Dial-in filters
- Bellows
- Lens
- Safelight filter
- Baseboard
- Rubber non-slip feet
- Lamp house
- Focusing knob
- Height adjustment crank
- Main column

supply. This helps to ensure consistent exposures and consistent color; even quite small variations in voltage will change the intensity and color of the light from the enlarger. If your enlarger is not equipped with a stabilizer and you do not want to buy one, it is advisable to avoid color printing at times of the day when the greatest voltage fluctuations occur – usually at sunset and at mealtimes, and when factory shifts change.

Safelights for use with color materials are available but they provide almost no light at all and are of dubious value. Because illuminating the darkroom is so difficult

Dial-in filters
Modern color enlargers, above, feature very convenient and easy-to-use dial-in dichroic filters.

Print processing tank
Because no safelight is really safe to use with color printing paper, a fully enclosed, light-tight tank, below, is used instead of open dishes.

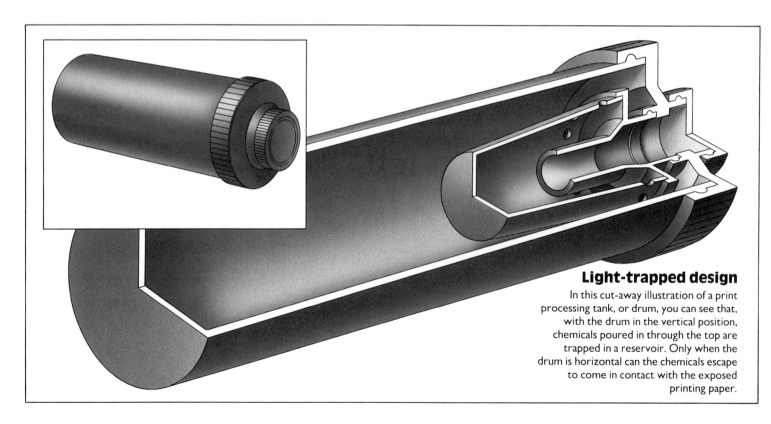

Light-trapped design
In this cut-away illustration of a print processing tank, or drum, you can see that, with the drum in the vertical position, chemicals poured in through the top are trapped in a reservoir. Only when the drum is horizontal can the chemicals escape to come in contact with the exposed printing paper.

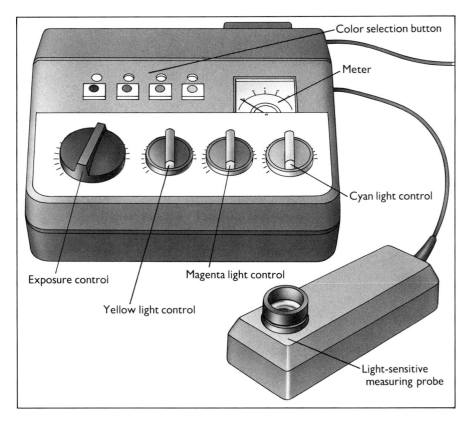

Color selection button

Meter

Cyan light control

Magenta light control

Yellow light control

Exposure control

Light-sensitive measuring probe

The best way to make a test print is to expose an 8 × 10 in (20 × 25 cm) sheet of printing paper using an L-shaped cardboard mask, which leaves one-quarter of the paper uncovered. By moving this mask you can make four quite separate exposures on the same piece of paper. Expose each quarter for 10 sec but, each time, change the lens aperture. Start at f 5.6, then f 8, then f 11 and, finally, f 16. Test prints are made this way with color paper, because in darkness you cannot see how much of a test strip is covered up.

Load the exposed paper into the drum by bending it into a roll with the emulsion facing inward. Put the lid on the drum and turn the room lights on. Warm the loaded drum by filling it with water at 104°F (40°C) for one minute. Drain the tank and pour in the recommended quantity of developer, having first checked that the temperature of the solution is at the correct level. Turn the drum on its side and roll it backward and forward along the top of the wet bench for the whole of the development period. Start emptying the drum about 10–15 sec before the end of the development time. Pour in the stop bath or water rinse at the same temperature as the developer and agitate the drum for about 20 sec before pouring out the solution. Next, pour in the bleach/fix, which requires a minimum of one minute at the temperature recommended. When all the chemical steps are complete, wash the test print in water heated to the processing temperature. This is best done in a dish so that the water can circulate freely around both sides of the paper. Drain the excess water off the print and let it dry in warm air.

It is not possible to judge the color balance of the print until it is dry, when it should be viewed in daylight or in bright room lights. Use the best exposed quarter of the print to assess the color balance. You will probably see that there is an overall dominant color, known as a color cast, which will have to be improved. See which of the colors listed in the chart is too dominant and adjust the filter pack in the way suggested.

when working in color, prints are usually processed in a light-tight drum. It looks a little like a multi-reel film developing tank. Once the paper is exposed, you simply roll it up and insert it into the drum, where it curls against the inside. With the lid on the drum, all processing can be carried out in normal room lighting. Processing drums require very small amounts of chemical solutions and agitation is achieved by rolling the drum on the bench top or any other convenient surface.

Color negatives

Color negative film records light subject tones as dark areas and dark subject tones as light areas. Colors are also recorded as their complementaries, or opposites. The base of the film is dyed orange, so the colors are somewhat obscured until they are printed. Color paper designed for printing negatives is coated with an emulsion that reverses the tones and colors of the negative, thus reproducing those of the original subject. Several brands of paper are available in photographic stores – Kodak Ektacolor Plus and Photocolor RC papers are popular examples. If you process your color negative films in Photocolor II chemistry, you can use the same kit to process your prints.

Making a test print

Mix the chemical solutions according to the instructions accompanying your kit and warm them to 93.2°F (34°C). Keep them at this temperature by placing the measuring flasks into a water jacket (see pp. 96-9). Place a negative in the enlarger, emulsion side down, adjust the size of the image and focus. As a starting point, select (or dial in) a 40Y and a 40M filter. Put these in the enlarger's filter drawer, together with the UV filter. This is called the filter pack.

Color analyzer
*The probe, **above**, can be held under the enlarger lens for a general reading or placed over a small area of the projected image to give a very accurate color filter recommendation.*

Gelatin filters
These filters can be used in any enlarger fitted with a drawer.

Color masking frame
As with black and white printing, the first step is to make a test strip from your negative. Since you must work in total darkness with color paper, the simple mask illustrated **right** *is an easy-to-make and inexpensive accessory. Cut away one-quarter of a piece of black cardboard the same size as the printing paper in use. Then, by reorientating the card over the paper, you will be able to make a series of completely separate exposures, each exactly one-quarter the size of the paper.*

Exposure compensation

When you change the intensity of the filter pack you also have to change the exposure to compensate. The manufacturers of the filters provide filter exposure factors for their own products. If, for example, you increase the strength of the magenta filter by 20M, look up the filter factor and multiply the original exposure by this number. Assume that the correct exposure is 10 sec and the filter factor for 20M is 1.5. You can work out your new exposure time to produce a print of the same density by multiplying 10 sec (the original exposure) by 1.5 (the filter factor) to give you a total of 15 sec. If you add two filters you must multiply both filter factors together to find the combined factor. If you need to remove filtration from the pack you simply divide the original correct exposure time by the factor of the filter you are removing. If you are removing two filters, then multiply the two factors together and use this result to divide the exposure time.

Understanding filtration

To make sense of color printing it is necessary to understand the way in which filtration works. Magenta and yellow filters used together produce red light, yellow and cyan filters produce green light and cyan and magenta produce blue light. All three filters used together produce a gray tone or neutral density, which increases the exposure. You need to bear this in mind when adjusting the filter pack.

Suppose you made a test print using a filter pack of 40M and 40Y, which was too green. In order to neutralize the green cast you could add green to the pack. You can do this by increasing the strength of the yellow filter from 40Y to 60Y and adding the same amount of cyan – a 20C filter. The addition of the 20Y and 20C produces green light. The pack now consists of 40M, 60Y and 20C, but there is now a neutral density of 20. This would work but you would need a longer exposure time because the presence of the three filters simply absorbs a lot of the light that would normally go

Color print processing

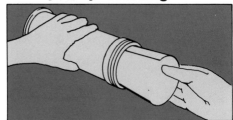

1 In total darkness, load the exposed paper, emulsion side inward, into the drum.

2 With the lid in place on the drum, you can now work in ordinary room lights.

3 Fill the drum with water at the correct temperature, which is discarded after the recommended time.

4 With the drum upright, pour in the correct amount of developer, preheated to the recommended temperature.

5 Place the cap in position and roll the drum on the bench surface for the stated time.

6 Because it takes a few seconds to empty the drum, start discarding the developer just before recommended time.

7 If your kit has a stop bath, pour the solution at the correct temperature in and agitate as before.

8 Discard the stop and pour in the bleach/fix at the correct temperature and agitate the drum.

9 Discard the bleach/fix, remove the print from the drum, and thoroughly wash and dry it.

toward exposing the printing paper. And because long exposures have their own effect on the color balance of the print, it is best to use only two filters at a time.

To overcome the problem in this example, you can achieve the same color effect (removing the green cast) by reducing the amount of red light. In this way, the proportion of green light reaching the printing paper increases. The red light actually exists in the magenta filter (magenta is a mixture of red and blue and the yellow filter absorbs the blue, leaving red). So to reduce red, all that you need do is reduce the strength of the magenta filter. When you reduce red, you increase the proportion of green light and thus correct the cast.

When you have decided on the new filter pack and any exposure compensations, make a second print. With luck, this will be correct, although it is not uncommon to have to make a further print.

Color slides

The Cibachrome process is considered the most successful method of making prints from color slides. The colors reflect very accurately the quality of the original slide and the dyes used in the paper are extremely stable. A practical advantage is that the recommended processing temperature is 75.2°F (24°C), making a drop in temperature during processing less likely.

Cibachrome paper is coated with an emulsion, which, like slide film, produces the same color as the light it is exposed to. In printing, the most important difference between the color negative and the color slide is that you have to think in reverse – more exposure makes a lighter print, less exposure makes a darker print. This is the same principle that applies to slide film in the camera. It also means that to correct a color cast you must subtract filters of that color. If your test print is too yellow you will have to reduce the strength of the yellow filter in the pack. Cibachrome paper and chemistry are sold in a convenient kit form with full instructions.

Choosing the right slide

Slides that are overexposed (too pale) will not print well. If you have made several exposures of the same subject – one exposure according to the meter reading and others half a stop and one full stop less exposure – you will find that often one of the darker slides makes the best print while the lighter version looks better when projected.

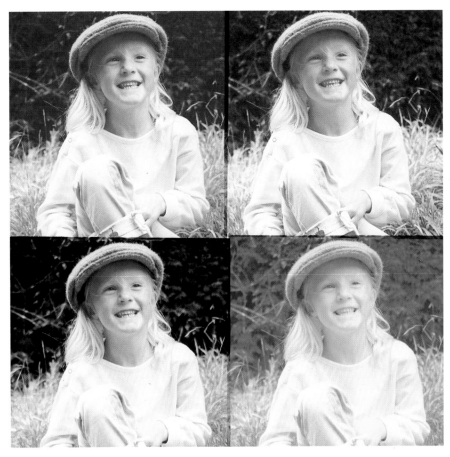

Color test print
*Once you have determined correct exposure, filtration may still need adjusting. The print **above** was filtered from top left and reading clockwise: 60Y 25M, 50Y 20M, 40Y 40M and 50Y 30M. The print, **left**, was made using filtration 50Y 30M at f 16 for 12 sec.*

Subtractive filtration
*The three complementary colored filters **below** – yellow, magenta and cyan – form a primary color where any two overlap. Where all three overlap, a gray neutral density effect is created.*

Filter pack compensation
(when making prints from negatives)

Color of cast	Very slight	Degree of color cast Slight	Considerable
Cyan	Subtract 05M and 05Y	Subtract 10M and 10Y	Subtract 20M and 20Y
Magenta	Add 05M	Add 10M	Add 20M
Yellow	Add 05Y	Add 10Y	Add 20Y
Blue	Subtract 05Y	Subtract 10Y	Subtract 20Y
Green	Subtract 05M	Subtract 10M	Subtract 20M
Red	Add 05M and 05Y	Add 10M and 10Y	Add 20M and 20Y

Hand coloring

Before color negative film was widely available, many amateur processing laboratories employed a professional hand colorer. In the last few years this process has become popular again, not as a means of producing a realistic rendition of the original scene – color film can do that much better – but to color black and white photographs to produce unusual effects, or to add striking or unrealistic colors to either color or black and white prints.

Coloring materials

Transparent water colors are usually used and these are easier to apply than oil-based colors but, for more unusual effects, you could also experiment with felt-tipped pens. You should bear in mind that water-based colors are transparent and so very often the best results are obtained with prints that are a grade softer and a shade lighter than a picture for normal viewing. If the blacker tones are still too strong, overall density can be reduced using a special bleach.

Photographic water colors are supplied as concentrated liquids, which can be mixed and diluted. As with retouching, it is easier to color fibre-based paper. Resin-coated paper can be colored but it is more difficult, since the dyes are not as easily absorbed.

Technique

Fibre-based prints for coloring should be soaked in warm water for about ten minutes. Squeeze excess water off the surface of the print and then place it on a few layers of blotting paper on the work surface. In general, it is best to start coloring the largest areas first. Mix a paler shade of the appropriate color by diluting the dyes in water. Apply several washes of the color, aiming to build up the required depth of color in stages. This will ensure even results and also avoid unsightly blotches and streaks. After each application of dye, blot off the surplus liquid using a fresh piece of blotting paper.

When the large areas of the print are colored to the correct depth, start work on the smaller areas of color. Always take care not to run the dye over the edges of the area you are working on. The dyes are designed to stain gelatin, so they cannot be removed easily if mistakes happen, although soaking the print in water again will lighten the color. The final stage of hand coloring involves applying color to any small areas of detail. For the successful application of small amounts of coloring material you will need a very fine artist's brush.

For a different treatment, you can combine hand coloring with a chemically toned print. A number of different chemical toners is available from most photographic stores and these can be used to produce an overall sepia, red, blue, olive-black or reddish brown. There is, of course, no need to color the whole of the print, and the most effective results may be obtained if you pick out just small areas and color these or, alternatively, color most of the print and leave just a small area black and white.

Partial coloring
When hand coloring a black and white print, you can often create maximum impact by applying color to only part of the image, as you can see in the before and after pictures **below**. *The original print is quite dark, and so only the lighter toned areas take the water color well.*

Retouching

Retouching is one of the skills that eventually every keen darkroom worker needs to learn. Unfortunately, no matter how careful you are there will always be some prints that have dust spots or black marks that draw attention away from the picture itself, and therefore need to be retouched after the print is fully processed, washed and dried.

Film fault

The most common blemishes are caused by fine particles of dust or dirt drying into the film emulsion during processing. Loose dust can be blown off the film surface before printing and should not cause a problem. You can, however, avoid hours of retouching simply by adding a filter to the tap used to wash the film. This will prevent the dirt reaching the film while the emulsion is soft and vulnerable. Replace or clean the filter every few months. Even if you are careful, there will still be the occasional white spot on the print, which will need toning down and blending in. To do this you need to apply colored ink or dye that matches the surrounding shade of gray, or color in the case of a color print.

White and black spots

Retouching dye for black and white prints is sold in two bottles – one brown-black and the other blue-black. Mix a few drops of each on a saucer to match the color or tone of the print. You then dilute this with a little water to make the required shade of gray. Color dyes are sold in kits and, again, you will have to mix them to match the color of the image surrounding the spot. Buy a good-quality retouching brush, which needs to come to a fine point when the hair is moist.

Very small spots represent almost no problem – simply match the strength of the dye to the surrounding tone or color and touch the paper delicately with the point of the brush. If you find that the dye or ink will not adhere to the paper – a problem most likely to occur with resin-coated paper – pass the brush across the gummed flap of an envelope. When you come to deal with larger spots, the trick is to disguise the edges of the spot first – dab tiny points of ink around the edges, imitating the grain structure. When this is done, work across the blemish in the same way until it disappears.

Black marks on a print are more difficult to remove, and they are caused by the emulsion being scratched so that light from the enlarger passes straight through the film. Special bleaches are available that can be applied in much the same way as dye or ink. The action of the bleach is quite slow and can be wiped away when the density of the black mark matches that of the surrounding print.

Another method is to scrape the black mark with sharp knife until it blends with its surroundings. You will need a special retouching knife for this, not a pointed scalpel. These are not suitable because the point is likely to dig into the paper base. Instead, you need a blade with a slightly curved point. Knifing is one of those jobs that seems impossible the first time but, with practice, you will get better.

Print reformation
Anybody producing a print with as many problems as the example **left***, should have a serious review of their darkroom procedures and practices. The print was purposely marred to give you an idea of how thorough print reformation can be, as you can see from the retouched version* **above***. A combination of different techniques was used, including knifing, airbrushing and the application of retouching dyes with a fine sable paintbrush.*

PHOTOGRAPHIC THEMES

In photography, the equipment and the ability to use it knowledgeably can be regarded as unlocking the door on a wealth of possibilities – some of these creative, or self-expressive, and some purely descriptive. Push the door open a little, however, and photography can be the vehicle for a greatly enriched lifestyle and, for the lucky few, photography can become a way of life.

In this section of the book, a wide range of subjects is presented accompanied by advice on how best to approach each one in an interesting and original way. Those included here are by no means exhaustive, but they have been selected because they encompass sufficient photographic techniques to allow you to apply the information to virtually any picture-taking situation. You can use this section in two ways. First, you can read it from beginning to end and treat it somewhat like a personal photographic course. In this way, you will be able to produce an unusually varied portfolio of pictures and, in the process, gain invaluable experience in many different branches of photography. The second approach, for the more experienced photographer, is to use the section as ready reference, dipping in here and there, extracting information about specific items of photographic technique.

Every theme demands its own approach and exercises a particular skill. Even if you are not interested in, for example, sports photography, reading and practicing the approach suggested there is a marvellous way of learning how to tackle photographic situations involving fast-moving subjects. This experience will be valuable every time you have to react quickly with a camera.

There is no shortcut to making good pictures; it takes time, practice and, often, support from those around you. In this regard, most people will benefit from working with a group of friends who meet regularly and offer constructive criticism of each other's work. This type of cooperative effort can also help off-set some of the costs of acquiring more specialist equipment.

Once the craft aspects of photography – exposure, lighting, depth of field, use of shutter speeds, and so on – have been understood, you can turn your attention to the problem of composition. Composition must be approached in a different way to technique because formulae which help to solve technical problems have only a limited value when you come to consider the arrangement of the elements within the frame.

Photographic composition

Technical knowledge serves to make material the image seen in the viewfinder; composition is the arrangement of the subject within the confines of the frame in an interesting or pleasing or orderly way. There are formal guidelines to composition, which can, sometimes, be helpful. But unless these are treated as guides only, they will lead your photographic efforts down a rather dull, predictable path.

For a feeling for composition to be acquired and applied to your own work, you have to look at good photographs, paintings and drawings. For some reason, many people who become fascinated by photography are reluctant to visit art exhibitions or even to spend much time looking through picture books. Unless you are one of the few people who have an extraordinarily developed sense of composition, you will have to learn by seeing how other people have arranged shape and color or tone within their pictures.

Learning to see

When you look at a painting or photograph, enjoy it as a picture first, and then look at it as an arrangement of shapes. Notice how the composition in good pictures connects different parts of the image together and draws attention to the most important part of the subject. Composition creates a feeling of cohesion and balance, not necessarily symmetry, in pictures.

When you put the camera viewfinder to your eye, look at the scene in front of you in the way described. Make yourself aware of the subject as a collection of

Eye-line
The line of sidewalk **above**, echoed and reinforced by its reflection in a side window, draws the eye deep into the frame. This theme is picked up by the horizontal sweep of brilliant red roof, which forces the eye to explore the very edges of the composition.

Central subject
The strength of this picture, **left**, lies in the tension created by the implied movement of the car statically placed dead center in the frame.

Repeating shapes
Strong perspective features here, **right**, with the overlapping shapes of the mountains receding to the ever-lightening blue of the horizon.

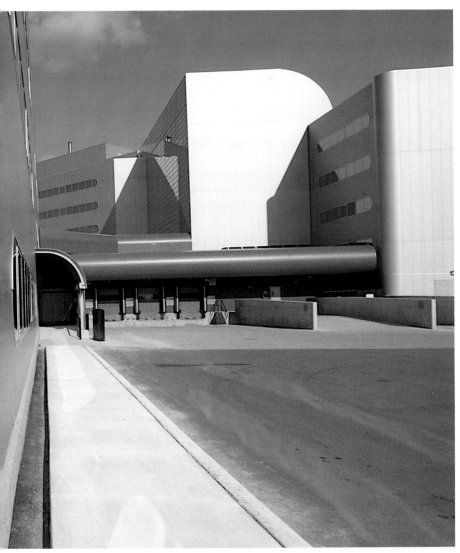

shapes within the frame and move the camera position until you have found the viewpoint that reveals your subject in the most interesting and most appropriate way. When you have the print or slide in your hands, it is often helpful to look at it upside down. This way you are not distracted by the subject itself, and you can see more clearly how the shapes fit together, or how they could be improved next time.

If you experiment with composition you will find a sense of order and balance develops in your work. Balance in photographic composition has been described as being more like a tightrope walker with a parasol than a see-saw or a pair of scales. A tightrope walker in continuous and perfect balance is only marginally more interesting than somebody walking on a concrete path. It is only through threatened imbalance, tension and movement that the performance achieves excitement and, therefore, interest.

Neither perfect technique nor a good sense of composition is enough, however. Photography is always a response to actuality; everything depends on the photographer being observant. You have to be able to pay attention to your subject. In that state of attention you will find the most powerful way to photograph your subject. It is as if the hand and eye merge with the scene in front of the camera. You may be trying to orchestrate a lot of activities in one picture or looking for a moment when the juxtaposition of simple, ordinary events reveals an unexpected image; sometimes you walk all day without seeing a single picture, then, suddenly, it is there in front of you – and you have in your camera an image that will be enjoyed wherever it is shown.

It is absolutely certain that anybody really interested in photography will find a way of taking photographs that will leave a powerful impression on the viewer. Portable photography is only one hundred years old and in a sense we are all pioneers in this extraordinary medium.

Family and friends

Many people buy a camera just to take pictures on their vacations and at other family occasions, but then find themselves becoming more and more interested in taking up photography as a hobby. The challenge then is to develop a style that combines the intimacy of the snap-shot with a picture that is interesting to look at on its own merits.

It may be that you have photographs of special occasions but you have not bothered to record the everyday events. Attempting to do this can be more of a challenge because you have to learn to see the daily routine with a fresh eye. Even if the pictures you take fall short of the standards you set yourself, they will not be wasted — they will become part of the way your family remembers its own history.

Since the actions you will be recording will be familiar to everybody, the success of these pictures will depend a great deal on the way you arrange the elements within the frame — in other words, the composition. If you look at the work of famous photographers, you will notice that there is nearly always a main point of interest, and the position of this within the frame is the first decision you have to make with your own work. Usually, however, the center of interest is not placed in the center of the frame at all, since this arrangement tends to produce a very static effect. Other elements in the picture are best arranged to balance the picture and help lead the viewer's eye to the main point of interest, which is usually positioned somewhere to one side.

Concentrate attention
Using a telephoto lens, it is possible to isolate your main subject and thereby concentrate the viewer's attention, both by excluding unwanted detail and by rendering the background unsharp, as in the example **above**.

Camera angle
A low camera angle, **left**, has helped to lift the subjects out of a potentially distracting setting by framing them against an open, clear sky.

Absorbing interest
At a certain age, children are wonderfully indifferent to being photographed, easily becoming absorbed in their own pursuits, **opposite**. All you need do is find the right environment, allow them to explore it and then stay alert to good picture-taking opportunities.

It is often worth encouraging people to choose their own setting for a portrait and really try to show them as they want to be remembered. But a gathering of family and friends usually calls for a more formal picture, and this often means posing people. In general, try not to make the group too symmetrical – people sitting in straight rows is not, usually, the raw material for visually stimulating photographs. Try to have an arrangement worked out in your own mind before you start to organize people, and it is a good idea to take some pictures as the people arrange themselves and also after the 'proper' picture has been taken – you are more likely to capture a few more unguarded expressions this way.

Picture sequences

As well as the single picture that stands on its own, look out for the chance to take a sequence of photographs. Half a dozen small pictures showing different expressions on a child's face may tell you more than one large picture. You might be able to show a baby learning to walk or older children playing or dancing more effectively in a sequence than in one image. Photographs are also very good at showing the way people change, and a series of pictures taken over a long time may become a fascinating record. Sometimes, the most simple arrangement makes for the most impact. You could, for example, photo-graph your own child on his or her birthday from the first year through to, say, the twenty-first birthday, always against the same plain white background and with very basic lighting. Pictures such as this do not require expensive cameras or elaborate techniques.

Lighting and lenses

If you enjoy taking photographs around the home and do not feel awkward, your family and friends will accept the presence of the camera as a natural part of you. When you can operate the camera quickly and confidently, people will hardly notice that they are being photographed. Try and use natural light indoors, even if it means using high-speed film. Direct flash is often inappropriate for pictures that should convey a feeling of intimacy. If you do need artificial light, try bouncing flash from a reflector or the wall or ceiling. Any camera can be used, but if you have an SLR you will probably find a moderate wide-angle and a moderate telephoto the most useful lenses. The popular 35 mm wide-angle will allow you to work in the reasonably confined conditions usual about the home, yet it is not wide enough to cause too many perspective distortions. A telephoto lens of about 100 mm will allow you to stand back and concentrate on a small group or the face of a single individual and it is an excellent lens for portraits.

Keeping records
Everyday events, such as a trip to the museum, right, need to be recorded. Although perhaps not important now, pictures like this are the stuff of happy memories in a few years time.

Changing fashion
The camera can be the best instrument to record the rapid changes of fashion through which we all go throughout our lives, below right.

Due ceremony
Graduation day is a must for the family album, but it does not have to be recorded as a stuffy, formal affair. A touch of humor, below, can help to relieve the tension and calm the nerves, too.

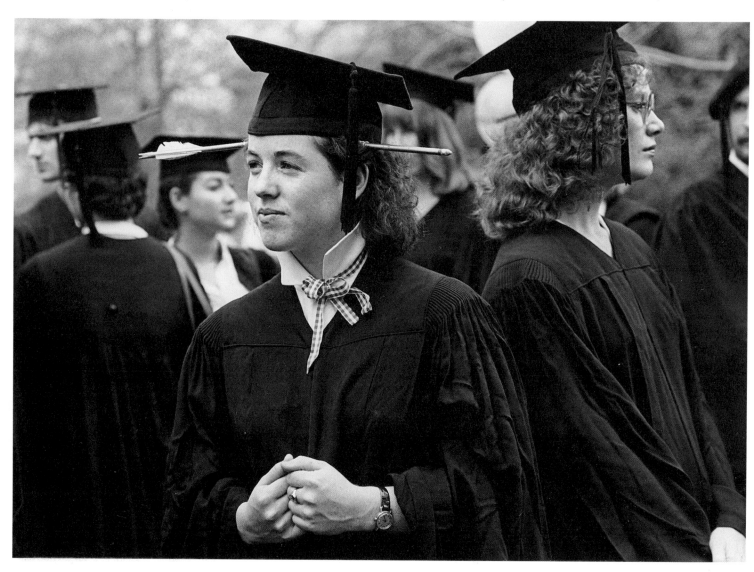

Vacations

The best vacation pictures extend the pleasure of the trip. If you can take photographs that look like your own memories of the vacation, you will have a record that you will value forever. If you want to participate in the vacation as one of the family and not just be the official photographer, a compact autofocus camera may be preferable to a more elaborate type.

Potentially good photographs are often lost by hesitating too long. The great advantage of compact cameras is that you can press the button immediately you see a special moment and you will have a sharp, correctly exposed picture every time. You can always look for a better viewpoint afterwards and see if you can improve on the first, instinctive shot. Even if your camera is not fully automatic, press the button and hope for the best if you see something that catches your eye. A slightly blurred, less-than-perfect picture may convey a more compelling impression of the scene than a second corrected picture taken when the gesture or expression has faded.

Equipment preparation

If you do buy a new camera for a vacation, or if you have not used an old one for some time, put a roll of color slide film through it before you leave to make certain everything is working properly. Allow enough time for the film to be returned from the processors. Use color slide film because it has the least tolerance to incorrect exposure. So, if your test shots are correctly exposed you can feel confident that the light meter and shutter are working as they should.

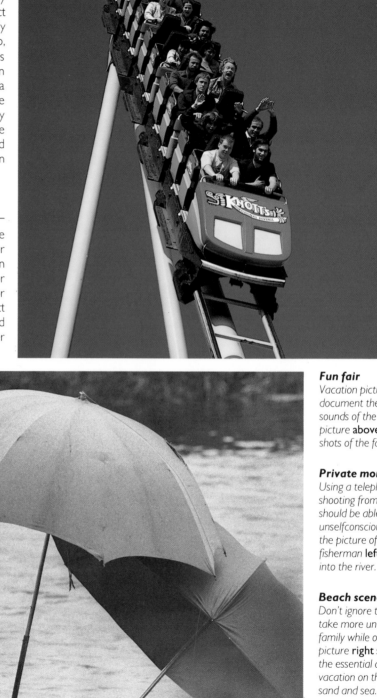

Fun fair
Vacation pictures should aim to document the sights and sounds of the trip, as in the picture **above**, not just be mug shots of the family.

Private moments
Using a telephoto lens and shooting from a distance, you should be able to capture quite unselfconscious moments, as in the picture of the elderly fisherman **left** catapulting bait into the river.

Beach scenes
Don't ignore the opportunity to take more unusual shots of the family while on vacation. The picture **right** seems to sum up the essential qualities of a vacation on the coast – sun, sand and sea.

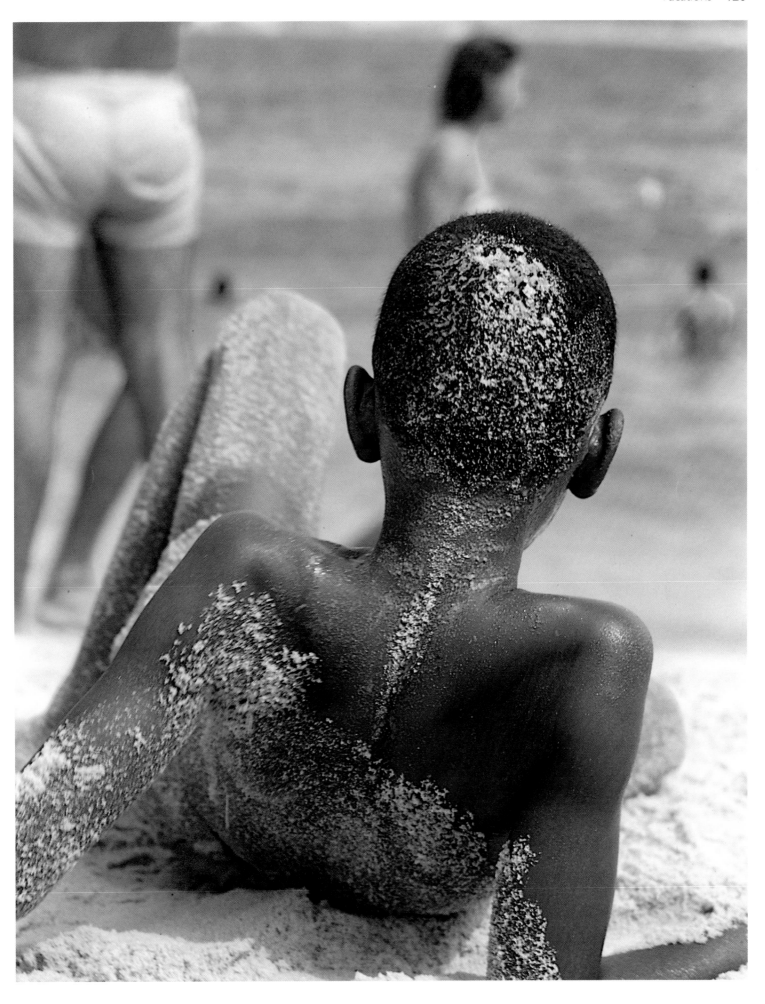

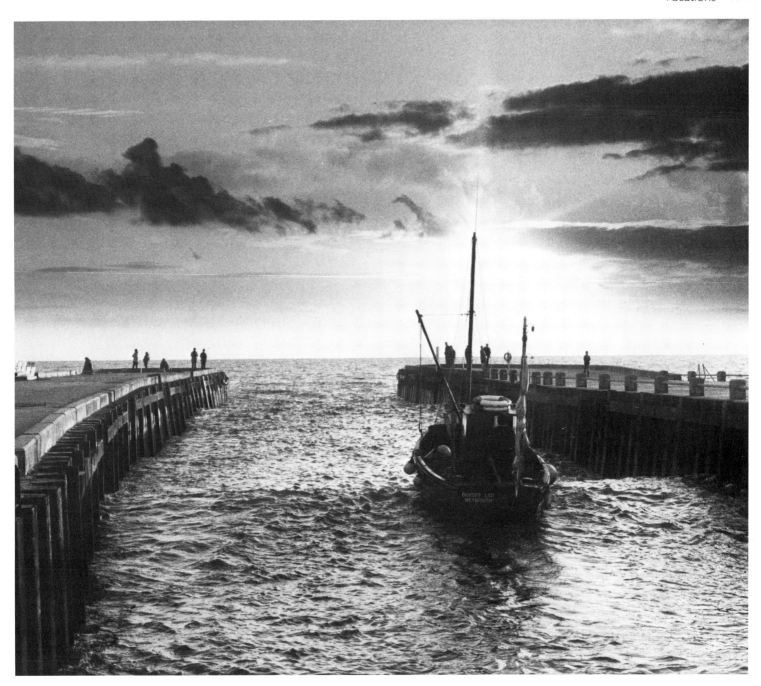

Be prepared
Good vacation pictures can happen at any time. A few enquiries at the quay was enough to discover when the fishing boat **above** *would be leaving harbor for a night fishing trip off the coast of Weymouth, Dorset, England.*

Details
Often you will find that details can be more evocative than general scenes. The picture of deckchairs and huts **left**, *with their contrasting colors and strong lines, would be welcome in any vacation slide show.*

If you don't use your camera very often, make sure you remember what every adjustable control does and how to load and unload the film. If batteries are required, put fresh ones in the camera and take along a spare set as a precaution. With new or expensive-looking equipment, take the receipts with you to avoid potential problems at customs. And, lastly, take sufficient film – it is often expensive at resort towns and in more distant places you might not be able to obtain supplies.

Picture presentation

If you are going to show your pictures as a sequence in a slide show or in an album, try to include a variety of viewpoints. A general view of your location taken from the top of a tall building or a hill will establish the setting. Vary the viewpoints of the other pictures so that you can include close-ups and mid-range shots. It is easier to keep a viewer's attention when pictures are taken this way. A series of static, posed photographs soon becomes boring

unless they are all masterpieces of composition and lighting technique.

Unposed pictures of your family and friends that show something of the new surroundings will probably be the most popular, but don't ignore little details – shop windows, architectural details, plants, and so on. Close-up photographs often evoke the atmosphere of the place very effectively, perhaps because when we see a scene for the first time we tend to look at it bit by bit, although we remember it as a complete picture.

People often put their camera away in dull weather because they want to show their vacation at its best only. Photograph the awful moments as well; disasters often make the best stories afterwards.

When you arrive home, you will have the job of editing the pictures. Your family will be curious to see all the photographs of the trip, but sort out just the ones you prefer to show your friends. The rule is that a selection of carefully chosen pictures will have much more impact than lots of similar-looking ones.

Portraits

There are many ways of approaching portrait photography, but to take good pictures you must be interested in the people in front of the camera. Ideally, a portrait should provide an insight into your model's nature and perhaps reveal something of your relationship with him or her. Some of the worst examples of portrait photography are the well-lit, well-printed pictures to be seen in the windows of most high street photographic stores. These pictures show the shape of the face, but they are totally impersonal and lacking in interest.

Being photographed is a little like a public performance. Most people, unless they are used to presenting themselves publicly, do find sitting in front of the camera intimidating. At the same time, they will probably value the opportunity to have a record of themselves made by somebody who is interested in them and who, they feel, is photographing them sympathetically.

The model

Even the best portrait photographers do not always manage to take successful pictures, so don't be too nervous. In fact, the first rule is to enjoy being able to meet somebody you might not otherwise have got to know, or spend a few hours with a friend trying to express in a picture some of the qualities you like about him or her

Try to find out through conversation what the interests of your model are. As you talk, watch for expressions that reveal mood and character. Some people's faces are constantly changing and animated, and the more relaxed you both can be with each other, the better chance you will have of capturing this on film.

If you are shy or find it difficult to put people at their ease, make your first portraits out of doors. Choose faces at random in the street and use a telephoto lens so that you do not intrude. As your photographic ability improves, so will your confidence increase and you should be able to start posing people – your friends at first and then strangers.

Backgrounds

The setting will exert a strong influence on your pictures. For a picture to be thought of as a portrait, the model will have to be the center of interest. The background can either be used as a shape, directing attention to the subject, or it can include objects that are associated with the subject.

If the background is to help describe the model, you will want it in sharp, or nearly sharp, focus. If the background is an aid to composition, you may want the model only in focus. If you are working in a studio the background will also affect your lighting, so think carefully about background color and texture before starting the session. Outdoors, your control of lighting and background is by choice of camera and subject position. To begin with, most people are hesitant to place the model in a shaded spot, although this can provide the most interesting and rewarding light. Direct sunlight is harder to use; it is more revealing and less flattering. It should not be discounted, however, because it can be ideal for

Framing/I
Portraits can be effectively composed, **above,** if the main interest is off centre.

Lighting
Natural daylight, **below,** is often best for informal shots.

Framing/2
Hair can also be used to set the model's face off, **right.**

some faces. Whatever light you choose, place the model so that he or she can look at the camera without squinting.

Halfway between an informal outdoor portrait and a studio portrait is the picture taken in the model's own home. It helps if you are able to visit the location before the picture session so that you can work out the time when the light is best for the backgrounds you intend to use. If you are going to use artificial light, you will be able to plan a lighting scheme, although, with the use of a tripod, exposures in natural light of up to 4 sec are possible, provided your model is comfortable and can sit still. Remember to take along a sheet of white cardboard to help reflect light into darker shadow areas – a particular problem when using very contrasty and directional window light.

Combining the elements

When you have worked out the background and camera angle, look carefully through the lens at the subject and decide how much of the frame you want to fill with the face. For a 35 mm camera, the lens often used for portraits is from 80 to 90 mm. The slight distortion caused by lenses of this focal length tends to flatter the subject. A lens of this length will not produce the perspective-flattening effect noticeable with longer lenses. Shorter focal lengths – 35 mm and less – tend to produce unattractive facial distortions when used close enough for a head-and-shoulders shot. Unusual portraits, however, can result from ignoring these recommendations. After all, flattering, head-and-shoulders shots are not necessarily what you want to produce.

While making these choices, it is helpful to explain to the model what you are doing and ask him or her just to sit without worrying about expression. With practice,

Group portraits
For the family group portrait, **left**, *a 50 mm lens was used so that a little of the home could be shown, too. Window light was the sole source of illumination, and so the photographer used a large piece of white cardboard, just out of shot, to bounce a little light back into the shadow areas on the left of the figures.*

Photographing children
Children can be much more natural and uninhibited in front of the camera than adults usually can. For the picture on the **right**, *the photographer used a 135 mm telephoto lens and a wide aperture to throw the background completely out of focus. Although initially quite serious, he soon relaxed and become animated when the photographer suggested his mother start talking and joking with him.*

Appropriate lighting
Portraits of people accustomed to being in front of the public, such as the ballet dancer, **left**, *are relatively easy to pose. Although a studio shot, the photographer has arranged the lighting in a very theatrical way, spotlighting her as she would appears on stage. The set is also reminiscent of the scene you would expect to see in the wings of a theater.*

these factors will be resolved quite quickly. Allow yourself to be guided by your own sense of arrangement. When you have decided on background, camera position and focal length, look very carefully at the lighting. In the studio, where you have complete control over lighting, you can expect to spend some time finding the best effect. It is a good idea to have some schemes worked out before you start but, overriding these, the personality of the sitter and the relationship you develop with him or her should be your guides.

When the lighting is pleasing, concentrate on expression. Be prepared to shoot lots of film: you are trying to capture the moment when the expression, camera angle and the relationship between the subject and background and lighting are all in harmony. When you set the picture up you have to think of these elements separately, but when you start taking pictures all these have to be considered together. It sounds difficult until you try, but much of this soon becomes instinct requiring surprisingly little conscious thought. Then there is a real delight in portrait photography, which your model will sense and respond to.

You may find it useful to use the camera on a tripod even when there is sufficient light for short exposures. If you can select a small aperture, the large depth of field will allow you to talk directly to your model without looking through the viewfinder. You can then move from one side of the camera to the other while you talk. Your model will then move his or her face to follow you and will, hopefully, more easily forget the camera.

Still life

Apart from the opportunity to create some potentially lovely images, the decisions you have to make when arranging and lighting a still-life picture will go a long way in teaching you how the camera 'sees'. In most cases, working with still-life subjects is a very solitary pursuit – you decide on subject content, arrange the composition and manipulate the lighting. As you carry out these tasks, you should be developing the instinctive ability to look at the subject and to see it as a photograph. You do not depend on anybody to model for you or to help you, and so you can work alone and at your own speed.

The raw materials

The best examples of still-life photography can be found all around us – for example, advertisements, book jackets, and record sleeves. Look critically at these as pictures, see how the objects used have been arranged and lit and at the camera angles used. The photographic quality, which is usually of a very high standard, can in most cases be attributed to the sophisticated, large-format cameras used by highly specialized commercial photographers. Their first attempts at still-life, however, would probably have shown a few common household objects photographed on the type of camera any of us may own.

This is a good way for anybody to start. Collect objects from around the house or garden to start with. Still-life pictures usually show objects linked by a theme, but you could select them simply for their shape or texture. In the course of making a series of still-life pictures, you should aim to include objects with different surface characteristics. At first, select objects of all one type – either all smooth or all textured – and experiment with different lighting schemes until you are satisfied with the results. Then try set-ups including a combination of different surfaces and use your experience to arrange a lighting scheme that suits both types of object.

Found subjects
Still-life subjects are all around us. In the example **above**, *cast shadows are an important compositional element. In the shot* **below**, *a shallow depth of field has successfully isolated the main subject.*

Equipment and accessories

Because most of the objects you will be working with will be quite small, you will need a table to stand them on and some sort of backdrop. This can be a roll of cloth or paper or even a piece of wood. But make sure that the surface of this material does not overpower your actual subjects. The background will probably occupy a large proportion of the final picture and needs to be considered carefully so that the color or tone complements rather than competes.

A tripod should be considered an essential piece of equipment for still-life pictures. Long exposure times are frequently employed and you will spend much of your time staring through the viewfinder, assessing lighting and composition. A 35 mm camera and slow film will produce excellent results, assuming you will not be going for massive enlargements. There is no denying, however, that still-life subjects are improved by the use of a larger-format camera, using 120 film.

Mount the camera on your tripod and start arranging the objects to be photographed on the table. If you are using a background paper or cloth, arrange the material so that it gently curves upward and is then pinned to a convenient wall. Build up your arrangement of objects, starting with the most important and then adding the others around it. Experiment with different arrangements, looking at the set-up frequently through the camera viewfinder. When you see a pleasing arrangement make a quick sketch of it, which can later be referred to when you are ready to start taking pictures. Try for as many interesting compositions as you can, using the same objects. The value of doing still-lifes is partly to see the effect shapes make as you move them about within the confines of the frame.

Lighting

Arranging the elements
*Still-life photography allows you to concentrate solely on details such as texture, form, shape and the arrangement of elements within the frame. In the picture **above**, the photographer has restricted nearly all color to browns and beige and introduced contrast between the coarse texture of the bread, accentuated by strong sidelighting, and the smooth form of the crock.*

When you feel you have exhausted all the possibilities, choose one of the reference sketches and replace the objects in the positions indicated. You now have to consider the lighting.

Don't think it essential to use studio or artificial lighting. You can, for example, arrange your table by a window or against a north-lit wall outdoors. If you decide to use window light or artificial light, the first consideration must be lighting direction. Low light raking across the subject will emphasize any surface texture and will also cast long shadows, which have to be considered as part of the composition. If the main light is in front of the set, the objects will look less three dimensional but color will be better recorded.

Look carefully to see if the shadows need lightening. If

so, use a piece of white card on the shadow side and move it just close enough to lighten the shadow so that detail will be recorded in those areas. If you are using artificial light you can shine the light directly at the card, which should be positioned so that it reflects it just where you want it on the set. For more information on studio lighting techniques, see pages 82-5.

Be sure to make diagrams of the lighting set-ups you actually use and when you have prints file them with this information. Still-life photography is an excellent way to learn about lighting, but the lessons are easily lost if you fail to keep good records. It takes experience to judge how close, for example, to place the reflector board. Make several exposures at different positions and look carefully at the prints along with the lighting diagrams. You will be pleasantly surprised at how quickly you develop the skills to light effectively when you work in this disciplined manner.

The nude

When you take an ordinary portrait, you nearly always aim to produce a recognizable image of your subject. You can approach photographing the naked body in much the same way, in which case the points discussed on pages 132-5 apply, as you will be producing portrait photographs of people without clothes.

There are, however, other ways to approach this theme. One of these regards the body as a flexible reservoir of abstract shapes. Either by framing, viewpoint, lighting or choice of lens, or a combination of any of these, the human body can be presented in a totally unexpected and surprising way.

The nude as abstract

When taking still-life or portrait photographs, there are certain conventions that are nearly always adhered to. Lighting, for example, is usually arranged so that one shadow only is cast and the effect will, in general, suggest daylight; extreme wide-angle or telephoto lenses are not often used because they distort the subject. All these conventions can be put aside when photographing the nude as an abstract form.

Instead of soft, suggestive lighting, you can experiment with flash and daylight used in a way that contradicts natural lighting patterns, or use harsh daylight to drive out any hint of flattering form. Mismatched film and light sources can also be used to help the abstraction process. Window light used with tungsten film, for example, will create a cold blue cast, while daylight film used in tungsten light will produce a warm orange cast. Try using a slow shutter speed and ask your model to move different parts of his or her body to create strange pictures, partly blurred and partly sharp. One of the most obvious ways to abstract the shape of your model is by using extreme focal length lenses. Wide-angles, because of their extensive depth of field (see pp. 54-9), can be used close in to the model, yet still include the whole figure, making the parts of the body nearest the camera disproportionately large. Telephotos can be used to isolate different parts of the body, helping to show the body as a collection of interesting shapes and textures.

The casting aside of photographic conventions does not make it any easier to take good pictures. The challenge of arranging shapes within the frame is no different. But by using as your subject the most familiar object there is – the human body – and photographing it in a non-representational way, you can gain an insight into composition, which may flow through to and benefit the rest of your work.

There is a practical advantage to approaching this area of photography in this way. Very few amateur photographers can afford the services of a professional model, so it is likely that your model will be a friend, who will probably appreciate a more abstract approach. Of course people are very individual in their responses, but it is natural to assume that your model is going to be, at least initially, a little shy. Much of this early awkwardness can be dispelled if you, as photographer, have rehearsed in your own mind a few set pieces. You will have in front of your camera somebody probably feeling at their most vulnerable, and he or she will be waiting to be told how

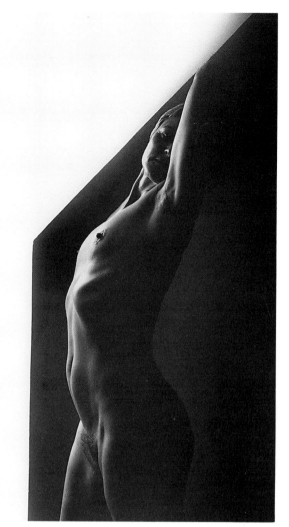

Standing nude
Imaginative use of light and shade adds interest to this simple picture of a nude woman, left. Her body, deeply arched to follow the shape of the steeply sloping attic roof, is only half illuminated by floodlights from the left – reproducing the pattern of light and shade within the room.

Body decoration
Nude photography can be the vehicle for simple, fun images. If your artistic talents are good enough, try decorating your model's body, as in the picture right. Your lighting should then be as even as possible, just as if you were photographing a canvas.

and where to sit, lie or stand. Have at least half a dozen ideas prepared for different photographs.

Lighting effects

If you are shooting outdoors you are not completely at the mercy of the sun. A wide variety of effects are possible, for example, simply using a flashgun. The most obvious use of a flash outdoors is to lighten unattractive shadows, but a combination of slow shutter speed, flash and a moving subject can create a strange mixture of sharp and blurred imagery. Flash can also be used to produce a secondary shadow. Reflector boards, used either in combination with the sun or with flashlight, are helpful for producing a more general, descriptive lighting scheme.

Once you move indoors to the privacy of a temporary or permanent studio you have a much greater control over lighting. Very directional light, perhaps from a window or studio lights, will maximize skin texture, cast the strongest shadows and reduce the number of skin tones. With this type of lighting, even very small movements of your model will change the overall lighting effect dramatically. The more diffused your lighting scheme the more soft and rounded will your subject appear. Skin texture will be lost, or at least minimized, as a result, but you or your subject will be able to move quite freely within the confines of the set without much altering the general lighting effect.

Window light
For informal nude pictures, you don't need anything more elaborate than a window to provide all the light necessary. In the picture of the male nude right, ASA/ISO 400 film rated at ASA/ISO 800 was used in order to create a more atmospheric, grainy image. Sidelighting has created deep pools of shadow, with only the top edges of his arm, torso and legs catching the light.

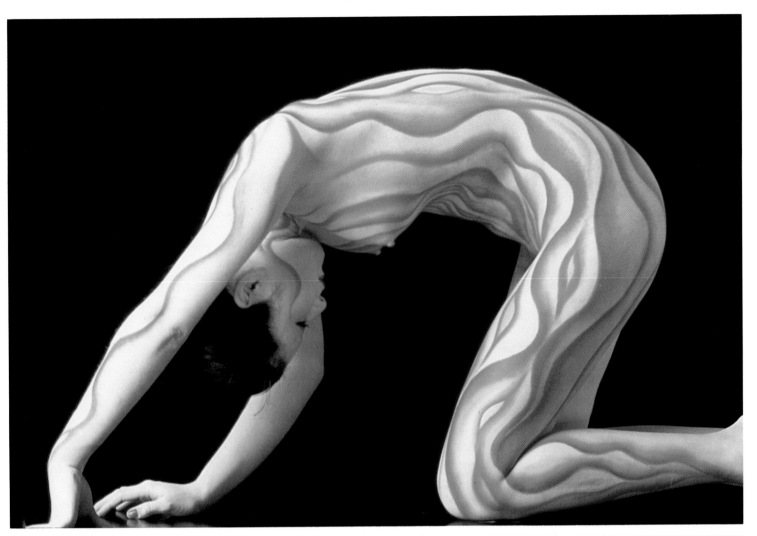

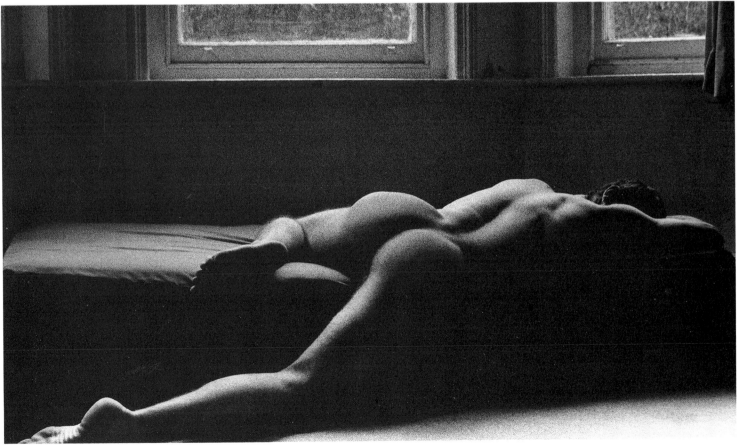

Landscapes

If you are out walking in the country and come across a beautiful stretch of scenery, the natural response, if you have a camera with you, is to photograph it. Unfortunately, the result is nearly always disappointing. Our eyes take in an enormous expanse of land, follow a distant line of hills against the sky and enjoy the grass and flowers growing at our feet.

A photograph can show only part of this view, so the first point to bear in mind when you take landscape photographs is to forget completely the whole view and look only at the scene presented to you in the viewfinder. Learn to see the land as pattern and color (or tone if you are using black and white film). Not all views that are lovely to look at make impressive photographs, and views that might not be lovely in themselves can make powerful photographs. The photographic grand-view, even if it is made on a large-format camera capable of recording fine detail, will never compare with nature. The landscape may have provided the subject but you have to select a detail that fits within the frame.

Lenses for landscape

The common fault with many landscape photographs is that often there is only part of the picture that is interesting enough to hold the viewer's attention. In real life we might concentrate on looking on one small area

that fascinates us. But because we look at the whole of a photograph, all the elements within the frame are important and must complement each other. Let us suppose that there is a line of hills you want to photograph. You could take a picture with a telephoto lens so that the frame is filled with just that part of the landscape or, alternatively, you could look for something in the foreground that echoed the shape of the hills and that could be used to lead the eye to your main subject. To achieve this, you might have to change your viewpoint or even your lens. A wide-angle lens will create the greatest sense of depth in a picture because it will include more of the foreground – distant objects will, therefore, be recorded smaller in scale. When you use a

Storm light
Dramatic lighting effects often occur just before a storm breaks, **above**.

Bryce Canyon, Utah
Slow ASA/ISO 50 film has recorded every rugged detail of this spectacular landscape, **right**.

Winter light
Even familiar landscapes are transformed in the muted light of winter, **below**.

wide-angle lens you will soon find that changing the camera viewpoint slightly has a major effect on how much foreground is included, but the scale and position of more distant objects is not affected very greatly.

A telephoto lens can be used to good effect for taking landscapes. They mass objects together, creating a cramped perspective, and allow you to fill the frame with more distant objects. You also have more control over color composition with a telephoto, since you include smaller areas of land.

Film considerations

If you use a 35 mm camera and want to record the finest possible detail, use a slow film and support the camera on a tripod if shutter speeds become too long. Although a tripod can be inconvenient to carry around, it will frequently enable you to take landscape pictures that would not be possible with a hand-held camera. Very often, the light is most interesting when there is not much of it – in the early morning or toward evening. If you use small apertures to maximize depth of field, coupled with a slow film, you will often be forced to set long exposures with the camera on a tripod.

Using a tripod, you will also be able to experiment with a technique involving moving water. Choose a viewpoint that includes a stream or brook, mount the camera on a tripod and allow an exposure of at least 5 sec. If there is a lot of light, even the smallest aperture and slowest film will still result in overexposure, so you will have to use a neutral density filter over the lens (see pp. 90-1). These filters reduce the amount of light reaching the film without affecting the tone or color balance of the light. The resulting photograph, instead of showing the water approximately as it appears to the unaided eye, records it as a soft, feathery, semi-solid body forming itself round the rocks and banks, which record as normal. It is a lovely effect in itself but, like any technique, you still have to arrange the shapes in the picture so that they work together into a satisfying composition.

Filter effects

Skies in landscapes often cause problems. If you are using black and white film and you want to record the blue sky as a tone in the resulting print, you should try using either a yellow, orange or red filter over the camera lens. With no filter, the sky is likely to record as pale to white and so clouds, especially white ones, will hardly be visible.

A medium-strength yellow filter will record blue sky as a light gray tone, which will look quite natural in a print. For a more dramatic effect, try an orange filter, which will record blue as a mid-tone, or a red filter, which will record blue as very dark gray or even black. Color film will record blue sky and clouds quite accurately without filtering, but if you want to intensify the sky color you can use a polarizing filter. Grey graduated filters are also very useful. They darken the grey without affecting the tones of the land below.

The quality of light

Light is the moving or variable element in a landscape. It is constantly altering our impression of the view. There is

no good or bad light. Each has its own quality suitable for certain pictures but not for others. If you only photographed one landscape you could make endless pictures of it if you visited it in different weather conditions and at different times of the day. In the past, especially, photographers looked for dramatic lighting, with the sun low in the sky emphasizing texture and the contours of the land. More recently, however, there has been a reaction against this approach and photographers are experimenting with light previously felt to be less attractive. Try yourself taking pictures when the sun is high overhead or on a dull day. It will initially be more difficult because we have all been conditioned to seeing dramatically lit images. But it is rewarding to take really original pictures that will help other photographers see new ways of approaching a familiar subject.

Creative shutter
*A swiftly flowing stream in the Great Smoky Mountains National Park, TN and a shutter speed of 7 sec have combined to produce the unusual image **above**. A neutral density filter was necessary in order to stop the film overexposing.*

Graphic qualities
Black and white film has been used here, **left**, to produce a strongly graphic image. The gray sky of winter has been rendered white – the perfect backdrop for the skeletal forms of a simple, single row of trees snaking into the distance.

Land usage
Landscape pictures can also feature human habitation and land usage, **below**. This mountain village in the highlands of Nepal seems to be in total harmony with its surroundings.

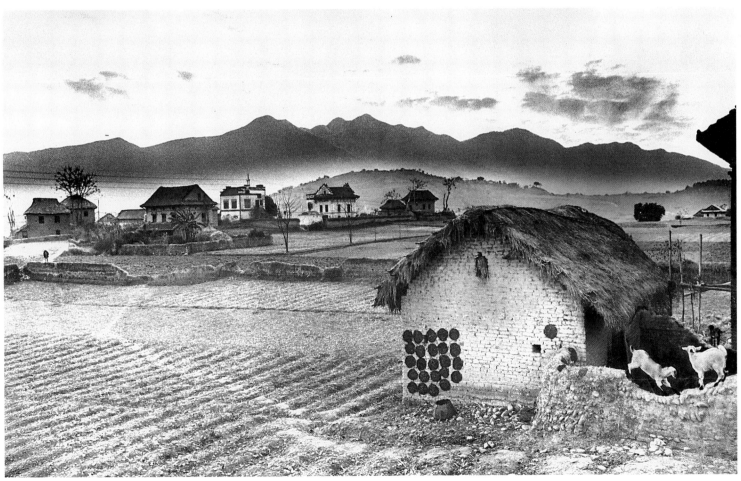

Sunrise and sunset

Film manufacturers' profits would be greatly reduced if the color of the light did not change so beautifully at both sunrise and sunset. But, as with any popular subject for the camera, it is worth trying to find a new way of approaching the subject. Usually, people direct the camera at the sun itself and there are many lovely pictures of cityscapes, mountain ranges, trees and boats outlined against an orange sky. Even though at sunrise and sunset the sun is relatively weak, you should still be careful before you include the actual disk of the sun in the viewfinder, since it could still be strong enough to cause permanent damage to your eyes.

Different types of pictures can be obtained by turning the camera away from the sun and seeing how the warm light shining from a low angle in the sky illuminates the land or makes complicated patterns on a building or 'spotlights' a few faces in a crowd.

There are no special exposure problems when photographing the setting or rising sun. Aim the meter at sun and expose for the value indicated. If you want more detail in the foreground, open up one stop. If you do this, the colors of the sky will not be so saturated, but you cannot have everything. If you use a wide-angle or even a standard, the sun itself will appear smaller in the picture than you remember it. A telephoto lens will emphasize the sun and even if the picture is not startlingly original you can be reasonably certain that it will be enjoyed by your friends.

Selective focus
The dying rays of a brilliant orange sun are reflected and returned by quiet lake waters, **left**. A 50 mm lens was used and focus was set for the foreground reeds. This has shown the disk of the sun itself out of focus, spreading and diffusing its light and, hence, increasing its apparent size.

Morning light
There was no alternative but to photograph these fishermen in this light because this is when they do their job. The challenge was to make good use of the low light and its silhouette effect, using fast colour film.

Reflected light
The rising or setting sun can act as a rosy-colored spotlight, picking out and highlighting individual structures. The highly reflective glass surface of the building **right** almost seems alight with the warm glow of the evening Californian sun.

Street life

Perhaps one of the richest and most rewarding of all photographic environments is open to all of us – the streets. There is an extraordinary feeling of freedom in walking out in the morning with a camera and a few rolls of film with no special plans.

Photographic 'seeing'

What is it photographers are actually looking for when they take time off from more commercial pursuits and take pictures for themselves? One approach is to try to catch on film the moments we all record in our memories from the constant stream of images taken in by our eyes. When you walk down a street you do not recall the continuity of that walk. Instead, you remember certain moments – a strange juxtaposition of events, an expression on somebody's face or perhaps a piece of graffiti on a wall or a jumble of torn posters. It may be a strange pattern made by the traffic and people trying to cross the road or a child with a toy gun walking past a soldier. Your pictures will reflect what you find strange or amusing or sad or happy.

To put these moments on film you have to learn to be observant. Most of us do not look very closely at our environment; looking demands a certain energy on the part of the spectator. Pictures are constantly forming on the retina, but the mind behind the eyes is aware of only a few of them. If you want to be aware of the potential pictures around you, you need to be tremendously curious and learn to experience what you see. You cannot do this if your mind is constantly thinking about

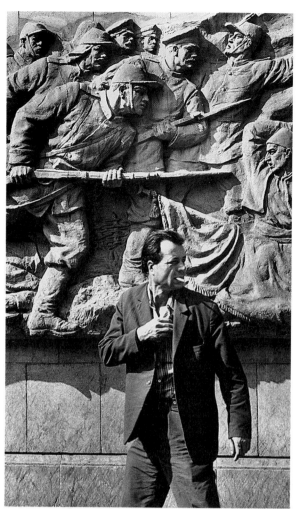

War memorial
A suitable backdrop was provided by the bas-relief figures of the war memorial, **left**. All that was necessary was then to wait for passers-by to enter the frame. In this picture it appears as if something has attracted the attention of all the characters.

Street venues
Street festival and carnivals are usually rewarding places for the camera. This performer, **right**, in full clown's outfit and make-up, immediately became the focal point in the otherwise dowdy city surroundings.

Street mural
Shoppers in the shot **below** look surprisingly similar to their painted counterparts on the walls behind.

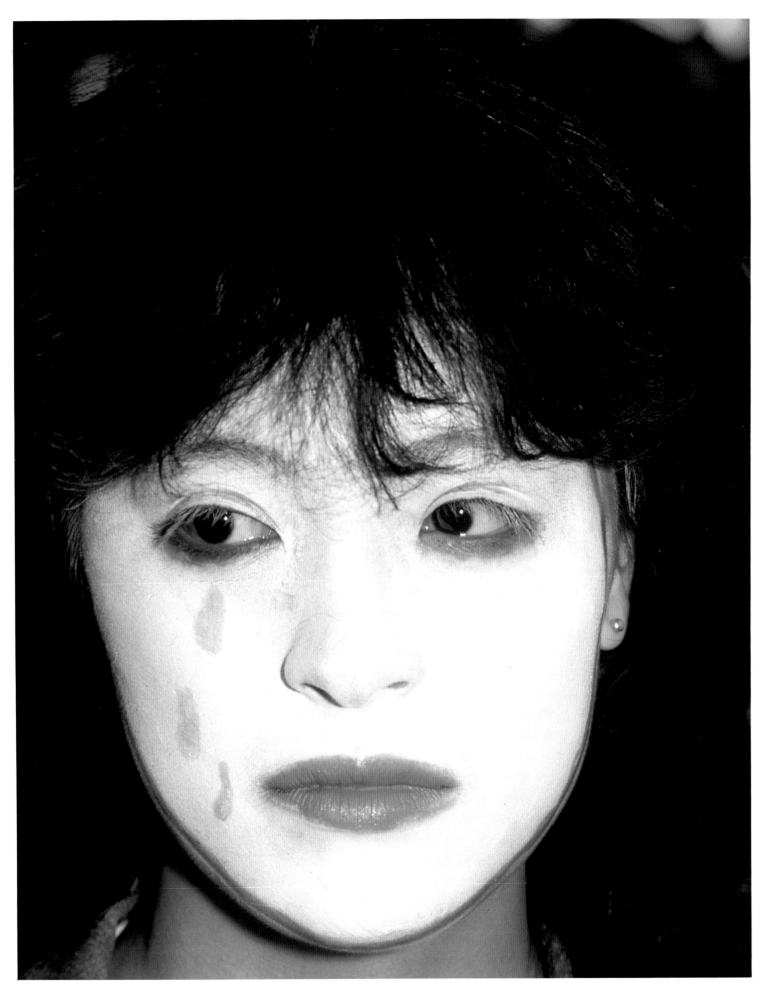

yesterday or tomorrow – you have to pay attention to and be curious about what is going on now.

For successful street photography, another skill you need to develop is that of blending in with your surroundings. Choose clothes that do not draw attention to yourself and don't carry a large flashy camera bag – just a small, reasonably quiet camera with, perhaps, a spare lens in your coat pocket and a few rolls of film.

It helps if you are completely familiar with the camera you take. It is difficult to be 'invisible' when you are struggling with the controls. People are less likely to notice you when your hands operate the camera confidently. Another advantage of knowing your camera well is that you will be able to react more quickly when a photographic opportunity presents itself: you are, after all, photographing strangers going about their normal business, not posing for pictures. You will be surprised just how little notice will be taken of you if you work quickly and confidently. If, on the other hand, you feel awkward and embarrassed, the people you attempt to photograph will feel the same.

Be prepared, though, to encounter a hostile reaction if you do not exercise tact about when and where you point your camera.

Another approach is to find a background and wait for something to occur in the foreground to either complement or contradict it. You may have to return several times before you get what you are after or, if you are lucky, it might happen straight away.

Another picture may show several apparently unrelated type events, joined together by the composition. It takes considerable experience to choose the right viewpoint and moment when everything within the frame is in the correct place. Even the best photographers do not expect to take many really good photographs of this type in a year. They do, however, expect to work very hard and to use a lot of film, and then to edit their results very critically. When you have learnt to discard the pictures that are quite good, and print and present extremely carefully only those that are really excellent, you are on the right path.

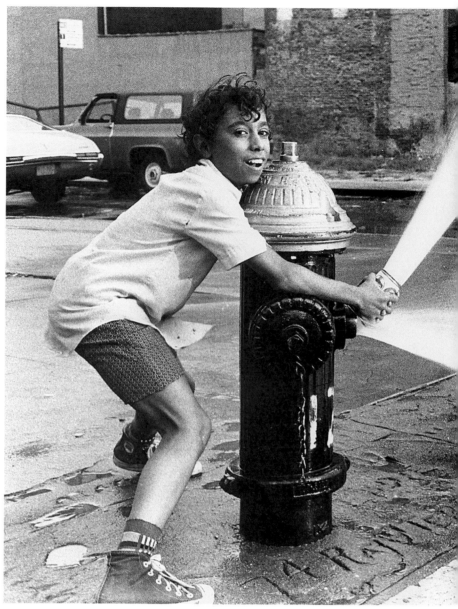

Political comment
Looking a lot like a Hollywood set, **left,** *this picture was in fact taken in Rumania as their huge political portraits were being brought out for the annual May Day celebrations.*

Summer relief
A gushing hydrant, a hot summer's day and a young boy are the perfect ingredients for this spontaneous slice of street life. Notice how the split stream of water makes an ideal frame for the distant graffiti.

Odd couples
Sometimes you have to rely on luck to provide you with the raw materials for a good shot, but you must stay alert to take advantage of the situation whenever it arises. This odd pair of couples were photographed on the fringes of a Thanskgiving Day Parade in New York.

The picture story

The first picture stories were developed by the photographers and picture editors working for the great illustrated picture magazines. The construction of these stories follows the traditional pattern of movies and prose stories – they require a beginning, a middle and a conclusion. They may tell of experiences common to many people by focusing on one typical individual; or they may convey impressions or attitudes about a place or situation. If, however, your particular interests are more theatrical, you could concoct a completely fictional story using actors (who could well be your friends, rather than professionals) working to a script.

Know the guidelines

Whatever the subject, there are certain ground rules that are useful to understand in order to plan the pictures to be used as a narrative sequence.

Before you start taking pictures you must research the subject thoroughly. Make a list of the facts that the pictures must convey. When you visit the location, first spend some time without a camera and try to see how you can translate the ideas you have into pictures. It is possible to divide the pictures you will need into four broad categories. The first is an establishing shot, which should show where most, or all, of the pictures are taken as well as providing an impression of the location in the viewer's mind. The second, and most important, picture

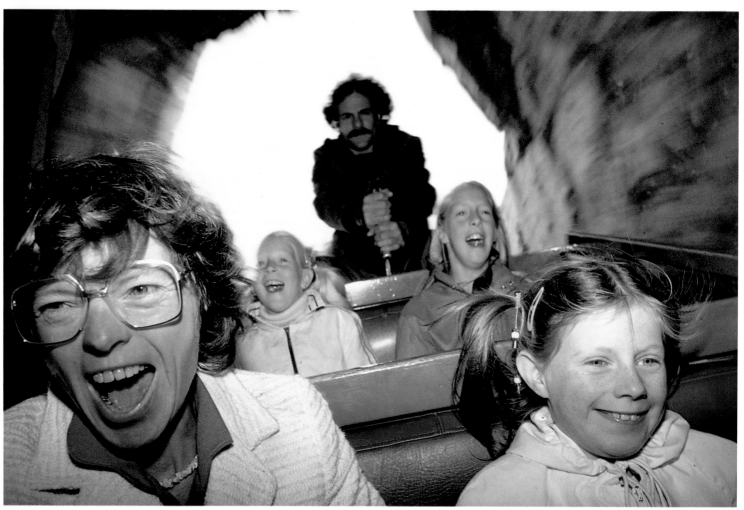

Tivoli Gardens
*All the shots on these two pages were taken in the Tivoli Gardens, Copenhagen, Denmark, and they could form the basis of a picture story. Picture 1 **above left** is the establishing shot, which shows where all the action is set. Picture 2 **below left** is the lead shot, and its purpose is to arouse curiosity in the viewer. Picture 3 **above right** is designed to start filling in some additional information about the location. Picture 4 **below right** is the concluding shot and it has to try to encapsulate how you feel about the location.*

is called the lead picture, and its purpose is to arouse curiosity in the subject of the story. It needs to be a particularly good picture in its own right, and if your picture story is going to be presented in an album, this picture could be enlarged to run over one or even two pages. It does not matter how hard it is obtain this shot, the story is not complete until you have it in the camera. The object, then, is a picture interesting to look at in itself, but which will make the viewer inquisitive enough to turn the page.

The third category of pictures have to communicate information about the subject – the flesh on the bones of the skeleton, if you like. The viewer is likely to be more interested in following the narrative if the pictures are made from a variety of camera angles or viewpoints. Choose mid-range, vertical and horizontal pictures, with the view of documenting, as elegantly as possible, the issues you want to draw attention to. However big or small the subject, most of the visual information will be

conveyed through these pictures and, if the story is to work at all, they must make their point clearly. Picture sequences taken from the same camera position can be very effective for showing the changing elements in a series of pictures. When layout considerations allow, an action sequence is most effective when presented vertically so that the eye can jump directly from the center of interest in one picture to the center of interest in the frame directly below.

The fourth, and concluding, type of picture, like the lead shot, can be difficult to find. It is important to end the story with a single, well-framed picture that sums up your feelings about the subject.

Story presentation

A picture story is only half complete when the photographs have actually been taken. You will next have to edit the material extremely carefully. If you have been taking prints, the size of the photographs on the page can be varied according to their importance to the narrative and the impact you wish them to have on the viewer. Transparencies should be arranged in their proper sequence and then put in a slide tray.

Very few picture stories will be complete without words and it may be best to work with somebody with a talent for the written word if you do not wish to take this aspect on yourself. Usually, ordinary curiosity requires more information than pictures alone can convey; people and places need to be identified and relationships explained. Apart from this, a written description is needed to elaborate on what is happening in the pictures themselves.

One form of text that photographers have produced themselves, and which combines well with the pictures, is tape-recorded interviews. It can mean a lot of additional time and effort transcribing and editing taped conversations. But when it is done, the spoken word and pictures can bring an impressive sense of realism and immediacy to the work as a whole.

Travel

A distinction is made here between holiday pictures and travel photography. Holiday pictures tend to be personal photographs of your family and friends on holiday. This section is written for people setting out on a journey who want to use the chance to explore a culture and try to convey in pictures the experience of being there.

Local customs

The chance to travel and explore distant countries is available to increasing numbers of people today, and it is extremely important to understand the cultural and ethical values of the country you are travelling to. This is especially important if you are a visitor in a country with a strong religious or political tradition different from your own – it is easy to give offense.

An ordinary sense of courteousness will prompt most travellers to learn enough about the local customs to avoid giving offense. If, however, you intend to make a photographic record, your research needs to be much more thorough. The more you understand of the place before you arrive the more ideas you will have for pictures. There are bound to be some restrictions – in some countries you are not allowed to photograph women, in others it is bridges, while in the communist world you are not allowed to photograph anything remotely connected with the military or police, whereas in other countries the military are proud to be included

in your pictures and religious ceremonies are out of bounds. The greater your understanding of the culture the more easily you will be able to blend unobtrusively into that society.

Before you go, find out if there are any festivities or parades during your visit. If there are, plan your itinerary around these dates. Photographers tend to be welcome and you have the chance to photograph people in an uninhibited mood.

Different approaches
Good travel pictures can concentrate on just an isolated detail, **above,** *or a monument of international fame, such as the Arc de Triomphe,* **below,** *or attempt to show something of the local people,* **right.**

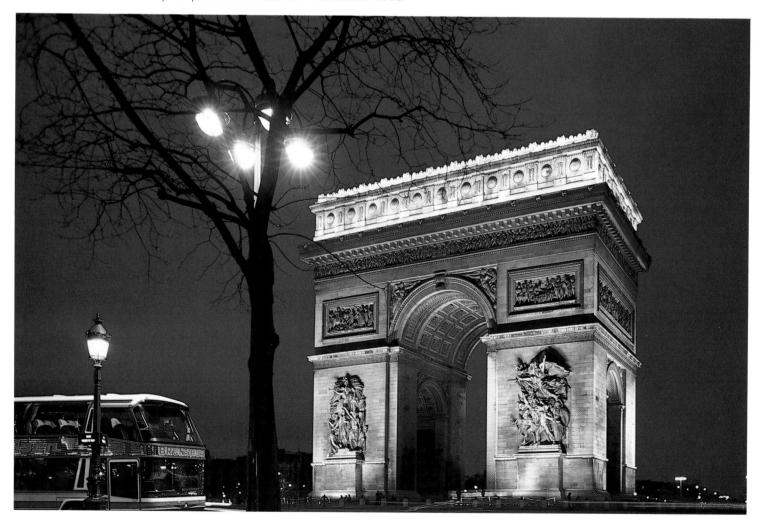

Daily routine
*You will stand a much better chance of taking more interesting photographs on your travels if you try to fit into the daily routine of the country you are in. For the delicate, almost intimate photograph **above**, of an Indian woman fetching water from a local river, the photographer had to rise at 5 am – the usual start of the day for this rural people. In a situation such as this, do ask permission before intruding.*

Be prepared

Take clothes which suit the climate, especially shoes – you will probably be doing a great deal of walking. Make sure your equipment is insured and that you have photocopies of receipts for all your equipment with you. If you expect to be off the beaten track, it is a good idea to have a small medical kit.

Before departure, check all your equipment thoroughly, allowing time to have any necessary repairs carried out before leaving. Your choice of film is, of course, a matter of personal taste. It is always difficult to calculate the number of rolls to take with you, but you can make an estimate by counting the number of days you expect to be able to spend taking pictures and multiply that by the number of rolls you use in a day at home when photographing a special event.

When you arrive, find out when people get up. In some countries beautiful religious ceremonies take place at sunrise. Also find out when people go to work and when the evening rush hour is and then fit yourself into the routine of the country. In most towns and cities there are certain streets where people tend to parade in their

best clothes. Find out the characteristics of the different areas of the city or town.

An attitude of mind

Photography is a solitary pursuit. You may go with friends but if you hope to take good pictures you must be prepared to be on your own when you are working, unless you are with somebody you do not need to talk to.

If you look interested in what you are doing people will be more inclined to talk to you. Explain that you are trying to make a record of the country, or city, or village. (A phrase book will be handy if you don't know the language. You can go only so far using sign language.) Ask local people for their ideas – after all, they know the place better than you. If you are lucky you may get the opportunity to take photographs in their homes, and this will add a much more intimate quality to your photographs, as well as providing a more rounded and complete insight into the country.

When you return home, consider making a photographic record of your own city or village and approach it in the same way as you did when working abroad.

Research your subject
With travel pictures there is always an element of luck involved — being in the right place at the right time. But luck can more often be on your side if you undertake a little research beforehand. In the shot **left** of a once-weekly African market, the photographer sought out a high vantage point days in advance in order to capture this evocative panorama. In the shot **above**, taken in Mexico City during a Palm Sunday passion play, the photographer planned his arrival to coincide with the festivities, allowing himself plenty of time to find the most effective camera position.

Architecture

Photographs of buildings generally fall into two groups – pictures that provide a realistic impression of the appearance of the building, or abstracts, pictures that say less about the building and more about the photographer. Abstract pictures are more usually made of modern buildings from a low viewpoint with a wide-angle lens. Descriptive, realistic, photographs tend to be made of buildings with more historic interest and often include close-ups of architectural details.

Abstract pictures of buildings can be quite eyecatching, but unless they are exceptionally good, they only tend to hold the viewer's attention for a short time. Unfortunately, modern buildings are too predictable and it is hard to include other elements to make a more complex or interesting composition.

The other conventional approach to architectural photography requires a measure of technical skill and a camera or lens that can be adjusted to correct converging vertical lines. At their best, these pictures convey the proportions, texture and color of a building.

More than skin deep

The architect, like the sculptor, works with shapes, but the shapes have to solve practical problems. The building is there to be lived or worked in and it should take into account the way ordinary people want to behave. No other artform employs a colder, more abstract form, but also is so intimately connected with our daily life.

Pictures that show the outside of a building in a realistic or abstract way show only the sculptural quality. A more rewarding approach is to combine both approaches and extend photography to show how the building functions as a place to work in or live in. To do this successfully you must not only see the building but experience it. Try photographing a building realistically and then in an abstract way, and go on to show how well the architect has succeeded in making it an enjoyable environment for those who use it.

Wherever possible, use available light, but if this is not possible, perhaps because there is insufficient or it is too contrasty, bounce flashlight from a ceiling or wall. If the

City skyline
The many reflective surfaces of the most famous skyline in the world are set off to perfection by the warm evening light, **top**.

Abstract shapes
Unusual architectural shots can be had while work is still in progress, **above**.

Interior views
An important part of architectural photography is involved in documenting how a building is used. In the shot **above** *of the Eaton Center, Toronto, the photographer has found the best position to show both the stylish interior design and the airy pedestrian rest areas and thoroughfares.*

room is too large for this technique, then use a reflector mounted on the flash unit. If the interior views do not include people you should be able to use available light, even if there is very little of it. Mount the camera on a tripod and, if you want a large depth of field, select a small aperture. A shutter speed of several seconds may be necessary, but this will not matter. Your viewpoint should take into account the film's limited ability to record detail in both highlight and shadow areas (see pp. 44-9).

When you come to photograph the outside of the building, try to visit it at different times of the day and then choose the lighting angle that shows the shape and

texture of the materials employed. It is also a good idea to try for a shot that shows how the building fits into the general environment.

Perspective control

When the camera back is parallel to the subject, parallel lines of the subject are recorded accurately by the lens. When, however, you photograph buildings from ground level, it is usually necessary to tilt the camera back in order to include the top of the building. The bottom of the building, being closer to the camera, is thus recorded

as larger than the top of the building. The result is that the sides of the building appear to converge toward some distant vanishing point, and the structure looks as if it is falling backward. This same optical effect occurs when we tilt our heads back to see the top of the building. The difference here is that the brain adjusts the impression transmitted by the eyes, and so we are not aware of the effect until the photographs are printed.

There are several ways to overcome this problem and produce natural-looking photographs which show the sides of the building parallel. If you stand well back from the building and use a telephoto lens, you will not have to tilt the camera to include the top of the building. In the city this is often not possible, but you may be able to take your picture from half way up a nearby building instead, if necessary using a wide angle lens. Neither of these solutions are always practicable and so if you plan to take a lot of architectural photographs it may be worthwhile to consider a perspective control lens.

These lenses, which are also known as shift lenses, are available for the leading makes of 35 mm SLR cameras in focal length from 24-35 mm. Instead of tilting the camera back with one of these lenses to include the top of the building, all you do is adjust the position of the lens on the mount. This movement allows you to keep the camera back parallel to the subject. The lens can be used to

correct vertically or horizontally converging lines, but it is usually only vertically converging lines that are considered unacceptable in a print or slide.

For the serious architectural photographer, another useful accessory is a special architectural viewing screen. This replaces the normal focusing screen, and so can only be used with cameras that have this facility. The screen has a series of perfectly parallel grid lines etched on its surface, allowing you to see at all times if the lines of the subject building are straight.

Architectural detail
Modern architecture can take on a sculptural quality when isolated and lit effectively, as in the imaginatively conceived picture **above**.

Old-world architecture
The mellowed stone walls and the subdued red of the tiled roofs **opposite** *benefit from the sympathetic lighting provided by an overcast sky in Prague, Czechoslovakia.*

New and old
The photographer has created a bond between new and old, **left**, *by capturing the reflection of the Old Court House, St. Louis, in the glass surface of a modern office block.*

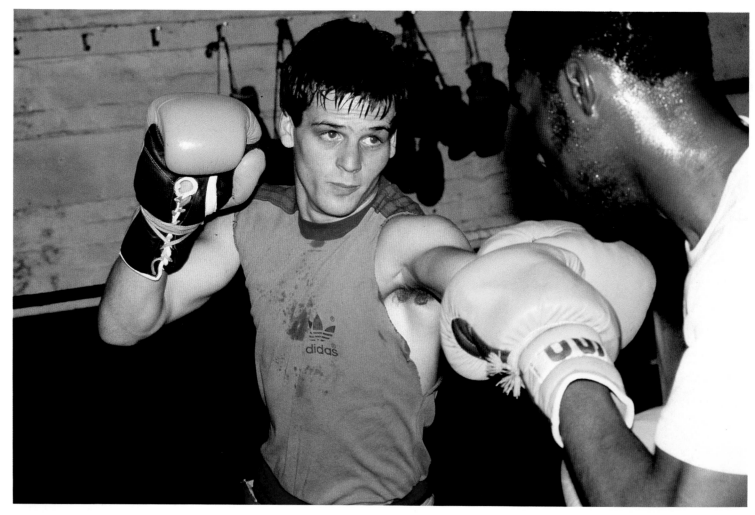

Sport

Almost all sport is performed with great elegance and often at great speed. Athletes have developed their skills through constant repetition and practice and for you to be able to photograph them at their best, it is necessary for you to do the same. One of the first things you must learn to do is to give total attention to the viewfinder image. When you watch the image closely it is almost as if the action slows down, and you should be able to place your subject in the frame in a way that reflects the grace of the activity. If you are familiar with the sport being photographed you may be able to anticipate the next move, and thus remain just ahead of the action, catching the key moments as they occur.

Focal length

It is often difficult for the amateur photographer to gain access to the more important sporting events. You might be able to persuade sports organizers to let you into the press area if, for example, you intend to exhibit your photographs at a local sports store or perhaps the library. You will almost certainly have to agree not to sell your work to publications that would normally use pictures supplied by press photographers.

Even at amateur events, available camera positions may be restricted and can be quite some distance from the action. Promising the organizers a free set of prints may strengthen your argument for a more favorable vantage point. Even so, a telephoto lens is essential for most sports photography. A zoom lens with a range of about 80–200 mm is an extremely popular choice with many professional photographers. A teleconverter will also prove useful for those occasions when the action is taking place at a greater distance.

With indoor sports, such as basketball, you may be lucky enough to gain a camera position very close to one of the baskets. For a more unusual type of sports image you should consider using a 28 mm or a 24 mm wide-angle. This type of shot will be successful only if you can get in close and really fill the frame. From the normal audience viewing position, a standard lens will not be of much value.

The noble art
Although not to everybody's taste, dramatic ring-side shots at boxing matches above are not difficult for the amateur to obtain. All you need do is buy the best seat in the house.

Group activities
For sheer spectacle, it is hard to beat the modern mass marathon, now held in many major cities throughout the world, right. Although this picture was taken from a helicopter, with a course over 26 miles long, there is ample opportunity for good close-up shots.

Quiet pastimes
Lawn bowls is becoming increasingly popular, and many suburban clubs would probably appreciate the attention of a keen amateur photographer. With quiet sports such as this, move in close and fill the frame.

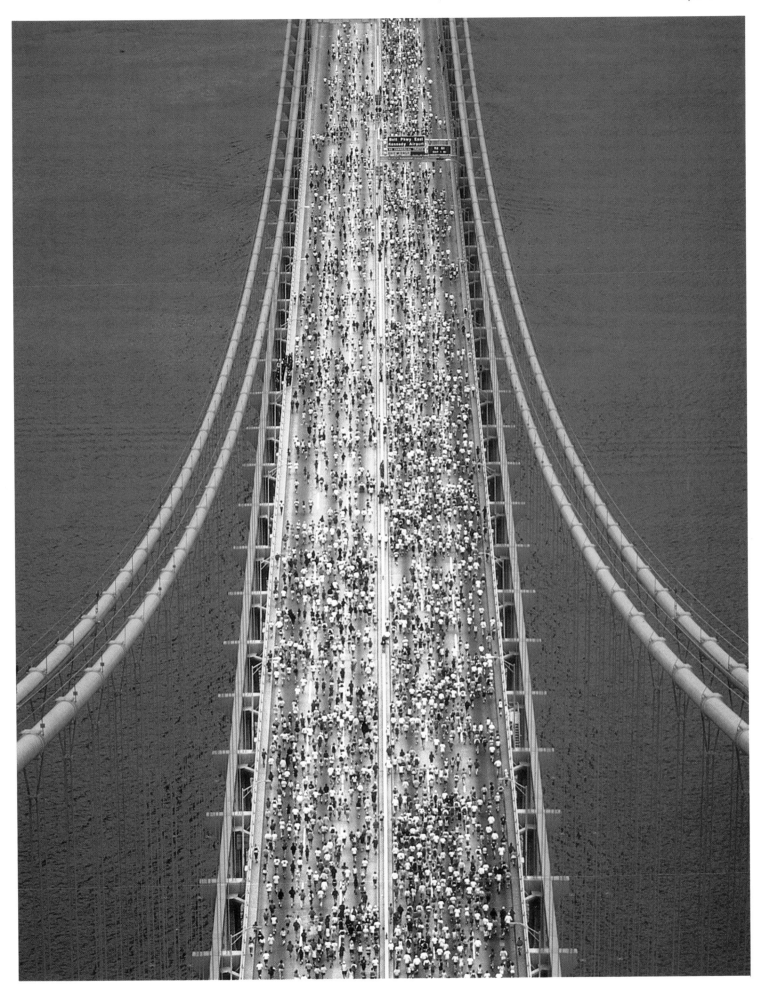

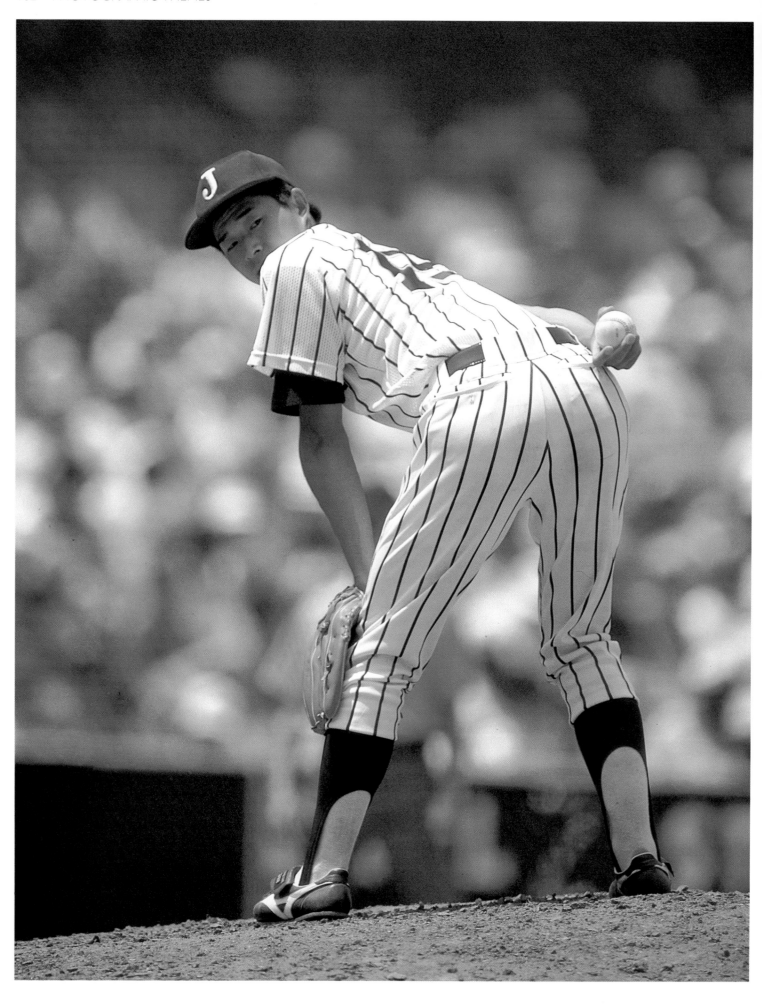

Motor drives

If your budget allows, a motor drive will be of great benefit to sports photography. It will, depending on type, take several photographs in quick succession, helping to ensure that at least one of the shots records the subject in its most dramatic position. You will also have the chance to take a potentially fascinating sequence of pictures showing the action at several closely spaced moments.

A motor drive can also be a great aid to concentration. Because you do not have to take the camera away from your eye each time you wind the film on, all your attention can be concentrated on composition and, of course, accurate focusing. You can, however, shoot a lot of film without really realizing it, so make sure you have adequate stock. A spare camera body, already loaded with film, will ensure you do not unnecessarily miss that once-in-a-lifetime shot. What you tend to lose by using a motor drive is the discipline of choosing just that one special moment, pressing the shutter release and capturing the picture on one frame.

Film and exposure considerations

Because of the limited depth of field associated with telephoto lenses and the frequent need to freeze a fast-moving subject, the new high-speed films – ASA/ISO 1000 to ASA/ISO 6400 – are highly recommended. They will allow a small aperture, to maximize depth of field, and shutter speeds of, perhaps, 1/1000 or even 1/2000 sec, if your camera permits.

Absolute sharpness is not always desirable. A slightly blurred image may help to communicate to the viewer a sense of speed in a more convincing way. What is desirable, however, is to be able to judge the speed of

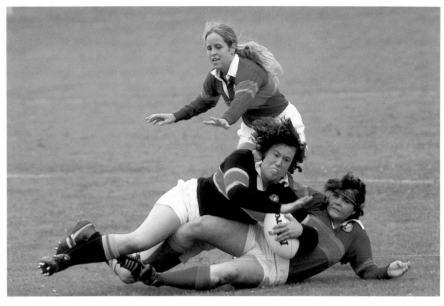

the subject and then choose the most appropriate shutter speed to create the particular type of image you want. Unfortunately, there is no rule of thumb to guide your choice of shutter speed, but 1/1000 or 1/2000 sec with a 200 mm lens will freeze most of the action you are likely to encounter in athletics and football.

It is a good idea to keep a record, whenever you can, of the shutter speed and aperture used for each picture and then compare this to your actual results. In this way you will have constant feedback and you should be able to 'fine tune' exposure decisions. Remember that subject movement across the field of view of the camera requires a faster shutter speed to eliminate blur than does movement toward or away from the camera. Another approach to freezing movement is to pan the camera in line with the subject (see pp. 60-4).

Amateur sports
*Many sporting activities are strictly amateur and tend to be played wherever space is available. This rather informal approach makes access easier for the amateur photographer, too. For the picture of a junior women's rugby football match, **above**, the photographer could approach right to the sidelines. Even so, a 250 mm lens was necessary.*

Professional sports
*Don't feel inhibited about taking photographs at professional sports matches, such as baseball. You almost certainly won't have access to the premium sites, but the shot **opposite** was taken from a spectators' stand using a 400 mm lens.*

High-speed sport
*If you are familiar with the sport you are photographing, you will increase the likelihood of capturing that special shot. Using a shutter speed of 1/500 sec and adopting a position slightly ahead of the cyclists as they approached the finishing line, **left**, the photographer was able to record the pain and determination on the competitors' faces.*

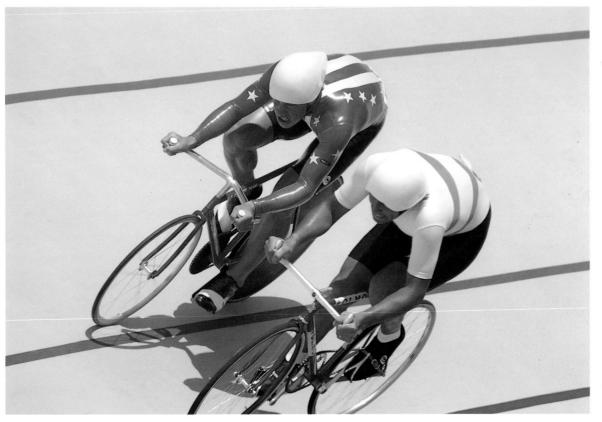

Nature

Landscape photography describes pictures that include several different elements associated with the country – water, rocks, trees, and so on, with a sweep of land connected in the photograph by the composition. Nature photography, on the other hand, looks at all these elements separately – a single tree or plant, or the texture and patterns you can isolate in the trunk and branches. The pictures may illustrate the four seasons in a series of miniature landscapes. With careful planning you could take four pictures from the same viewpoint in spring, summer, fall and winter, or show the same view throughout the day with the sun shining from different positions.

An eye for detail

If you know how to look, even a commonplace object such as a tree can be an endless inspiration and source of photographs. Use, for example, the outline of the tree against the sky, close-ups of the leaves or a view from underneath looking up through the branches and pictures framed so that the tree makes weird abstract shapes. The tree, as well as being the subject of photographs, is of course also host to hundreds of tiny insects and larger animals, all worthy of photographic attention. Spiders, ants, moths, butterflies, mice, the jewel-like image of a dew-laden spider's web or the redundant husk of some long-dead insect are all there if you take the time to look for them.

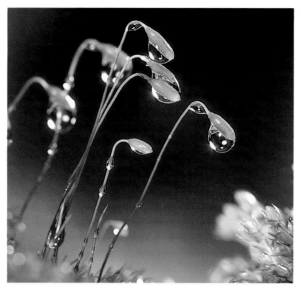

Dew on moss
If only you make the effort to look, there is a wealth of photographic opportunities literally under your very feet. This picture of early morning dew on moss, left, was taken with a telephoto lens with macro facility and lit by flash.

As an exercise, find one tree and see how many photographs you can take of it. Explore it with the camera in a variety of different lighting conditions and at different times of the year. An effective sequence of pictures could be made by first showing the tree in a quite realistic, descriptive way and, as the sequence progresses, introduce more abstract, interpretative types of shots, which perhaps are not immediately recognizable as a tree. A second sequence of pictures could detail the types of creatures that depend on the tree for their survival. The lessons learnt from such an exercise can be transferred to any other type of natural history subject.

Seed head
Using extension tubes the photographer was able to fill the frame with this single salsify seed head, below. These wind-borne seeds need to be sheltered from even the gentlest breeze while you take your photographs.

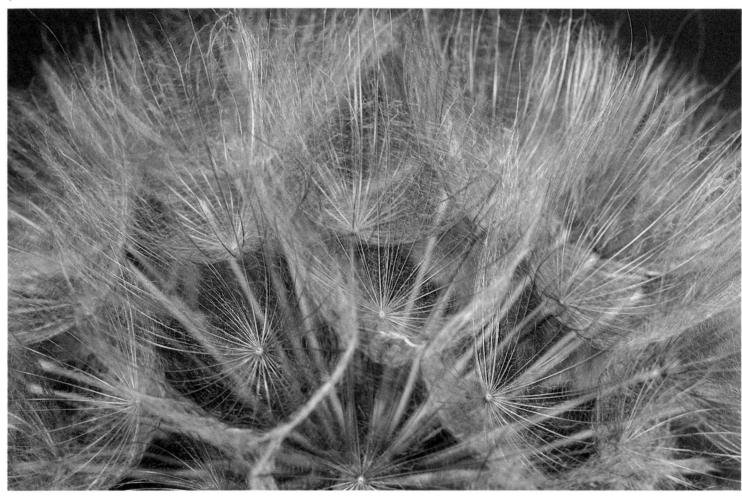

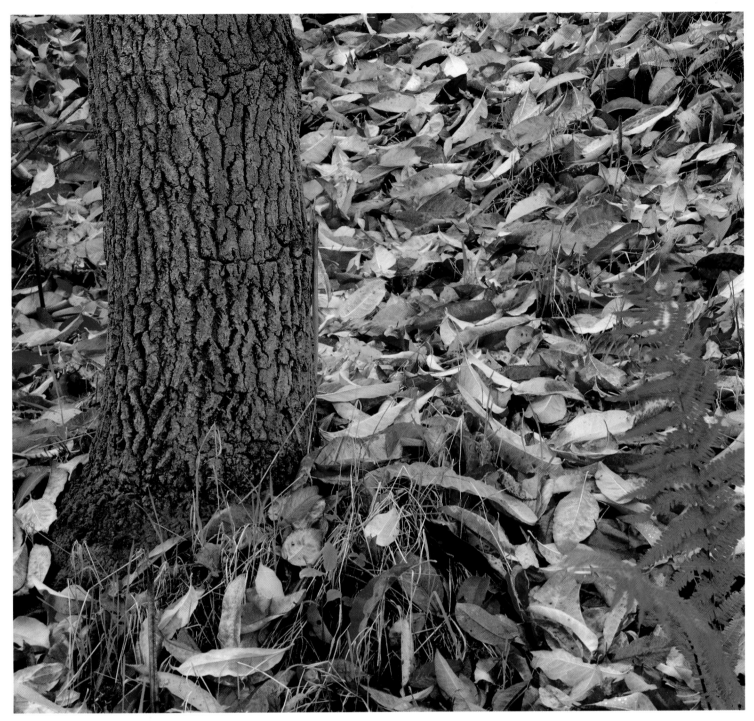

Equipment and accessories

Many nature subjects will be off the beaten track, and so the minimum of equipment should be taken. Useful items include a small flash unit and a piece of white card to help bounce light into small inaccessible nooks and crannies and to reduce excessive contrast when shooting details. Also important is a sturdy tripod for long exposures and sequences. This will allow you to set the camera up and take a series of pictures throughout the day from exactly the same point of view.

For best photographic quality use a slow film. If you have only one camera you will have to decide on whether to use black and white or color. This is largely a question of personal taste, but if you want to cover yourself, consider buying short lengths of both types.

If you are using black and white film you may want to experiment with very hard, or contrasty, enlarging paper. This will tend to reduce your image to a few simple black and white tones and it can be extremely successful with subjects that have interesting surface textures or contours. For this technique to work best, the subject should be so arranged that the light illuminates it from the side. In this way, texture is highlighted as the oblique light creates tiny shadows cast from each minute ridge on the subject's surface.

Whether your interest is trees, seashells, flowers, insects, or the pattern dried mud makes, you will never need to run out of new ways to photograph them. Nature is constantly changing so keep trying out new viewpoints and lighting schemes. It does not cost anything to look through the camera's viewfinder. Even when you think you have the best view – look again!

Autumnal colors
Nature photographs don't have to be detailed studies of single, tiny specimens. In the picture **above** *the photographer has filled the frame with the marvellous reds, golds and russets of autumn. Diffuse skylight has produced a virtually shadowless image and, also, a strong cold color cast can be seen on the highly textured tree trunk.*

Animals

This particular branch of photography covers such a wide range of techniques that very general points only can be covered here. Photographers who want to take pictures of their own pets can usually do so using pretty basic equipment. Cats and dogs, for instance, are large enough to fill the frame easily, unless a wide-angle lens is being used. The difficulty here is not so much obtaining an image, but more trying to capture the personality of the animal – something that requires much patient waiting and watching and a fair amount of film, too. One point to bear in mind when photographing all animals is that it is usually best to get down to the level of the subject. Often the most interesting pictures are obtained if you can get down below subject eye level and shoot upward.

Zoos and wildlife parks

Successful photographs of zoo animals require a little more effort. Usually an SLR camera is essential and a telephoto lens of about 200 mm. A lens of this size is needed in order to obtain reasonably detailed shots of animals quite some distance away in their enclosures. The minimal depth of field associated with such a lens can also be used to advantage. In the first place, traditional animal enclosures tend to be rather bleak, and a wide aperture (f 2.8 to f 5.6) can be used to isolate your subject by throwing its surroundings out of focus. A telephoto lens can also be used to overcome the

problem of intervening wire mesh surrounding the enclosures. If you place the lens very close to the mesh and open up to the widest possible aperture you will notice on the focusing screen that the mesh is so far out of focus that it practically disappears. There will, however, be a very slight lowering of sharpness on the resulting pictures.

The more open, modern zoo enclosures are easier for the photographer to work with. These are built usually with a wide moat and a low fence to prevent members of the public approaching too close. Some of these enclosures may have only heavy glass screens separating you from the animals. These allow you to obtain marvellously detailed pictures of animals close up, but you may need to use a polarizing filter to remove distracting reflections. It can also be a good idea to carry a cloth with you to wipe the glass down before shooting.

Wildlife parks offer a much more natural environment in which to photograph animals. Parks run by societies and national bodies often provide superb facilities, such as photographic hides, approach routes guaranteed not to disturb the animals and, some, even overnight or longer stay accommodation. Wildlife photography in this type of environment demands a specialist knowledge of the animals or birds. You cannot expect to take good pictures unless you understand the routines and habits of your subjects. Even once inside the hide, you may have to sit for hours on end to obtain your pictures.

Hides are effective only if there is a minimum of movement backward and forward; so make sure before setting out that you have all the equipment you are likely to need. This includes spare lenses, extra film, filters,

Zoo animals
*Old-fashioned concrete zoo enclosures can be depressing, especially for the animals. But with the animals confined in this way you should be able to get reasonably close using a moderate telephoto lens only. If you contact the zoo before your trip, you will be able to find out when the animals you are interested in are going to be fed. With this information, shots such as the one **below** of three zebras preoccupied with their lunch, should not be difficult to obtain. Another advantage of using a telephoto lens is that its narrow angle of view effectively excludes most potentially distracting and unwanted subject information.*

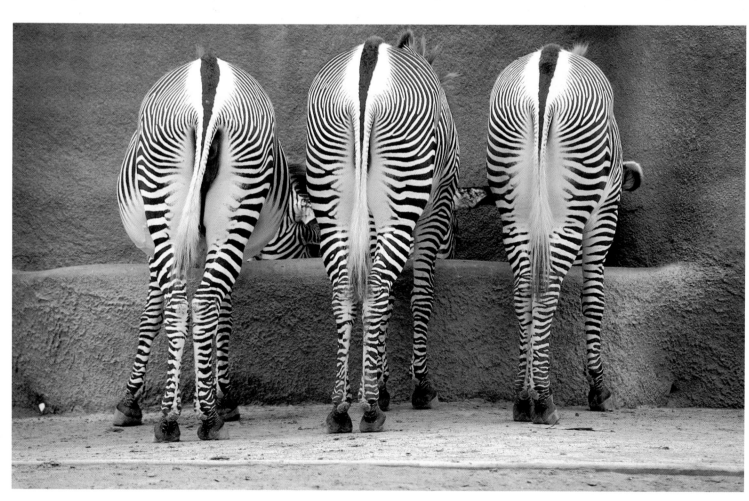

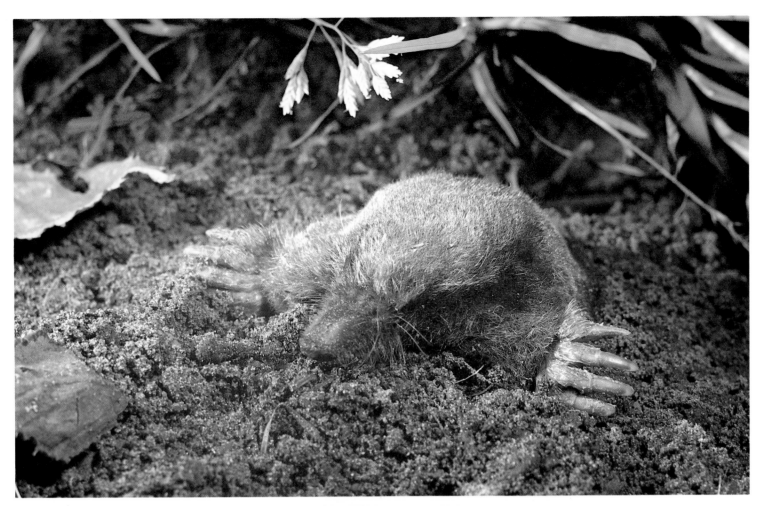

camera batteries and, of course, something for you to eat and drink during the day. A useful item of equipment is a teleconverter. The small additional weight is well worth the ability to double or triple the focal length of the lens you have. This type of patient waiting and watching makes a tripod an indispensable piece of equipment to have along. With the camera set up and focused on a likely spot, you will have both hands free to adjust the aperture or shutter speed controls.

Less demanding but, nevertheless, rewarding animal photography is possible in a safari park. Here you are confined to your car, but the big cats, monkeys, baboons and so on will usually approach extremely close (sometimes you may think too close). The rules of these parks usually insist that you do not switch your engine off, so you must be careful that you do not rest your body or the camera on any part of the car's frame. Vibrations from the engine will be transmitted to the camera and result in blurred pictures. Before entering the park, clean your car windows both inside and out. Although the camera lens will be too close to actually focus on the glass, dirt and grease smears will lower sharpness and contrast. Autofocus cameras using a sonic beam may be fooled in this situation and will almost certainly focus not on the animals but on the surface of your car windows.

An interesting wildlife picture story could be made about animals and birds living in cities and towns. If you start looking you should be able to find many species living and breeding even in quite densely populated areas. Animals that have adapted to a man-made environment may be slightly more approachable than their counterparts living in the wild.

Small mammals

Shots like the one **above** of the shy grassland mole are not common. This animal is practically blind and rarely comes to the surface. Evidence of their underground excavation work, however, can often be seen on the surface, much to the annoyance of gardeners, and weeks of patient observation was necessary before this picture was obtained.

Family pets

Few people would fail to be moved by this scene of a new-born labrador pup fast asleep in the comforting warmth provided by its mother's body. Shots of family pets are not difficult to obtain. The animal should be relaxed and trusting and so you will be able to get close enough using only a standard lens.

Close-ups

Quite unexpected results can be achieved when photographing plants, vegetables and other ordinary household objects in close-up. Many people find 'still-life' photography on a miniature scale more rewarding and interesting than pictures that will invite comparison with the very professional work to be seen in advertisements.

Equipment for close-ups

The SLR camera is by far the most suitable for close-up photography, especially if it has a built-in light meter. The viewfinder remains accurate no matter how close you approach the subject and precise focusing is possible using the ordinary focusing screen. Special macro lenses, which focus from infinity to within a few inches of the subject, are made for SLRs. These lenses are optically corrected for close-up work and produce extremely sharp results; their price, however, is more than a similar lens without a macro facility.

A relatively inexpensive way of taking close-up pictures is by fitting extension tubes between your existing standard (or moderate telephoto) lens and the camera body. Extension tubes are available in sets of three, and they can be used either one at a time or in different combinations. The longer the extension the closer you can approach the subject and, therefore, the greater the degree of magnification. Extension tubes can also be used in conjunction with a macro lens.

A more flexible way of taking close-up pictures is by using an adjustable extension bellows. Instead of a series of rigid tubes, which only produce a set magnification depending on the combination of tubes employed, the bellows can be either extended or compressed by sliding the lens forward or backward on a set of rails. In this way, any intermediate degree of magnification can be selected. Bellows, typically, allow the photographer to fill

Household objects
*Even common household items, such as paperclips, **below**, can become a suitable subject for the camera lens. With objects as small as these, lighting does not usually cause problems. After arranging the clips on a magnetic black pyramid to form an attractive color pattern, the photographer used a single flash diffused by an umbrella reflector to light the arrangement.*

Natural subjects
You never know when you are going to be presented with a worthwhile photographic opportunity, and one of the best pieces of advice is always to be alert. The intriguing close-up study above looks as if the remains of some ancient pottery site have been unearthed. In fact, these shapes are simply the pattern formed by shrinking mud at the bottom of a dry river bed. Lighting, too, is natural. The photographer waited until just after midday so that short shadows could add a little depth and modelling.

the frame with subjects ranging in size from ¾" (2 cm) to 5" (13 cm) across.

Close-up supplementary lenses for viewfinder cameras are available in different strengths of magnification, so that the camera lens can be focused at progressively closer distances to the subject. Neither the viewfinder nor the rangefinder will be accurate, so the correct field of view must be estimated and focusing carried out by measuring the precise distance between the front element of the lens (with supplementary lens in place) and the subject itself. These lenses screw on to the front of the standard lens in the same way as a filter. Supplementary lenses can also be used with an SLR camera; they are considerably cheaper than either extension tubes or bellows units, yet they still yield correct framing and precise focusing.

Exposure considerations

When extension tubes and bellows units are used, additional exposure must be given to the film. When extension tubes are used on an SLR the brightness of the image as seen on the focusing screen is decreased. The built-in light meter will compensate for this and no further adjustment need be made. If, however, your camera is not equipped with a built-in meter, to determine correct exposure you will have to multiply the exposure reading by a factor that depends on the length of the extension. Measure the distance between the film plane and the extended lens and divide the square of this by the square of the focal length of the lens in use.

Aperture and shutter speed

Depth of field is greatly reduced at close focusing distances. In practice, this means that you will have to use a tripod and align the camera so that parts of the subject you want to be sharp are all at nearly the same distance from the camera. To gain maximum depth of field, it will usually be necessary to use the smallest possible apertures and this could well result in exposure times of seconds rather than fractions of a second. A cable release is usually used as a precaution against any slight camera shake caused when you press the shutter release button. Many SLRs have a mirror lock control; this allows you to lock the mirror up against the viewfinder screen after you have focused the lens. With the mirror out of the light path, the exposure is then made. No matter how well the camera is designed and made, there will always be some vibration caused by the mirror flipping out of the way. At normal shutter speeds this is of no consequence, but with close-up photography the use of a cable release and the mirror lock, you will ensure the sharpest possible pictures. It is equally important to prevent subject movement when such slow shutter speeds are being used. If possible you should bring your subject indoors, away from any breezes. If this is not possible you may have to construct some form of shielding to stop the wind getting through to the subject. Position this carefully so as not to cast a shadow and so further restrict the amount of available light.

Alternatively, use flash. This provides extra light, and freezes all subject movement.

Special effects

The following techniques show you how to contradict the comfortable assertion that 'the camera never lies'. Although the camera is an excellent tool for producing images that resemble our own impression of a view or object, there are many ways the medium can be used to distort reality. The use of special film or filters, very long or short focal length lenses and multiple-exposed frames can all be used to create images that suggest recollections of dream sequences or show objects in a way that reveals our subjective impressions of them. Of course, subjective photographs do not depend on special effects. Some of the most unusual photographs, which transmit a personal vision of the photographer, have been made with a standard lens and conventional film, but special techniques for distorting our view of the world have always played an important part in the development of photography. It is the medium's ability to be both objective and subjective that has made it one of the most important art forms of the twentieth century.

One of the often-made mistakes is in creating images that rely just on the 'special effect' for their power and interest. The technique employed has to be appropriate for the subject, and the way the subject is photographed has to suit the technique, or the results will soon become boring.

Infrared film

Color transparency and black and white negative films sensitive to infrared light are readily available through better photographic retailers. These films are also sensitive to ordinary visible light and to be able to use them effectively it is important to be able to visualize the way they will respond to colors and tones.

Basically, these films are designed for scientific research purposes and their instruction sheets give information that explains filtration and exposure for only a limited range of effects. This should not prevent you from experimenting with a wider range of color filters. Infrared color film is frequently used with a yellow, Wratten 12, filter. Using this filter, blue sky is recorded quite naturally but any green foliage is rendered magenta in color and yellow records as green. Warm-colored filters will also have a dramatic effect. A sepia filter, for example, darkens blue sky and turns green foliage red.

Infrared black and white film is much more subtle and will produce very beautiful, grainy pictures, recording green foliage as white and blue sky as black. It is usually used with a red filter, which absorbs a proportion of the visible light. The stronger the color of the red filter the more pronounced will be the effect of the infrared light on the film.

Reflections and shadows

Without special effects filters or lenses you can take intriguing abstract pictures of shadows and reflections. We are so accustomed to looking at objects that sometimes we fail to notice how beautiful and descriptive shadows can be. Reflections attract our attention more readily, but they are often ignored as photographic subjects. The surface the reflection is seen in may distort

Shadow pictures
A simple yet intriguing picture, **right**, was created by using a powerful spotlight to cast shadows of a group of people standing on scaffolding on to a nearby wall.

Mirror distortion
Fairground mirrors, **left**, can be an endless source of fun images. Either photograph the reflection alone or, as in this example, the subjects and their reflections together.

Unusual reflections
In this otherwise normal scene, **below**, a single puddle of water in the middle of the road acts as a mirror, reflecting light from the neon sign in the background.

Multiple exposure
A casual glance at the photograph **above** *reveals what appears to be a picture taken through a restaurant window showing the reflection of sky and clock tower opposite. In fact, it is a double exposure – the sky and tower were taken first and then the restaurant scene was exposed on the same piece of film. The photographer was careful to position most of the diners in the open space left by the rather weakly exposed sky.*

the object beyond recognition or it mirror a perfect image. With 'active' autofocus cameras (see pp. 12-15), allow plenty of depth of field if you want a sharp picture of the reflection as the reflection is not the same distance from the camera as the surface in which it occurs.

Photographs of reflections in water are especially attractive. When the water is still you can see a perfect, undistorted image; the least wind movement or other disturbance will cause the colors and shapes to 'melt' together, creating unpredictable abstract forms.

Reflections of a street scene in the glazed surfaces of modern buildings can also be a valuable source of images. The mirror-like surfaces divided into rectangles distort the reflection, and the effect of the straight lines where the panels join and the fluid, reflected shapes give the impression of a double exposure in real life. Wet pavements and roads in cities are also a fascinating source of reflections, especially if there are lots of different colored lights and signs nearby.

In certain light, the shadows an object casts can be more interesting than the object itself. When a shadow is reflected from an interestingly shaped object, it will combine qualities of the object casting the shadow and the reflective surface in a potentially fascinating way. You can, of course, arrange objects of your own choosing behind a shadow pattern. Interesting still-life, nude and portrait photographs have been made using this very same technique.

When you look at a shadow, decide if you want detail to be recorded in the shadow area or if it should be recorded as a black, featureless shape. If you do want detail, take a light reading of the shadow so that your exposure will be long enough to produce an image there. As an exercise, one bright sunny day take a series of photographs where the shadows themselves are the

center of interest. It might be that you decide not to include the object itself, preferring to concentrate on the shadow alone.

Multiple exposures

There are several ways to combine images to produce one final picture. Most cameras have a device to prevent accidental double exposures. On some cameras this can be switched off, but even if it cannot it is quite easy to overcome the problem. After you have taken your first exposure make sure the film is wound tight in the cassette by gently turning the rewind crank until you feel slight resistance. Next, depress the film release button, usually found on the baseplate of the camera, and then wind on, making sure you keep the rewind crank under tension. This will reset the shutter but leave the film in the same place, allowing you then to make a second exposure on top of the first. Remember that your frame counter will no longer be accurate.

Exposure is cumulative, so you should reduce the exposure of one or both images. If you want both elements to have equal density, reduce each exposure by one stop.

The problem with multiple exposures in the camera is that it is difficult to visualize the results. All too often they turn out confusing and muddled unless you plan them out on paper first. Often, the best multiple pictures result when one image is dominant – either through exposure or by arranging the other image so that it occupies only a small portion of the frame. When using negative film, remember that the second image will only be visible in dark areas of the first. This is because dark subject areas are recorded on the negative as clear areas of film. When using transparency film, the opposite is true.

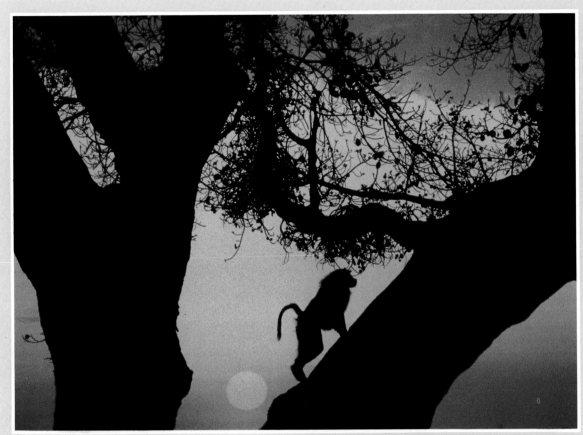

Slide sandwich
This image of a baboon on sentry duty in Kenya is, in fact, the result of the two photographs **below**. *The picture of the baboon and tree, although a good picture in itself, lacked interest in the sky area. To overcome this, the photographer took the sunset picture, making sure that the colorful but open area of sky was centrally placed in the frame. The two slide images were then sandwiched together in the same slide mount and copied on to another piece of slide film.*

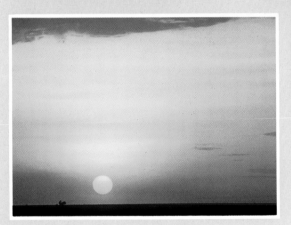

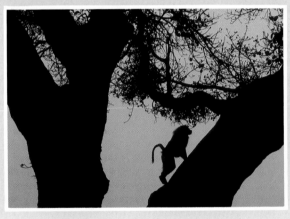

Because it is difficult to judge the effect of two pictures superimposed over each other, many people prefer to combine separate images in the darkroom using an enlarger. First, enlarge one of the images to the correct size and place a sheet of drawing paper on the baseboard. Draw an outline of the picture on the paper with a black felt-tip pen. Replace the drawing paper with printing paper and make a test print to determine correct exposure. Now replace the first negative with the second and, using the outline drawing made previously, size and focus this image so that it fits together with the first one. Determine correct exposure for this negative and place a fresh sheet of printing paper on the baseboard. Make the exposure for the second negative and replace the paper in a lightproof box after you have marked one corner. (This will allow you to replace it the right way round for the next exposure.) Now put the first negative in the enlarger and reposition the image using the drawing. Replace the printing paper

from the lightproof box the right way round (by referring to the mark you made) and make the second exposure in the normal way.

With some subjects it will be necessary to hold back part of one image so that the superimposition works effectively. If you wish you can hold back completely one part of the first image printed, leaving a white space that can be filled with the second image. To do this, take a piece of cardboard a few inches larger than the print, hold it about 1 in (2.5 cm) above the baseboard and trace out the area to be held back. Cut this shape out of the card and attach a piece of stiff wire to it. When printing the image, hold this over the area throughout the entire exposure, moving it slightly in order to soften the edges a little. This will allow the superimposed picture to blend more convincingly into the space you are creating.

The piece of card with the hole left in it after cutting out the shape above is then used to cover the printing paper when you make the second exposure. The image

from this second negative should fit exactly into the area held back the first time. Again, move the cardboard mask during the exposure so that the second image will blend with the first.

Using projectors to make multiple images you have the advantage of seeing the effect as you work. In addition to two projectors, you will need a screen in a darkened room and a camera loaded with film. If you are projecting color slides you will need tungsten-type film, and Dia Direct black and white slide film if you are projecting black and white negatives. Dia Direct will reproduce the negative image on the screen and can therefore be used to make prints. If you want a final positive slide image of the projected negatives, you will have to use a black and white negative film in the camera. Contradictory though it sounds, a negative film will produce a positive of a projected negative image.

First project the pictures on to the screen until you have the effect you want. Take a light reading and simply rephotograph the screen. You can vary the effects endlessly by projecting from an angle or using part of one picture and the whole of the second. A variation of this technique is to project a transparency on a three-dimensional object, such as a stone or part of the body, and then to photograph that. Another simple way of creating superimposed images is just to place two transparencies or negatives in the same mount and project them together on to the screen. These can be left permanently in the same mount or rephotographed as described above.

Sharp and blurred images

A completely different way to make multiple images is by electronic flash used on-camera and pointing directly at the subject. There will have to be a reasonable level of ambient light for the technique to work. If a slow shutter speed is selected a blurred image of a moving subject will be recorded on the film by the action of the available light and another, sharp one recorded on the same frame by the action of the flash.

The results look quite complex but the method is simple, although some experimenting is necessary before you will be happy with the final images. The light from the flash will illuminate and freeze movement in those parts of the picture within range of the flash unit. The available light is used to record more continuous movement, so make sure you select a slow shutter speed. It is important to be able to adjust the output of the flash so that it balances with the available light. A more powerful flash is needed when you shoot in bright light; when there is less available light, and the aperture is open to a larger setting, a less-intense flash is sufficient to balance the exposure.

Choose a shutter speed long enough to record subject movement as blur – 1/15 sec, for example. The aperture setting depends on the level of available light and film speed – let us assume f 8. You must then set the flash to expose the film correctly at this aperture. On adjustable flash units, you can alter the brightness by changing the aperture selection dial, so in this example you would set it to f 8. You now have one more adjustment to make because the combined exposure from both light sources is cumulative. To correct for this, reduce the exposure by half a stop from daylight and half a stop from flash. This should produce a result in which both the available light and the flash are in balance. Often a more interesting picture is obtained by underexposing the available light image by one full stop and exposing the flash image correctly, or vice versa.

Dominant flash
Flash used outdoors in weak daylight creates a strange, contradictory type of image, **right.** *The foreground ballroom dancers, illuminated by the full, movement-freezing power of the flash, almost seem to glow in the subdued evening light, as if performing in front of a projected backdrop.*

Flash and daylight
An entirely different type of image results from using flash when there is a high level of background daylight. The two images, **below** *and* **below right,** *both show a combination of frozen and blurred movement, caused by using a slow shutter speed (to record blurred movement) and weak flash (to record frozen movement).*

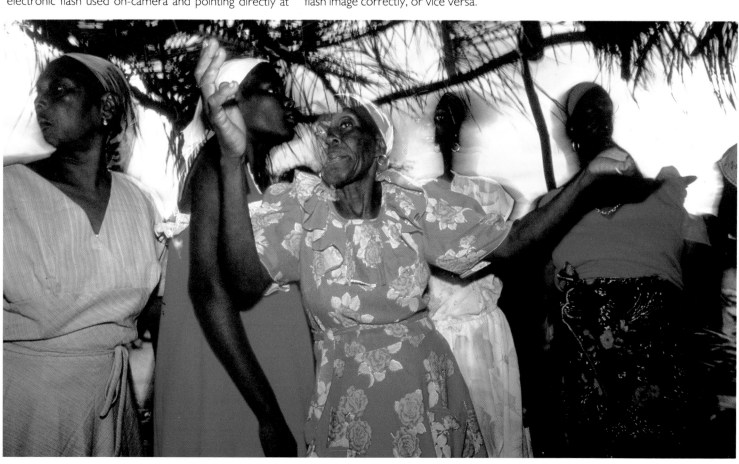

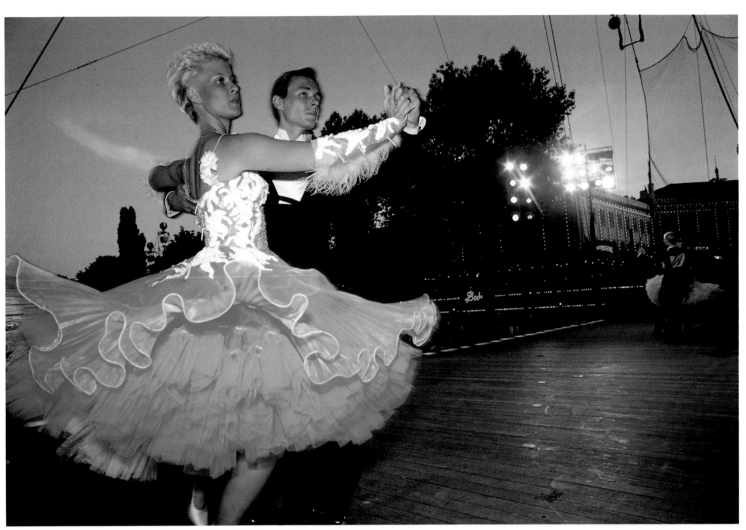

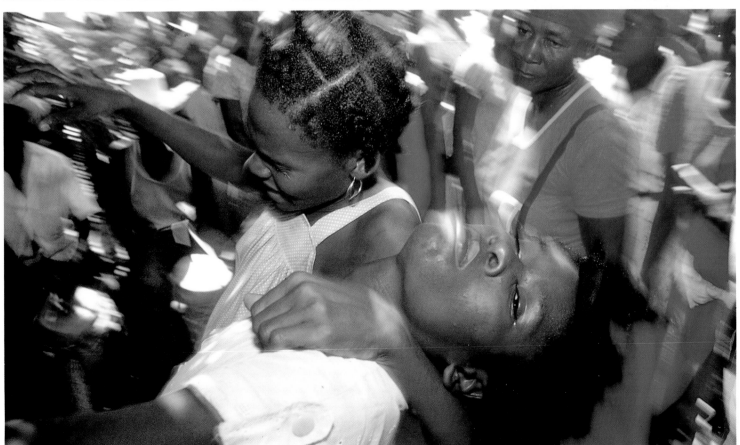

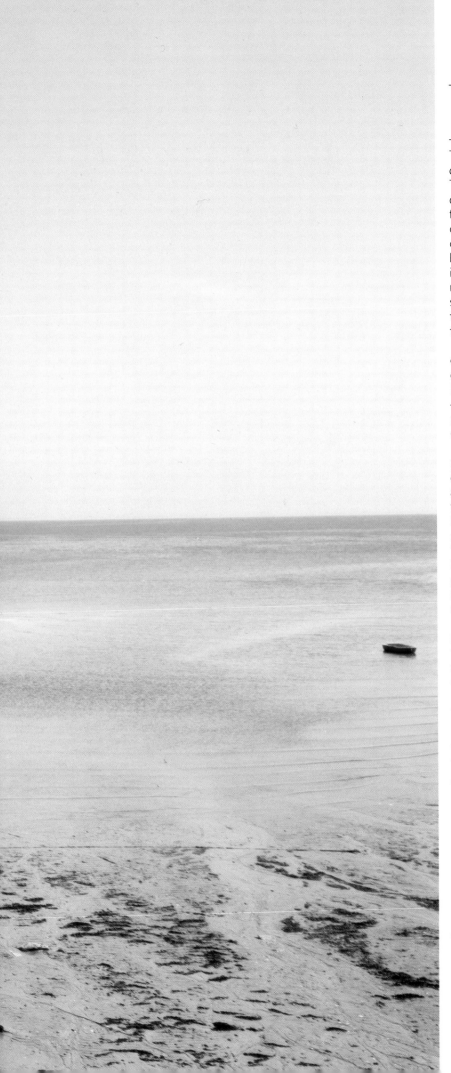

A PERSONAL VIEW

The development of photography has involved physicists, chemists, opticians, businessmen and engineers. Their combined inventions have produced the modern camera and film, a new language for society, a profession for some and, also, a means of personal expression for others. The camera has accompanied us to every corner of the Earth and beyond, far into space and inside the human body itself. It has recorded many of the most important moments of history and the daily lives of millions of ordinary people all around the world. Film is so sensitive it can record traces of nuclear particles and the expression that flickered across a loved one's face on the beach fifty years ago.

This book is an invitation to join in and be part of the evolution of photography. The photographs in this final chapter have a special place in that story. They can be looked at time and time again without losing their magic – a rare quality in any medium. Look at the way the photographers have chosen the exact moment when every part of the picture appears in its correct place.

Even the most gifted photographers do not expect to produce many pictures of this quality. A story is told of a conversation overheard between Henri Cartier-Bresson and Eugene Smith, two of the most accomplished and famous photographers to work in the medium. Cartier-Bresson turned to Smith and said, "If you work hard how many really good photographs do you take in a year?" "Well," said Smith, "if I have been working at my best and I have been lucky, I suppose I would get twelve really good pictures in a year." There was a moment's silence and then Cartier-Bresson said, "Yes, you always did exaggerate Eugene."

Good photographs are the result of countless experiments, near misses and hard work. You need to be able to react quickly when the moment is right and with the appropriate technique. And you have to learn to be observant. If you are prepared to look carefully at photographs and enjoy taking them, you will develop your own sense of composition.

Take whatever opportunity you can to visit photographic exhibitions and see good photographs. Don't just glance at the pictures, look at the details and see how the composition links the various elements together. Look at the expressions and gestures and see how the picture is framed. Words help you to learn about photography, but looking at pictures shows you what photography really is. When you look carefully and with attention, you will find yourself developing your own personal style of photography, which is not simply an imitation of other people's work.

Bay/sky, Provincetown, 1977
Joel Meyerowitz takes delicate, almost fragile color photographs using a large-format plate camera. We are unused to seeing color pictures of this high technical quality, but it is always the way he sees and records his subject that is remembered. This part of the coast is a favored spot for American photographers – the quality of light and colors challenge the camera. No one has more successfully met that challenge than Meyerowitz.

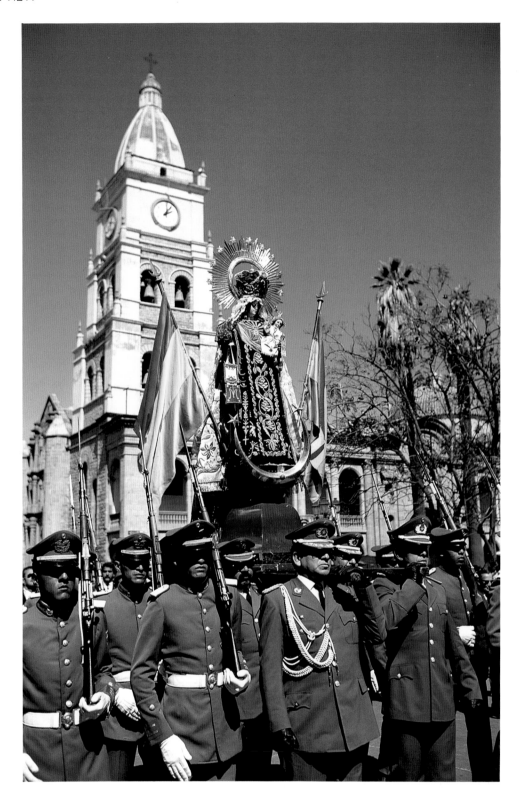

Our Lady of Peace

Soldiers carrying the statue of 'Virgen de La Paz' on the feast of Our Lady of Peace in Chochabamba, Bolivia.

Born in Chile in 1944, Carlos Reyes-Manzo studied photography at the Film Institute of the Catholic University and has been a photo-journalist for 27 years. After the military coup in 1973, he spent two years in a concentration camp for political prisioners. In 1975 he was sent into exile to Panama where he worked for the Bishops' Conference and the for the national and international press. In 1979 he was expelled from Panama accused of taking photographs hostile to the government, and has since lived in Britain. He has travelled widely as a documentary photographer. His work has been published extensively in newspapers, books and magazines and he has held many exhibitions.

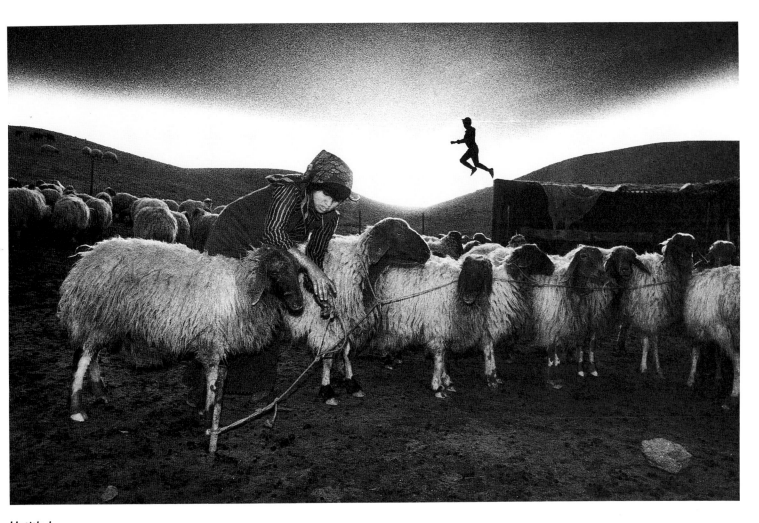

Untitled

Brian Cohen studied photography in London and has since
travelled widely, taking documentary pictures in many countries.
He has taught photography and has held many exhibitions.

His black and white photographs have a timeless, metaphysical
quality. His use of light and his tight framing of the subject create
a melancholic mood, encouraging the viewer to question what is
real and what is imagined.

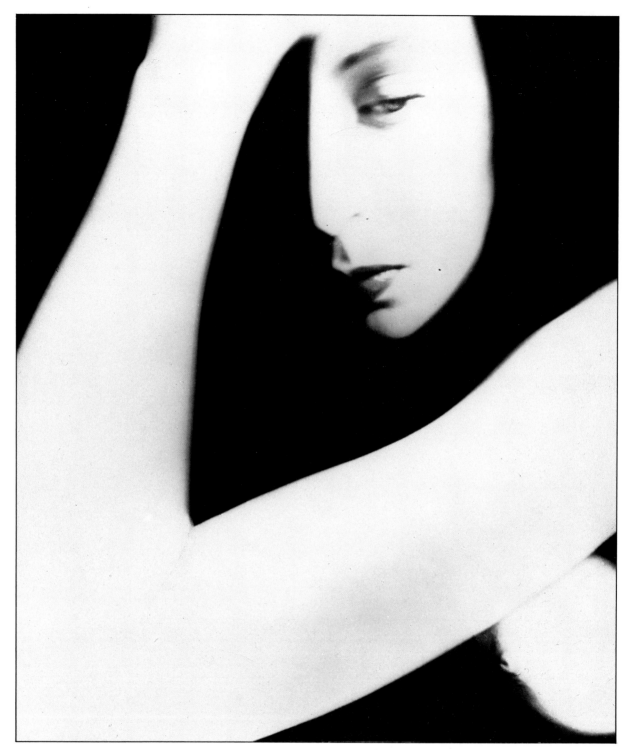

Nude: March 1952

Bill Brandt was educated in Germany and, as a young man, went
to Paris. While there, he became friends with the artists and film
makers in the Surrealist movement. When he went to England in
1931 he photographed with special sympathy the victims of the
Great Depression. His most published photographs, however, are
the nudes he took between 1948 and 1960.

Arguably, no other photographer has made more impressive
pictures of this popular subject. They are astonishingly beautiful
interpretations of the human body and they can be looked at time
and time again without losing any of their magic.

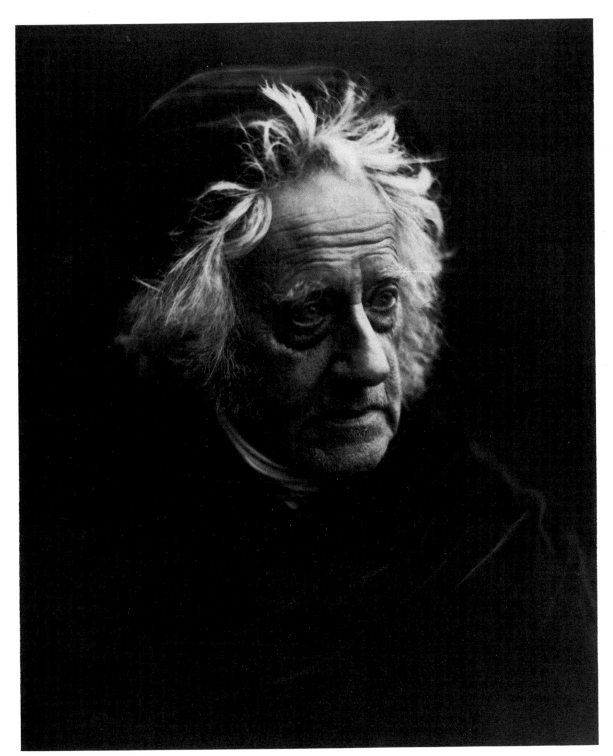

Sir John Herschel

Julia Margaret Cameron, eccentric, intelligent, wealthy Englishwoman, took up photography when she was 48 years old. Her husband had gone on a business trip to India and she needed something to occupy her time. Her studio was a converted chicken coop and her models were her personal friends. They suffered in the hot, stuffy studio and later discussed their ordeal among themselves.

Unlike many of her contemporary Victorian counterparts, Cameron's pictures are 'alive' – you can feel the personality of the sitter coming off the page. Although films and cameras have improved beyond recognition since her day, it is very few photographers who are able to express the personality of their models with as much skill.

This picture tells us almost too much about Sir John Herschel. It is hard not to feel like an intruding third party. Something of the man seeps into you as you look quietly at the photograph.

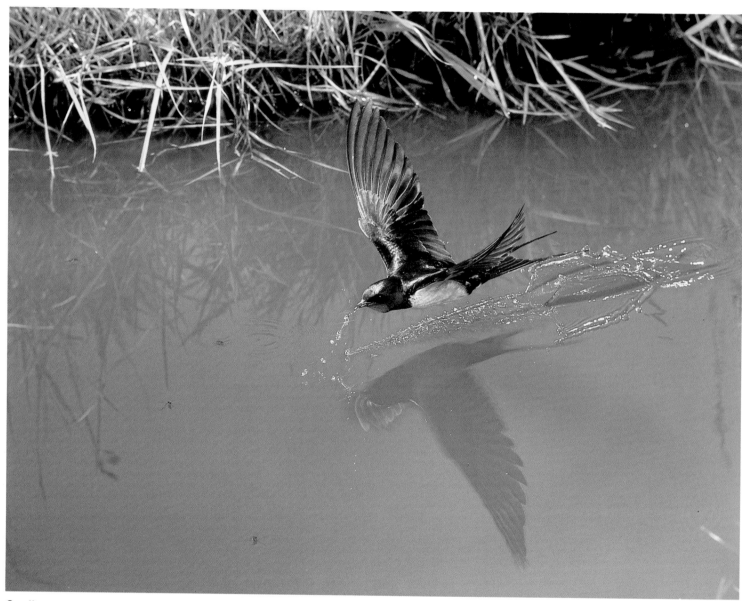

Swallow

Stephen Dalton is a naturalist who became fascinated by the
challenge of photographing insects and birds in flight. To do this,
he had to design special flash equipment that would produce an
extremely short burst of very bright light. This was necessary in
order to produce a sharp image of his rapidly moving subjects.
With help from his friend Ron Perkins, an electronics expert, they
built flash equipment and an electronic trigger that would fire the
flash within one-millionth of a second of a light beam being
broken by an insect or bird movement.

His photographs have been published in a number of books
and, apart from being beautiful to look at, they have considerable
scientific value.

This picture took several weeks to take due to the problem of
persuading the swallows to strike the water where the camera
was focused. Over this period of time, Dalton masked most of the
pond with netting, thus confining the splash down to a small area.
He then set up a motorized camera, an automatic triggering
device and high-speed flash heads. After another week or two of
test exposures, he was able to make a series of pictures showing
swallows drinking and bathing.

THIS PHOTOGRAPH IS MY PROOF

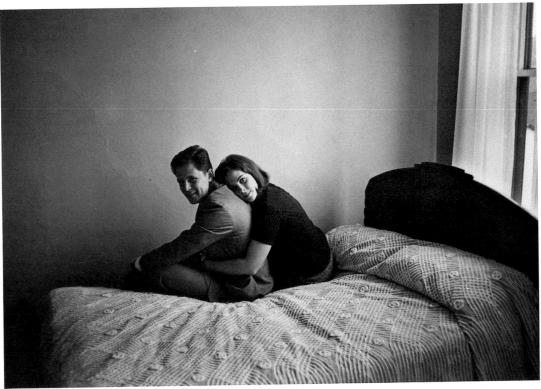

This photograph is my proof. There was that afternoon when things were still good between us, and we embraced and were so happy. She had loved me. Look, see for yourself.

This photograph is my proof

Duane Michals prefers the title of short story writer to that of photographer. Much of his work is presented as sequences, which are often strange and disturbing to look at. This photograph is about the sadness that follows the ending of a love affair. Although our memories fade, photographs remain as clear reminders of our own history. This picture, as personal as a snapshot, has the contradictory quality of the exhibition print.

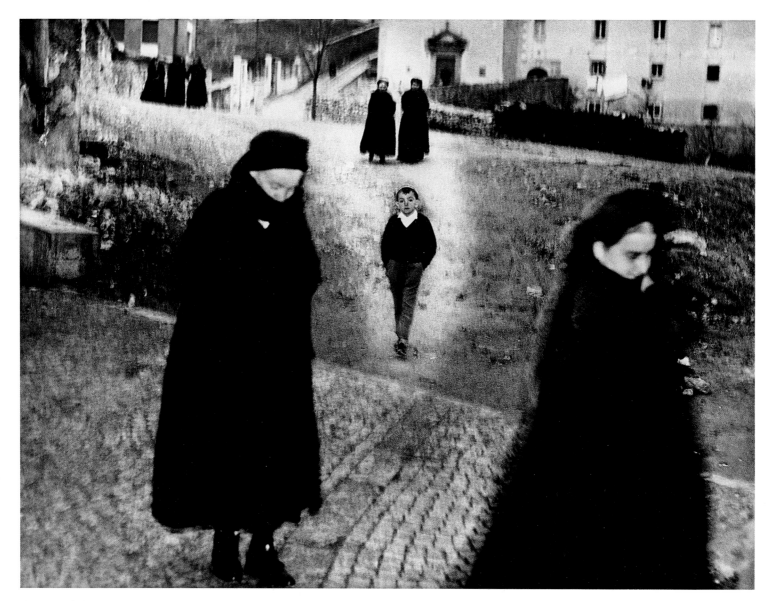

Seanno, 1963

Look at this picture! It is not very sharp, the focal point of the picture – the boy – is almost in the center of the frame and he is looking directly at the camera. It breaks almost all the 'rules' of composition and technique and, by rights, it should not be a picture that succeeds at all. And yet it does. It is among the most beautiful black and white photographs to have been made. It tells us to be guided by our feelings when we look through the camera, so that we can make pictures in our own way and develop our own style.

Mario Giacomelli is not a photographer by profession. He was born in 1925 in Italy and spends his time photographing rural life in his native country.

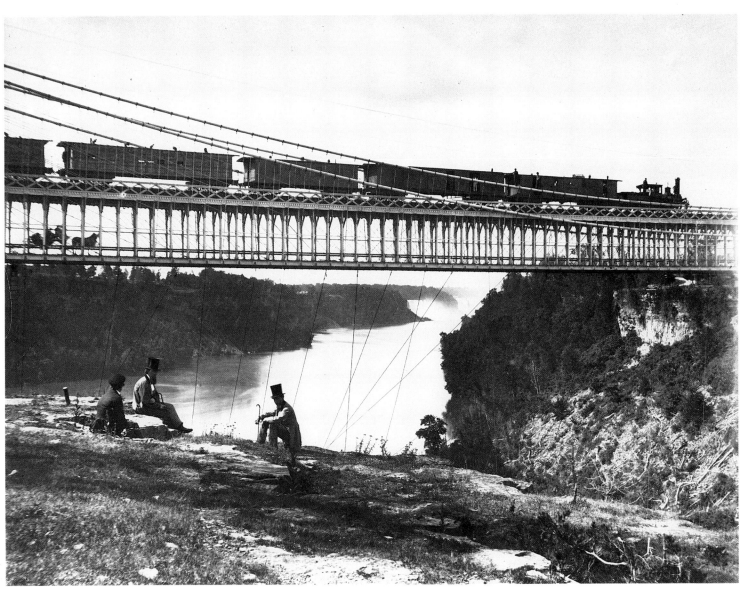

"Collection – The Museum of Modern Art New York."

Niagara Suspension Bridge, 1859
William England was one of the early travel photographers. He explored most countries in Europe and travelled extensively throughout America with his bulky and awkward photographic equipment. England was one of the first photographers to make use of glass plates. Until 1851, negatives were made on thin paper and the resulting prints lacked detail. England was able to produce as many fine-quality prints as the market demanded, and his pictures sold by the thousands.

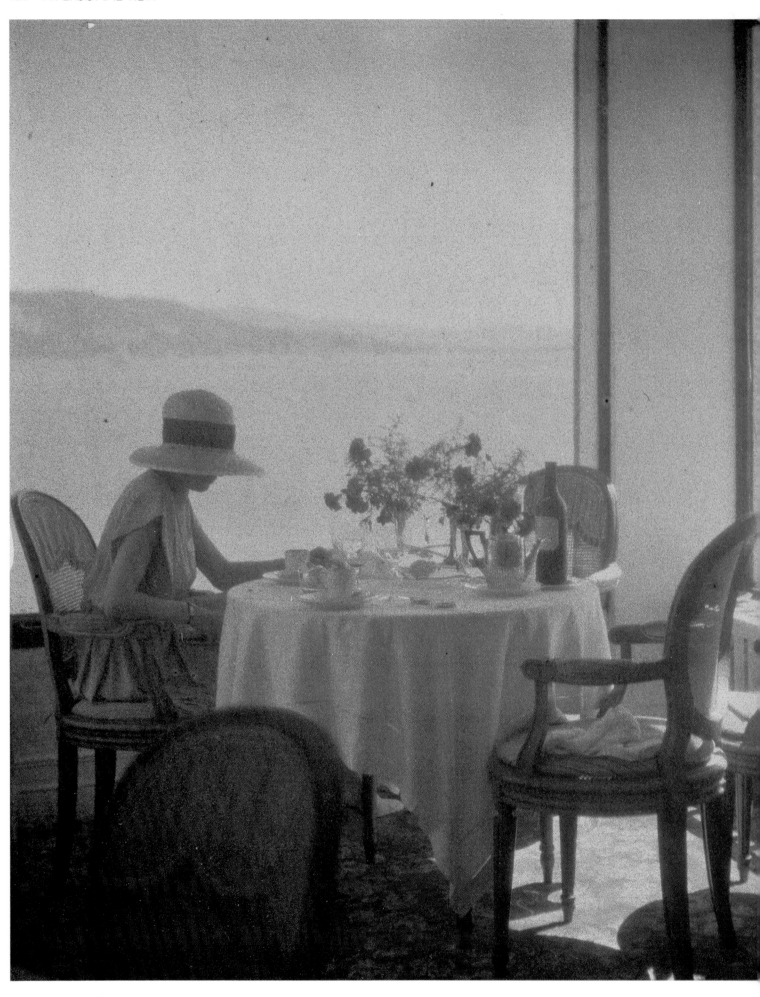

Bibi in Eden Roc Restaurant

Jacques-Henri Lartigue was born near Paris in 1896. His father, a wealthy businessman, presented him with a camera when he was six years old and with it he recorded his very gifted and eccentric family.

By profession a painter, Lartigue has taken photographs all his life and his reputation as a photographer has now surpassed his standing as a painter.

His photographs are beautifully observed. They combine the intimacy of the snap-shot with an eye for a telling composition. More importantly, they are the pictures by a man obviously delighted to be alive. His color work has been likened in feel to paintings, while many of his black and white photographs explore the camera's ability to freeze movement.

This picture was taken in 1920 using the autochrome process. It is a simple, quiet photograph of a friend waiting for Lartigue to put his camera away and join her at the table. The grainy quality of the picture adds another dimension and even today's high-speed emulsions could not produce this effect.

INDEX

PICTURE CREDITS